THE PRIEST
THE PRINCE
AND THE PASHA

LAWRENCE M. BERMAN

THE PRIEST
THE PRINCE
AND THE PASHA

The Life and Afterlife of an Ancient Egyptian Sculpture

MFA PUBLICATIONS
MUSEUM OF FINE ARTS, BOSTON

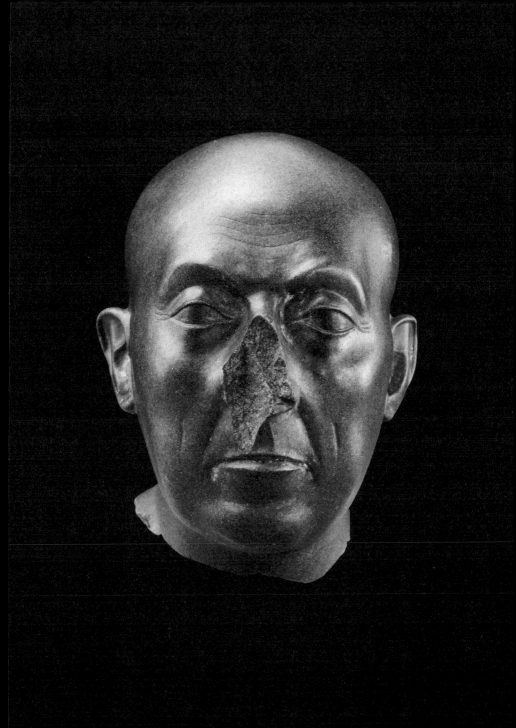

mfa
MFA Publications
Museum of Fine Arts, Boston
465 Huntington Avenue
Boston, Massachusetts 02115
www.mfa.org/publications

Support for this publication was provided by the Egyptian Publication Fund at the Museum of Fine Arts, Boston.

© 2015 by Museum of Fine Arts, Boston
ISBN 978-0-87846-796-9

For a complete listing of MFA publications, please contact the publisher at the above address, or call 617 369 3438.

All illustrations in this book were photographed by the Imaging Studios, Museum of Fine Arts, Boston, except where otherwise noted.

Produced by Marquand Books, Inc., Seattle
www.marquand.com

Edited by Jennifer Snodgrass
Editorial assistance by Katherine Harper
Designed by Jeff Wincapaw
Typeset in Dante by Tina Henderson
Proofread by Ted Gilley
Index by Enid Zafran
Color management by iocolor, Seattle
Printed and bound in China by C&C Offset Printing Co., Ltd.

Distributed in the United States of America and Canada by
ARTBOOK | D.A.P.
155 Sixth Avenue
New York, New York 10013
www.artbook.com

Distributed outside the United States of America and Canada by
Thames & Hudson, Ltd.
181A High Holborn
London WC1V 7QX
www.thamesandhudson.com

FIRST EDITION
This book was printed on acid-free paper.

CONTENTS

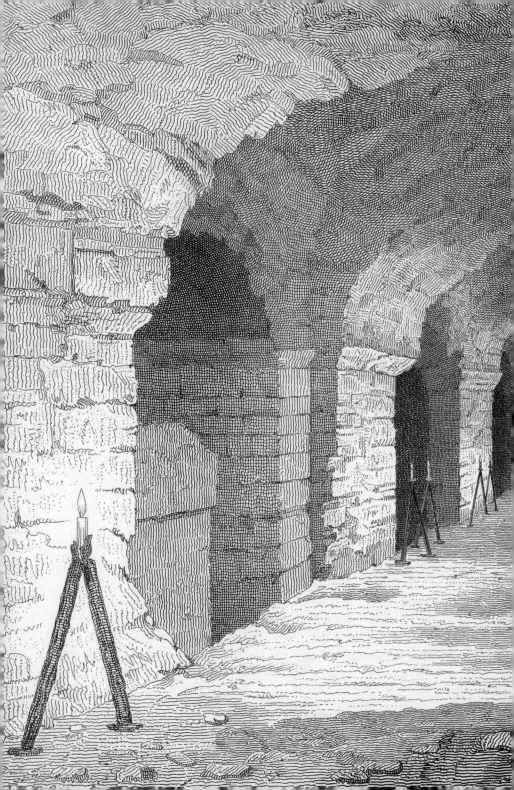

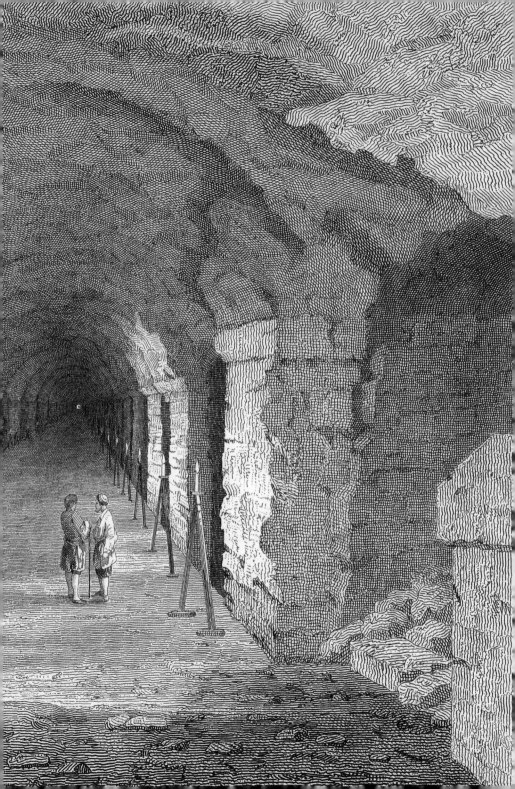

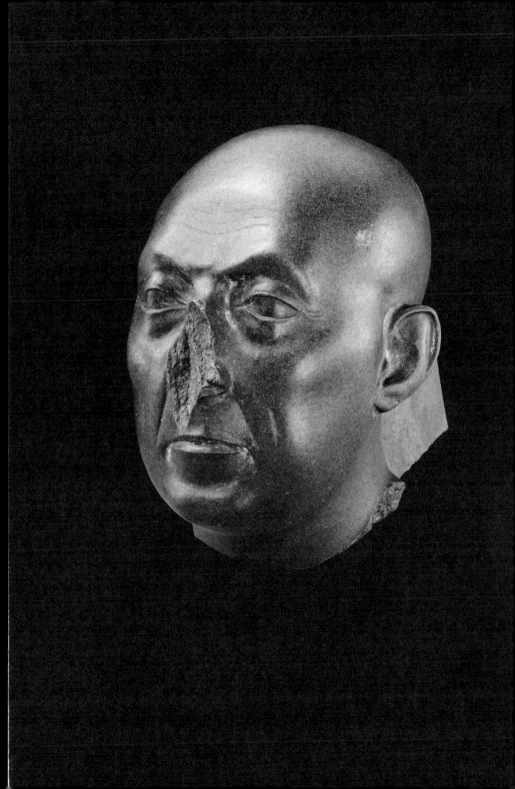

PROLOGUE THE BOSTON GREEN HEAD

In 1904, the Museum of Fine Arts, Boston, acquired a small portrait head of an old man, broken off from a statue, in fine, hard, dark gray-green stone. The head is a masterpiece, beautifully carved, the features wonderfully lifelike and individual. Parallel light wavy lines indicate the furrows of the man's brow, and crow's feet radiate from the outer corners of his eyes. The top of his nose has a pronounced bony ridge. The nose itself is gone. From the spring at the bridge, it clearly must have been a large and prominent feature—a pity, as its loss is the sole significant damage the head has suffered. Deep creases run from the edges of his nose to the corners of his mouth. Thin lips and a downturned mouth impart a feeling of strength and determination. Details such as the slight wart on his left cheek and a second, shorter crease below it further enhance the realism of the features. Most remarkable of all is the sense of skin and bone, the bumps and shallows of the skull, the heavy arched brows, and roundness of the eyeballs set deep in their sockets, the delicacy of the lids, the prominent cheekbones, hollow cheeks, and slightly saggy jowls.

So lifelike is the artist's rendition that it is natural to assume that the portrait faithfully captures the subject's distinctive facial features. In truth, we will never know. The ancient Egyptians did not make statues just to admire them as works of art. Statues served a specific religious purpose in tomb or temple, as places where the gods and the spirits of the dead could reside. The ritual of "opening of the mouth," in which a priest wearing a leopard skin touched the statue with a carpenter's adze, brought the statue's senses to life and enabled the spirit inside to receive offerings of food and drink in perpetuity. The same ceremony was performed on statues of deities and on wrapped mummies. This religious function did not preclude portraiture. The Egyptians seem to have been capable of making individual portraits and in some periods this was considered desirable, even mandatory. Statues of King Menkaura (reigned

Head of a Priest (The Boston Green Head).

..

2490–2472 BC) are a case in point. The king is consistently shown with bulging eyes, puffy cheeks, a bulbous nose, and drooping lower lip.[1] There would be no reason to reproduce these particular features unless they corresponded with reality. With non-royal images it is harder to say whether a statue is a portrait, as we do not always have other statues of that person with which to compare it.[2] After the Fourth Dynasty, which ended in the late twenty-third century BC, conventionalism prevails, everyone conforms to a type, and an inscription identifying the subject by name was enough to individualize the statue. Realistic portraits occur again in Egyptian art, notably around the nineteenth century BC, with the highly expressive features of Senwosret III (1878–1841 BC) and his son Amenemhat III (1844–1797 BC).[3] In the Late Period, with two thousand years to look back on, the situation is more complex. Statues with realistic features, mostly of older men, full of character, coexist with statues with bland, smiling, impersonal faces. The former look like realistic portraits, the latter clearly are not. For some scholars, even the Boston Green Head, for all its individuality, is but a type representing an older man.[4] For others (among them the present writer) it is one of the great portraits from antiquity, a worthy successor to the great earlier works.[5]

The remains of the back pillar—a peculiar feature of ancient Egyptian sculpture—with hieroglyphic inscription leaves no doubt about the Egyptian origin of the piece. The stone itself tells as much. Often misidentified as basalt, schist, or slate, it is in fact graywacke from the Wadi Hammamat quarry in the Eastern Desert of Egypt, about halfway between Koptos and Quseir along one of the main routes from the Nile to the Red Sea.[6] A fine-grained sedimentary rock, graywacke ranges in color from dark gray to gray-green.[7] The Egyptians sent expeditions of thousands, sometimes even tens of thousands, of men to this harsh desert region to quarry stone for statues, vessels, sarcophagi, shrines, and obelisks. The stone was prized throughout Egyptian history from the Predynastic Period, when it was used mainly for stone vessels, down to Roman times, but especially in the Late Period (743–30 BC), when artists and those who

commissioned them showed a particular appreciation for the highly pol-
ished surfaces of hard dark stones. The Egyptians called it *bekhen*-stone.
It is an irony of linguistics that the Egyptian word *bekhen* is the origin,
through Greek *basanites lithos* and Latin *lapis basanites*, of the English
word "basalt," which in modern usage properly describes an entirely dif-
ferent brownish-black volcanic stone less often used for sculpture.[8]

It was immediately apparent that the head dated to the Late Period,
but it has been placed in various eras during that seven-hundred-year
span from the Kushite invasion to the end of the Ptolemaic Dynasty: the
Saite Period (7th–6th century BC), Dynasty 30 (4th century BC), and the
mid-Ptolemaic Dynasty (late 3rd–early 2nd century BC).

Although only ten-and-a-half centimeters high (a little more than
four inches), the head makes a monumental impression. When com-
plete, the figure was probably standing or kneeling. Most Egyptian stat-
ues in the Late Period were made to be placed in temples rather than
tombs. Our man was probably shown holding an attribute appropriate
to the temple setting such as a statue of a deity, or a *naos*, or shrine, con-
taining the image of a deity, as an emblem of his piety. If standing, the
figure would have been about 71 centimeters (28 inches) high; if kneel-
ing, about 44 centimeters (17½ inches) high, to which one would have
to add up to 2 inches for the height of the integral base.[9]

Our only clue to our subject's identity is his coiffure, or rather, the
lack of one. Egyptian priests were required to shave their heads for
reasons of ritual purity. Although not all priests appear shaven-headed
in Egyptian sculpture, most statues of shaven-headed men represent
priests.[10] Handed down through the centuries, from Roman wall paint-
ings and statues of priests of Isis to Hollywood movies, the white-robed
shaven-headed Egyptian priest is a familiar character.[11] The trapezoidal
top of the back pillar preserves the name of a funerary deity worshiped
in Memphis, Ptah-Sokar, the beginning of a prayer that would have con-
tinued down the pillar to the base of the statue. The complete inscription
would have included, at the very least, the subject's name and occupation.

The base might also have been inscribed with another prayer, perhaps including additional titles, the name of a family member, or—if we were lucky—even a snippet of historical information. If he was holding a *naos*, that too may have been inscribed. As it is, for lack of anything better, the piece is known worldwide as the Boston Green Head, after the color of the stone and the place where it now resides. Under that name it has become world famous.

The head has, moreover, a fascinating modern history. It was discovered in 1857 by Auguste Mariette at the Saqqara Serapeum. Just seven years earlier, the young French Egyptologist had discovered the tombs of the sacred Apis bulls, one of the most sensational discoveries in the history of Egyptology. Its first modern owner was the notorious Prince Plon-Plon, nephew of Napoleon I and first cousin of Napoleon III, who kept it in his Pompeian House in Paris. It came to the MFA via Edward Perry Warren, a Bostonian expatriate collector who transformed the museum's holdings of classical art from an assembly of plaster casts to America's premier collection of Greek and Roman originals. Through these and other individuals, the story of the Boston Green Head reaches back to the beginnings of Egyptian archeology. The successive stages of that history reflect the reception of Egyptian art in the modern era. That story is the subject of this book.

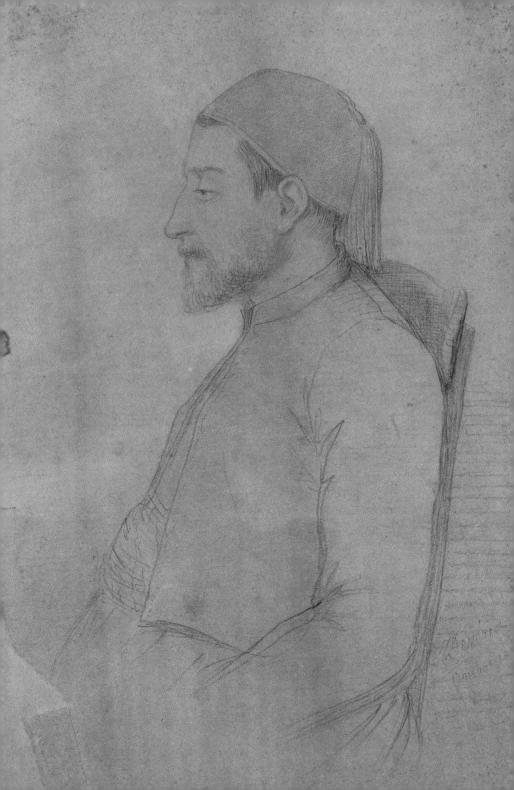

THE ARCHAEOLOGIST

On October 2, 1850, a young French Egyptologist named Auguste Mariette disembarked at Alexandria. He was twenty-nine years old. The French Government had commissioned him to visit the Coptic monasteries of Egypt and make an inventory of the manuscripts preserved in their libraries. It was his first visit to Egypt, and he was supposed to stay six months. Mariette returned to France four years later a famous man, having made one of the greatest finds in the history of Egyptology: the Serapeum of Memphis and the catacombs of the sacred Apis bulls. He sent back to France some six thousand objects—statues, steles, bronzes, jewelry, funerary equipment—dating from the Old Kingdom to the Ptolemaic Dynasty. These and other discoveries would ultimately lead to Mariette's appointment as Egypt's first director of antiquities. Along the way he would also discover a small head of a priest in green stone.

François Auguste Ferdinand Mariette was born at Boulogne-sur-Mer, on the English Channel, on February 11, 1821.[1] As a youth he showed a talent for drawing; in 1839, at the age of eighteen, he went over to England, where for a year he taught French and drawing and then tried his hand at making designs for a ribbon manufacturer in Coventry. In 1841 he returned to Boulogne to resume his education, and in six months received his bachelor's degree with honors at the University of Douai. He then accepted a teaching position at his old middle school in Boulogne, where he put his artistic talents to use designing and painting scenery for school theatrical productions. But he was increasingly drawn to journalism and wrote on a variety of topics for the local press: literary sketches, reviews, investigations into local history, even poetry. He became the editor of a local newspaper, *L'Annotateur boulonnais*.

Mariette's introduction to Egyptology came in 1842 by way of a deceased cousin, the painter Nestor L'Hôte (1804–1842).[2] One of the unsung heroes of early Egyptology, L'Hôte first went to Egypt in 1828–30 as

part of the joint Franco-Tuscan Expedition led by Jean-François Champollion (1790–1832), the brilliant young scholar who in 1822 read his epoch-making paper before the French Academy of Inscriptions and Belles-Lettres announcing his discovery of the hieroglyphic alphabet.[3] Cosponsored by King Charles X of France and Grand Duke Leopoldo II of Tuscany, the fourteen-member expedition (made up of seven Frenchmen and seven Italians) stopped at every known important archaeological site between Alexandria and Wadi Halfa, at the border between Egypt and Sudan. It had been many centuries since anyone had come to Egypt who could read the inscriptions written on the monuments. From Wadi Halfa, an elated Champollion wrote back to Bon-Joseph Dacier, permanent secretary of the Academy of Inscriptions:

> Now that I have followed the course of the Nile from its mouth to the Second Cataract, I am in a position to tell you that we need change nothing in our *Letter on the Alphabet of the Hieroglyphs*. Our alphabet is correct: it applies equally well to the Egyptian monuments built during the time of the Romans and the Ptolemies, and—what is of much greater interest—to the inscriptions in all the temples, palaces and tombs dating from the time of the pharaohs.[4]

The twenty-four-year-old L'Hôte was one of four young French artists who traveled with Champollion, the Father of Egyptology (himself only thirty-eight) on his first and only trip up the Nile.[5] An assiduous worker, L'Hôte made over five hundred watercolors and drawings on this journey, only a small portion of which found their way into the final publication.[6] By the time he returned to France in March 1830, he had been away for twenty months. Two years later, on March 4, 1832, Champollion died suddenly at the age of forty-one, the victim of a stroke. The French government sent L'Hôte back to Egypt in March 1838 to fill gaps in the documentation and complete the study of the sites that the expedition had left unfinished. A severe case of dysentery forced him to return to France in September 1839. Unfortunately, the paper

pulp impressions of inscriptions, known as paper squeezes, that he was counting on to help him complete his drawings suffered water damage when his ship sprung a leak. Barely recovered, he went back to Egypt for another year, from July 1840 to August 1841, during which he crossed the desert to the Red Sea twice. This trip so weakened him that he fell ill and died on March 24, 1842, ten years after the death of his mentor Champollion. He was just thirty-eight.

Shortly thereafter L'Hôte's father relocated to Boulogne, bringing with him his son's papers from Egypt. The task of sorting through this material fell to Mariette, as the only member of the family with any literary pretensions. It appealed to his taste for romance and adventure, and Mariette fell in love with Egyptology. He applied himself to the study of hieroglyphs with the limited resources at his disposal, including L'Hôte's notes from his own study with the decipherer himself, and managed to teach himself the rudiments of the language. Mariette applied his newfound learning to the study of the small collection of Egyptian antiquities in the Boulogne Museum, which included a set of painted wooden coffins from the eighth century BC covered with hieroglyphic inscriptions and scenes from the Book of the Dead.[7] A copy of the *Description de l'Egypte* (*Description of Egypt*) in the municipal library was his only other resource. This was the monumental record of the work of the scientific commission that accompanied General Napoleon Bonaparte's Egyptian campaign of 1798–1801, published from 1810 to 1828.

By 1846 Mariette felt ready to apply for a government grant to travel to Egypt on a scientific expedition, but the time was not right and his application was politely declined. Not ready to give up so quickly, Mariette then proposed to undertake explorations in Egypt at his own expense if the government would grant him free passage on a mail steamer from Marseille to Alexandria, but this too was denied.

Eager to make himself known, Mariette inserted an article in the March 18, 1847, issue of the *Annotateur boulonnais* impressively offering an "Analytical Catalogue of the Monuments Composing the Egyptian

Gallery of the Boulogne Museum." He sent offprints to Paris, where his work attracted the attention of one of France's leading Egyptologists, Charles Lenormant (1802–1859), who wrote back encouragingly. Although Mariette was clearly unfamiliar with the latest scholarship, his writing showed promise. Emboldened by the favorable response, Mariette decided to risk all and move to Paris to seek a career in Egyptology. This was an extremely audacious decision, as he had no definite prospects and was by this time already married and a father. But Mariette was daring, energetic, and persistent, qualities that characterized him all his life. He had already quit his editing job; he now obtained a leave of absence from his teaching position, and so in the summer of 1848 at the age of twenty-seven, with a wife and three daughters to support, with no professional position and without any formal training in his chosen field, Mariette went off to Paris to make his name.

And in spite of all odds he succeeded, in 1849, in landing a temporary position in the Egyptian department at the Louvre cataloguing recent acquisitions and mounting papyri on Bristol board. Mariette made the best of his time during the day by copying all the hieroglyphic inscriptions in the Louvre, drawing up an inventory of its Egyptian monuments, "and in the evening reading all the classical authors on Egypt, all the Byzantine historians, and all the scholarly articles in German, French, English, and Italian he could get his hands on that had appeared since Champollion's time, thereby making up for the lack of resources in Boulogne. He hoped to find a permanent position at the Louvre, but there were no foreseeable openings. Lenormant, ever supportive, encouraged Mariette to apply for a government grant to go to Egypt, as he had done four years earlier; this time, his friends in the Academy of Inscriptions and Belles-Lettres would support his proposal.

At Lenormant's suggestion, Mariette proposed to visit the Coptic monasteries of Egypt to make an inventory of manuscripts in Coptic and other languages preserved in their libraries. It was long known that Coptic was the latest phase of the ancient Egyptian language, written with

a modified Greek alphabet. Coptic had been instrumental in enabling Champollion to decipher the hieroglyphic script. In the centuries following the Arab conquest of Egypt in AD 639–41, Egypt changed from a predominantly Coptic-speaking Christian country to an Arabic-speaking Muslim one. Coptic had ceased to be a living language probably by the fifteenth century AD, though it survived, and still survives, in the liturgy of the Coptic Church. The monasteries of Egypt were a vast repository of Coptic as well as Ethiopian and Syriac manuscripts: Bibles, homilies, acts of the martyrs, lives of the saints, and occasional translations of ancient Greek literature.

In 1833 a British scholar, Robert Curzon, had visited the monasteries of Wadi el-Natrun, in the desert between Alexandria and Cairo, and walked away with a fine collection of manuscripts, having overcome the monks' resistance with judicious doses of rosoglio, a heady liqueur.[8] Six years later, the distinguished British Coptologist Henry Tattam repeated Curzon's exploit with equal success. Their unscrupulous methods had scandalized the scholarly community, but Mariette wouldn't have to resort to deceit—he would buy the manuscripts or copy those he could not buy. To show himself ready he went through all the Coptic manuscripts in the Bibliothèque Nationale and drew up a complete bibliography.

Mariette's proposal was worthy of consideration because it avoided the most popular area of research in Egypt, the pharaonic monuments, in favor of the neglected Coptic legacy. It also appealed to the Anglo-French rivalry: it was intolerable that Britain should have a better collection of Early Christian manuscripts than France. But although manuscripts were the main objective, Mariette proposed a second agenda—a kind of escape clause. Even after the Franco-Tuscan Expedition, discoveries remained to be made, so Mariette also proposed to undertake excavations at ancient sites that were as yet incompletely explored. Just as Lenormant had predicted, the government referred Mariette's application to the Academy of Inscriptions and Belles-Lettres for review, the Academy (of which Lenormant was a member) returned a favorable report, and Mariette

got his grant. The Ministries of Public Education and of the Interior each contributed funding.

Such was the position of Auguste Mariette when he arrived in Egypt. After checking in at the French consulate he stayed in Alexandria just long enough to see the few ancient sights the city had to offer the traveler in those days: the two obelisks known as Cleopatra's Needles (now in London and New York), and Pompey's Pillar. In the gardens of the Belgian consul, Count Stephan Zizinia, a dozen or so limestone sphinxes about four feet long and executed in the cool and elegant style of the last dynasties, some with Greek inscriptions on the sides, caught his attention. A fruitless visit to the Coptic convent in Alexandria having taught him that he would get nowhere without permission from the authorities, Mariette hastened to Cairo, where the Coptic patriarch, who remembered Tattam and Curzon only too well, put him off with one excuse after another before finally agreeing to write him a letter of introduction to the abbot of Saint Macarias, the oldest of the monasteries of Wadi el-Natrun. While awaiting the letter, Mariette made the acquaintance of the French expatriate community in Cairo. Prominent among them was Louis Maurice Adolphe Linant de Bellefonds (1799–1883), also known as Linant Bey. (Bey is a Turkish title of rank, below that of pasha; like most Turkish titles it follows rather than precedes the name.) Linant came to Egypt in 1817 as a draftsman in the service of the Comte de Forbin, general director of the museums of France, and never left. Between 1818 and 1830 he took part in numerous and far-ranging explorations in Egypt and Sudan. After that he settled down somewhat and took up hydrologic engineering. In 1831 Muhammad Ali Pasha, viceroy of Egypt, made him engineer of Upper Egypt; he later rose to chief of bridges and roads and then director of all public works. Linant was among the first to demonstrate the feasibility of a direct canal linking the Nile and the Red Sea. Linant had visited Wadi el-Natrun in 1828, and gladly offered to go back with Mariette.[9]

As Mariette waited for the Patriarch's letter to materialize he became more and more impatient. In several private collections in Cairo he noticed sphinxes exactly like the ones he had seen in Alexandria. All, he learned, had come from Saqqara, the cemetery of ancient Memphis, and had been purchased from the same dealer, Solomon Fernandez. It seemed clear to Mariette they must have come from an avenue of sphinxes that led to a temple yet undiscovered. He began to feel the urge to forget about the Coptic manuscripts and go after antiquities, which had all along been his ulterior goal. On the evening of October 19, he climbed up to the citadel of Cairo, absorbed in thought:

The stillness was extraordinary. At my feet lay the city. Upon it a thick and heavy fog seemed to have settled covering all the houses to the rooftops. From this deep sea rose three hundred minarets like masts from some submerged fleet. Far away, towards the south, one could perceive the palm groves that rise from the fallen ruins of Memphis. To the west, bathed in the gold and flaming dust of the sunset, were the pyramids. The view was superb. It held me and absorbed me with a violence that was almost painful. The moment was decisive. Before my eyes lay Giza, Abusir, Saqqara, Dahshur, Mit Rahineh. This life-long dream of mine was materializing. Over there, practically within my grasp, was a whole world of tombs, stelae, inscriptions, statues. What more can I say? The next day I hired two or three mules for my luggage, one or two donkeys for myself; I had bought a tent, a few cases of provisions, all the necessities for a trip to the desert and on October 1850, I pitched my tent at the foot of the Great Pyramid.[10]

After a few days at Giza, Mariette moved on to Saqqara, about twelve miles farther south. Here was a much larger cemetery, with tombs from every period of Egyptian history—as Mariette would later describe it, "the most important, the most ancient, and yet at the same time the

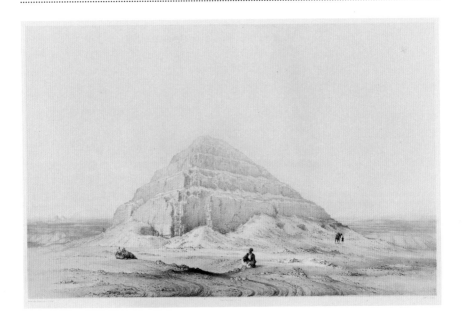

most modern of all the cemeteries of Memphis."[11] While exploring the area north of the Step Pyramid, Mariette came upon a sphinx buried up to its head in sand, with features just like the ones he had seen in Alexandria and Cairo. This was where his familiarity with the classical authors paid off. The sight of this sphinx recalled to him a passage in Strabo's *Geography*:

"One finds [at Memphis]," said the geographer, "a temple to Serapis in such a sandy place that the wind heaps up sand dunes, beneath which we saw sphinxes, some half-buried, some buried up to the head, from which one can suppose that the way to this temple could not be without danger if one were caught in a sudden windstorm." Did it not seem that Strabo had written this sentence to help us rediscover, after over eighteen centuries, the famous temple dedicated to Serapis? . . . This buried sphinx, the compan-

The Step Pyramid at Saqqara as it appeared in 1850, before Mariette's excavations, from Carl Richard Lepsius's publication of the Prussian Expedition to Egypt.

ion of fifteen others I had encountered in Alexandria and Cairo, formed, with them, according to the evidence, part of the avenue that led to the Memphis Serapeum. . . . It did not seem to me possible to leave to others the credit and the profit of exploring this temple whose remains a fortunate chance had allowed me to discover and whose location would henceforth be known. Undoubtedly many precious fragments, many statues, many unknown texts were hidden beneath the sands upon which I stood. These considerations made all my scruples disappear. At that instant I forgot my mission, I forgot the Patriarch, the convents, the Coptic and Syriac manuscripts, Linant Bey himself, and it was thus, on 1 November 1850, during one of the most beautiful sunrises I had ever seen in Egypt, that a group of some thirty workmen, working under my orders near that sphinx, were about to cause such a total upheaval in the conditions of my stay in Egypt.[12]

That is the official version of the story published in the final excavation report and often quoted since. That report, however, did not appear until 1882, a year after Mariette's death and thirty-two years after the events described. Contemporary accounts indicate that Mariette knew just what he was looking for when he went to Saqqara in 1850, even before he saw that sphinx in the sand.[13] He was after the Serapeum.

In the early days of exploration, scholars and laymen alike relied heavily on the writings of the classical authors for information about ancient Egypt, mainly for lack of other sources. Educated Europeans and Americans in the nineteenth century were more familiar with the classics than are their counterparts today. As late as 1896, Murray's *Handbook for Egypt* included Herodotus's *Histories*, Strabo's *Geography*, Diodorus Siculus's *Library of History*, and Plutarch's *Isis and Osiris* in a list of books that "will be found of use to the traveler."[14]

The Serapeum (also spelled Sarapium or Sarapieion) was one of the principal sights of ancient Memphis. Strabo, who visited Egypt about 25 BC

in the company of Gaius Aelius Gallus, the first Roman prefect of Egypt, describes the main attractions of the city, still large and populous just five years after Cleopatra's suicide and the end of the Ptolemaic Dynasty:

> It contains temples, one of which is that of Apis, who is the same as Osiris; it is here that the bull Apis is kept in a kind of sanctuary, being regarded, as I have said, as god; his forehead and certain other small parts of his body are marked with white, but the other parts are black; and it is by these marks that they always choose the bull suitable for the succession, when the one that holds the honour has died. In front of the sanctuary is situated a court, in which there is another sanctuary belonging to the bull's mother. Into this court they set Apis loose at a certain hour, particularly that he may be shown to foreigners; for although people can see him through the window in the sanctuary, they wish to see him outside also; but when he has finished a short bout of skipping in the court they take him back again to his familiar stall.[15]

He goes on to describe the Hephaesteium, or temple of Ptah (Hephaestus to the Greeks)—a large and costly edifice, with a colossal statue in the dromos, the avenue leading up to it—and the temple of Aphrodite, "who is considered to be a Greek goddess, though some say that it is a temple of Selene." The Serapeum follows next, in the passage quoted by Mariette.[16] Although Strabo tells us where the Apis bull lived, he does not say where he was buried. That information comes, somewhat unexpectedly, from the *Description of Greece* written about AD 175 by the Greek writer Pausanias: "Of the Egyptian sanctuaries of Serapis the most famous is at Alexandria, the oldest at Memphis. Into this neither stranger nor priest may enter, until they bury Apis."[17]

Sacred animal cults, which have a long history in ancient Egypt, became particularly important in the Late Period, seemingly as an expression of national identity in response to successive invasions and periods of occupation by the Kushites or Nubians (728 and 712 BC), Assyrians

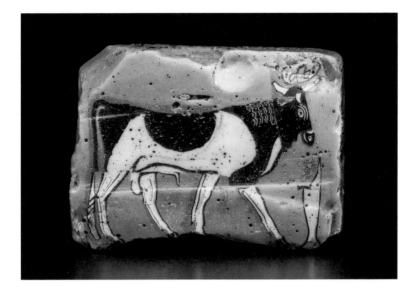

(671 and 669 BC), and Persians (525 and 343 BC).[18] Because each deity could manifest itself as a species of animal, all kinds of creatures—cats, dogs, baboons, ibises, falcons, fish, snakes, crocodiles, and more—were protected in life and after death mummified and buried by the thousands in specialized animal cemeteries.[19] This was the aspect of Egyptian religion that triggered the curiosity of Greek visitors like Herodotus and provoked the ridicule of later Roman visitors such as the poet Juvenal (late 1st–early 2nd century BC): "Who knows not . . . what monsters demented Egypt worships? One district adores the crocodile, another venerates the Ibis. . . . In one part cats are worshipped, in another a river fish, in another whole townships venerate a dog."[20]

The bull cults were different, however: there was only one sacred bull at a time. Whereas there were other bull cults—Buchis at Armant, and Mnevis at Heliopolis—Apis was the oldest and most prestigious. When an Apis bull died, he received a burial fit for a king, and the priests searched for his successor, who would be identified by his distinctive

Mosaic glass inlay of an Apis bull, showing the sacred animal's characteristic markings.

markings. When they found him they took him to Memphis, where he was stalled in luxury beside the temple of Ptah. His mother came too, for she was now the Isis cow. She had her own temple, as mentioned by Strabo, and her own catacombs north of the Serapeum.

In life Apis was the "herald," or incarnation, of Ptah, but in death he was Osiris, or Osiris-Apis, known in Greek as Osorapis. The Ptolemies, who were lavish sponsors of the Apis cult, were responsible for a further development of the cult. As part of their policy of forging a synthesis of Greek and Egyptian religious traditions, they introduced the god Sarapis (Serapis in Latin), who took his name from Osorapis but his iconography from Zeus—bearded, majestic, wearing a grain measure on his head as a symbol of abundance. He became a universal god, combining within himself Osiris, Apis, Zeus, Hades, Dionysos, and other deities. In this form he was worshipped all over the Mediterranean world. The passage in Pausanias quoted above regarding the Egyptian sanctuaries of Serapis occurs in reference to the Serapeum located at Athens, far from Egypt and in the heart of the classical world. And so his name survived through the ages. Europeans in Mariette's time would not have heard of Queen Nefertiti or King Tut, but they would have known of the divine Apis bull. That is why the discovery of the Serapeum made such a sensation.

But in order to find the Serapeum one had first to know the whereabouts of ancient Memphis. It is difficult to believe today that the location of one of the greatest cities of antiquity, whose foundation goes back to 3000 BC, whose ruins, even in the Middle Ages, stretched for miles on end and inspired the wonder of Arab travelers, could ever have been in doubt. Nonetheless the identification of ancient Memphis with the modern village of Mit Rahina, twelve miles south of Cairo, was not firmly established and accepted by the scholarly community until the publication of the *Description of Egypt* beginning in 1810.[21] Earlier scholars had favored Cairo or Giza, so unprepossessing were the mounds of Mit Rahina, and even today, after decades of excavation, the site has little to show for its former splendor. For nineteenth-century travelers, Mem-

phis was a place to reflect on the fleeting nature of earthly glory; one bestselling travel account observed that the visitor "tries in vain to realise the lost splendours of the place. . . . One can hardly believe that a great city ever flourished on this spot, or understand how it should have been effaced so utterly."[22]

The French cartographer and engineer Edmé François Jomard (1777–1862), chief editor of the *Description of Egypt* and author of the chapter on Memphis and the Pyramids, correctly situated the Serapeum in the sandy desert west of Saqqara and indicated what would be required to uncover it: "One would have to undertake large excavations between Saqqara and the Step Pyramid . . . to the north, and dig in the sands deep enough to bring the sphinxes to light; these doubtless formed an alley, as in Thebes, leading to the door of the temple."[23]

Find the sphinxes, find the temple. But nobody followed the lead. The French went looking on the wrong side of the Nile, the English at Abusir to the north, the Germans at Dahshur to the south.[24] Meanwhile the sphinxes began to emerge. In 1832 Doctor Marucchi, a Genoese working on behalf of the French consul, found two Serapeum sphinxes but left them on the spot on account of their poor condition. A few years later, a "resident of Cairo," who could only be the dealer Solomon Fernandez, removed thirty of them; twelve were sold to Zizinia in Alexandria, eight to private collectors in Cairo, and twelve to an Englishman who shipped them to Calcutta.[25] Around the same time, excavations undertaken by the Egyptian government yielded more sphinxes, six of which went to the École Polytechnique in Cairo. Karl Richard Lepsius, who from 1842 to 1845 led the Prussian Expedition to Egypt and Sudan, the best-prepared outfit yet to explore the valley of the Nile, found two Serapeum sphinxes in situ while excavating an Old Kingdom tomb on Serapeum Way. He failed to put two and two together, a fact relished by Mariette, who could not resist rubbing it in: "I find it hard to explain how none of the learned travelers who passed through Egypt thought of putting a name to the temple of which the avenue provided so many indications of its ancient splendor."[26]

In fact somebody had. In 1848, two years before Mariette came to
Egypt, Anthony Charles Harris (1790–1869), an English merchant at Alex-
andria, best known for his magnificent collection of papyri—including the
"Great Harris Papyrus" now in the British Museum, at 133 feet the longest
of all Egyptian papyri—gave a report to the Royal Society of Literature
in London. Harris had essentially followed the same trail that Mariette
would. Having seen, at a dealer's shop in Cairo, a number of sphinxes of
uniform size and workmanship, Harris inferred they must come from an
avenue leading to a temple. Harris knew that the dealer (Fernandez again)
employed men to excavate at Saqqara and surmised the temple was at
that site. At a later visit to Saqqara, Harris witnessed three sphinxes of
the same type being laid bare. His guide explained that at least a hundred
of these sphinxes still lay buried in the sand and pointed out the location
of a number of them. Harris conjectured that the undiscovered temple
they led to might be the Serapeum described by Strabo as being in "such
a sandy place." But the suggestion remained in his unpublished notes.[27]

Nonetheless, Mariette had no time to lose. He began work on
November 1, 1850. Picturing to himself the ramrod-straight sphinx-lined
avenues of Thebes, Mariette assumed he had only to determine the axis
of the sphinxes and project the course of the alleyway westward toward
the Serapeum. To the west one could see in the distance a vast enclosure
outlined in the sand. In the center of the enclosure rose up tall hills of
sand and debris, the ruins of an ancient temple. The avenue of sphinxes
must lead there. So Mariette transferred his workers to the middle of the
hills of sand and started digging. To their surprise they found nothing,
not one section of wall, though they dug down to bedrock. The Sera-
peum was not there.

Maybe they had gone too fast. If the alleyway did not lead to the tem-
ple, at the very least it must lead to the enclosure. There must be a door,
a pylon, an entryway of some kind where the alley met the enclosure
wall. But still there was nothing. Mariette wasted a whole month this
way before deciding to go back to square one. After all, the terrain was

so disturbed, so broken up by hills and troughs, he might have miscalculated the path, so he directed the workers to uncover more sphinxes to confirm the direction of the alley. Soon they had excavated four pairs of sphinxes, spaced six meters apart, giving them a line of eighteen meters (almost 60 feet) to work with. If they had made a mistake, they would see it. And then they did see: The sphinxes were not in line. The avenue veered slightly to the left—partly on account of the unevenness of the terrain, and partly to avoid existing structures.

There was no choice but to go from sphinx to sphinx and see where they led. By clearing a wide path, Mariette was able to find the road fairly quickly, at least at first, as the sphinxes were buried only about four meters deep, ten or twelve feet. In the process he also uncovered a number of Old Kingdom tombs, in one of which he found the *Seated Scribe*, still today the most famous Egyptian statue in the Louvre (see page 100).[29] But soon the digging became more difficult, as the sphinxes were found buried deeper and deeper beneath the sand.

He discovered 134 sphinxes in this way and then he lost the trail.[29] At this point the sand was twenty meters (seventy feet) deep. Mariette's workmen could advance only one meter per week. "The Serapeum is a temple built without any regular plan, where all was conjecture, and where the ground had to be examined closely, inch by inch. In certain places the sand is, so to speak, fluid, and presents as much difficulty in excavating as if it were water which ever seeks its own level."[30] Finally, on the evening of December 24, the 135th sphinx was revealed, lying at a right angle to the others. Here the avenue abruptly changed direction and headed south, rounding a large hill. Could the tomb of Apis be here, cut into the flank of this hill, like the tombs of the pharaohs in the Valley of the Kings at Thebes?

Fortunately the excavation did not have far to go in this direction, for after the 141st sphinx, Mariette found, not another sphinx, but a statue of the Greek lyric poet Pindar, made of local limestone and executed in the Hellenistic style. And that was not all. From this statue of Pindar a

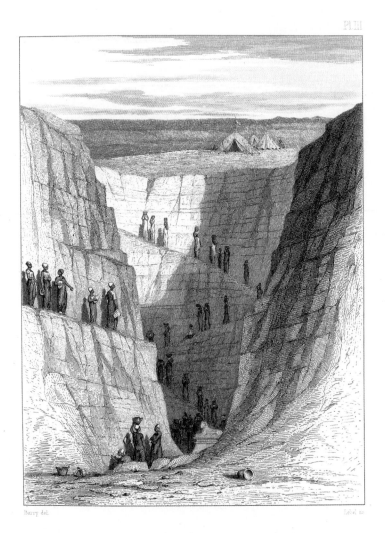

TRANCHÉE OUVERTE A TRAVERS L'ALLÉE DE SPHINX.

Découverte du 135ᵉ Sphinx.

Excavation of the avenue of sphinxes, from an early publication by Mariette, showing the discovery of the 135th sphinx, where the avenue changes direction.

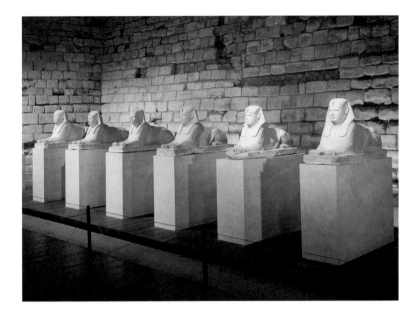

whole conclave of poets and philosophers—Hesiod, Homer, Protago-
ras, Thales, Heraclitus, Plato, with Homer in the center—and others
unidentified, perhaps including a Ptolemy or two, arced eastward.[31] And
so the alleyway of sphinxes came to a dead end in a hemicycle of Greek
philosophers. It was like running into Raphael's *School of Athens* in the
middle of the Egyptian desert. Recovering from his initial shock—and
some disappointment—Mariette continued eastward toward the hill,
where, after the eleventh and last Greek statue, he uncovered a pair of
sphinxes, larger than those lining the avenue, bearing the cartouches of
Nectanebo II (360–343 BC), Egypt's last native pharaoh. These flanked
the entrance to a temple that just had to be the Serapeum. The work-
ers proceeded to clear everything that lay between the sphinxes and the
hill. Beautifully carved wall reliefs portraying Nectanebo standing before
Apis represented in the form of a bull-headed man seemed to show they
were on the right track, but the tomb of Apis was nowhere to be found.[32]

Sphinxes from the Serapeum on display in their current home, the Louvre Museum in Paris.

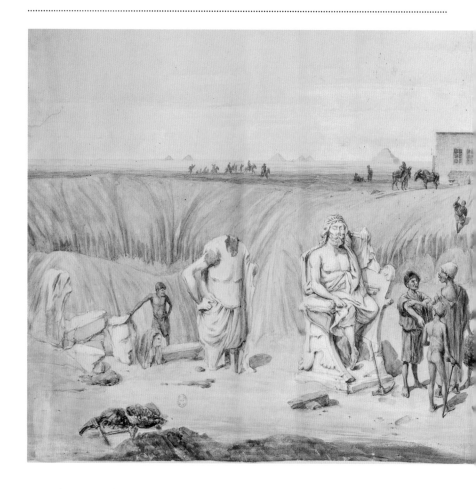

What sort of temple was this, which turns its back to the Nile and faces out into the open desert? Upon reflection, it could not be the main temple; it must be a subsidiary structure whose orientation stood in relation to another, more important building. Mariette's thoughts turned again to the enclosure to the west. Seeing that the transverse axis of the temple was parallel to the east wall of the western enclosure, he projected a line from the entrance of the temple to the point where it intersects

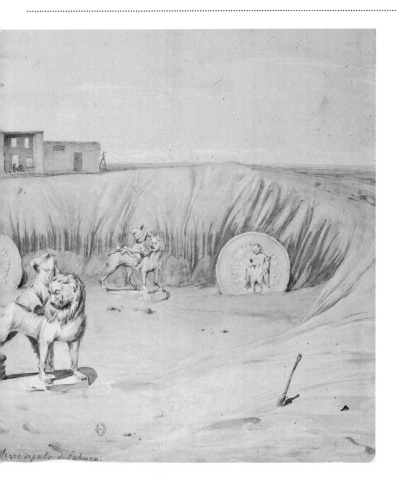

the line of the enclosure wall and sent a gang of workmen to investigate. Et voila! Some eighty meters west of the hemicycle was the base of a pylon that lined up directly with the entrance to the temple of Nectanebo II. Inscriptions at the pylon named Nectanebo I. Two magnificent recumbent lions in limestone flanked the entranceway.[33] Their distinctive pose—head at right angle to the body, paws crossed—immediately recalled the famous pair of granodiorite lions inscribed for Nectanebo I

Mariette's watercolor of statues from the hemicycle and dromos shows a bizarre gathering in the desert, with the Step Pyramid in the distance.

in the Vatican Museum, among the best known Egyptian antiquities in Rome and copied frequently since the Renaissance.[34] These lions were as reassuring as the circle of philosophers had been disconcerting.

Now Mariette knew he had found what he was looking for. It was March 15. He had been away more than five months and his funds were running low. It was time to notify Paris. Mariette drew a plan of what he had found so far, the lions of the entryway, the Greek statues of the hemicycle, and a summary of the work done, and sent them back to Lenormant, who would communicate the discoveries to the Academy of Inscriptions. The results were so promising that he hoped they would not mind that he had abandoned the quest for Coptic manuscripts before he had even begun and spent all his grant money in the pursuit of antiquities.

Mariette now proceeded to explore the approach to the Serapeum proper. A wide road paved with large stones connected the temple of Nectanebo to the enclosure wall. Mariette called it the *dromos*, borrowing from Strabo this Greek term for the formal approach to a tomb or temple. Low retaining walls to keep out the sand bordered the avenue on both sides. Mariette called these the *mastaba* of the south and of the north respectively, using the Arabic for bench (this term is most often applied today to the superstructures of Old Kingdom tombs). Here more surprises were in store, for the mastabas served as pedestals for a series of most unusual statues. On the south mastaba, two colossal peacocks with spread tails stood on either side of a an equally gigantic panther, all three creatures mounted by a young boy representing the child Dionysos; next, a falcon with the head of a bearded man wearing the double crown of Upper and Lower Egypt; after that, a winged female sphinx seated on her hind legs in the Greek manner; last and weirdest of all, a siren in the form of a bird with a woman's head, playing a cithara.[35] On the north side, a massive Cerberus also mounted by the child Dionysos stood by a lion in Egyptian style.[36] Next to Cerberus, two chapels, one in Hellenistic style, with Corinthian columns, the other in pure Egyptian style, stood side by side, looking like two national pavilions juxtaposed

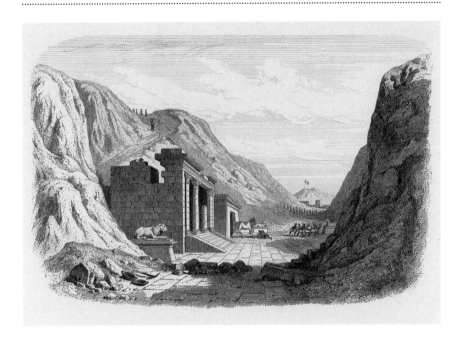

at a world's fair. The Egyptian chapel housed a magnificent, nearly life-size statue of an Apis bull, made of limestone and painted to show its characteristic markings.[37]

What are we to make of this menagerie? It appears strange to us only because we think of Egyptian and Greek religions as wholly separate. But from at least the fourth century BC, the Greeks equated Osiris with Dionysos.[38] The secret Mysteries of Dionysus were often said to resemble those of Osiris: "For the rite of Osiris is the same as that of Dionysos," writes Diodorus, "the names alone having been interchanged."[39] Plutarch is even more explicit in directly conflating Osiris, Dionysos (Bacchus), and Apis:

And that therefore he [Osiris] is one and the same with Bacchus, who should better know than yourself, Dame Clea, who are not

Workmen dragging a large statue of Apis out of the dromos's Egyptian-style chapel.

only president of the Delphic prophetesses, but have been also, in right of both your parents, devoted to the Osiriac rites?. . . But now the things which the priests do publicly at the interment of the Apis, when they carry his body on a raft to be buried, do nothing differ from the procession of Bacchus. For they hang about them the skins of hinds, and carry branches in their hands, and use the same kind of shoutings and gesticulations.[40]

Dionysos would have had an added resonance in Ptolemaic Egypt: as conqueror of the East, Alexander the Great had followed in the steps of Dionysos. The Ptolemies, successors of Alexander, also identified with Dionysos, and Ptolemy XII, the father of Cleopatra, even called himself the New Dionysos. For that reason some scholars date the Serapeum sculptures to the time of Ptolemy XII, although most place them earlier in the Ptolemaic Dynasty.[41] In fact, there could be no better introduction

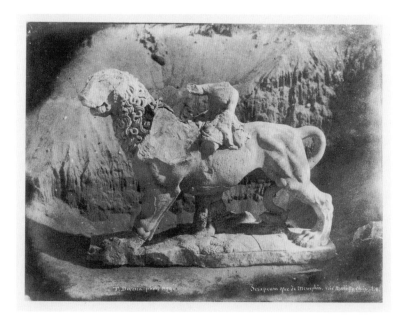

OPPOSITE: Finds from the Serapeum, including the Apis bull statue and several depictions of young Dionysos; ABOVE: a photograph from 1859 shows the statue of Dionysos astride Cerberus.

a.

H.1ᵐ.25.

b.

c.

H.1ᵐ.75.

H.1ᵐ.80.

d.

H.2ᵐ.23.

DROMOS.

a. b. c. Mastaba du Nord. - d. Mastaba du Sud.

to what the foremost modern historian of Ptolemaic Memphis calls the "complex, bifocal world" of the Serapeum than this bizarre gathering of Dionysiac peacocks and panthers and Egyptian lions and sphinxes, where Greek and Egyptian wisdom converge.[42]

Mariette would have understood none of this: he was looking for the tomb of Apis. Convinced that it was underground, Mariette had his workmen turn the stones of the dromos upside-down and probe the course of the enclosure wall looking for a burial shaft. Another surprise awaited them. For centuries the Serapeum had been a holy place and center of pilgrimage, where those who could afford to do so dedicated bronze statuettes of deities and presented them to the temple to ensure that their memory would endure among the gods. Over time the sanctuary became overcrowded with these offerings, and in order to dispose of them in a respectful manner and to make room for new offerings, the older ones were collected and buried in sacred ground when the opportunity arose during a renovation or expansion of the temple precincts. In just a single day Mariette's workmen found over fifteen hundred statuettes buried near the pylon; on another, they found a cache of 534 under the pavement of the dromos. These figurines included national gods like Osiris, Isis, and Horus; gods of Memphis such as Apis, Ptah, Sekhmet, and Imhotep; and others including Amen, Bastet, and Anubis, who were not primarily associated with Memphis, but known from literary sources to have been worshipped there—in short, a whole pantheon.[43]

So far Mariette had been storing the smaller antiquities in the house of the dealer Fernandez in the village of Saqqara, but with finds this numerous, the arrangement was becoming inconvenient. He decided to build a structure at the site that would serve as both his home and a secure storehouse. Over this he hoisted the French flag, as though claiming the territory for France.

Meanwhile word of Mariette's discoveries reached Cairo. He was hardly alone at Saqqara: not just Fernandez, but the Austrian consul-general, Christian Wilhelm von Huber; the German missionary Rev-

erend Rudolph Lieder; the Cairo-born Italian Egyptologist Rudolfo Vittorio Lanzone, and many others had workmen digging for them at Saqqara.[44] These men were resentful that this inexperienced newcomer had found something that they had missed, though it was right under their noses. Von Huber was most vociferous, saying to all who would hear: "The Frenchman in Sakkarah is a thief. My agent, the Spanish Jew Fernandez, is the real discoverer of the Serapeum. See these sphinxes, which he brought into my house already four years ago, but he is so stupid as to tell him about it over there. Then the secret was revealed, and the thing was completely out!"[45]

These men were determined to get Mariette in trouble. Rumors spread that Mariette had found not just bronze statuettes, but gold ones. And now Mariette ran into trouble with the authorities for excavating without a permit. In 1835, Muhammad Ali Pasha, viceroy of Egypt, had issued a decree regulating private excavation and the export of antiquities.[46] No one could dig for antiquities without a permit, called a *firman*, and all antiquities were decreed the property of the state. In his haste to get started, Mariette in his typical fashion had neglected to go through the proper channels. He might be forgiven for thinking the law was no longer in effect, or at least would not be enforced: the others had no permits either and were excavating in plain sight. Why should he be singled out?

But if Mariette thought the current viceroy, Abbas Hilmi I, would look the other way, he was mistaken. On June 5 Mariette received the order to stop work immediately and turn over all his finds to the authorities. Of course the pasha was entirely within his rights, but Mariette refused to recognize any authority other than the French government. He appealed to Arnaud LeMoyne, the French consul general in Egypt, who negotiated an agreement with Stephan-Bey, the pasha's minister of foreign affairs. On June 29 Mariette was allowed to resume work, although the question of who would take possession of the antiquities he discovered remained unresolved.

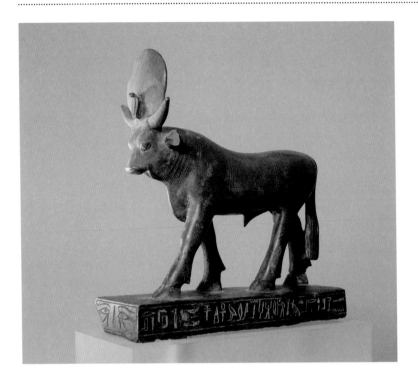

The news that the French Government had approved a credit of thirty thousand francs to complete the clearance of the Serapeum and transport the objects to France only exacerbated the situation. Abbas would not be overlooked in his own domain. On September 12, 1851, Stephan-Bey notified LeMoyne that all the antiquities were required to be turned over to the Egyptian Government and deposited in the Ministry of Public Instruction. In addition, five officers would be stationed at the site to inspect the work and make sure that nothing was stolen, objects from Mariette's excavations purportedly having turned up in the antiquities market in Cairo. Accordingly on September 15, three (of the promised five) officers appeared with a list, none too specific, of 513 objects drawn up by Mariette's foremen: "40 stones bearing inscriptions

This bronze statuette of an Apis bull is typical of images of gods deposited at temples and sacred sites.

and broken statues," "432 figures of men, birds, and others, in bronze, of various sizes," "25 statuettes of men, of which 17 are complete and 8 broken," and so on.[47] LeMoyne advised Mariette to turn over a few of the objects on the list as a gesture of conciliation. The government agents would take them back to Cairo, where Stephan-Bey predicted that Abbas, satisfied with this tacit recognition of his authority, would be more amenable to deciding in Mariette's favor.

On November 19, 1851, the pasha announced his decision: All excavations in Egypt were suspended until further notice. He awarded to the French government the antiquities found so far, but would authorize future excavations only if the French government renounced all claim to any objects found from that point on.

Meanwhile on November 12, Mariette had found the entrance to the underground catacombs of the Apis bulls. Nothing in the world would induce him to content himself with the objects already discovered, now that he had found what he had been looking for all along. Nor would he relinquish all future finds to the pasha, who would only give them away to the first passing prince. (Which is exactly what happened. In 1855 Abbas's successor Muhammad Said Pasha presented Egypt's share of the antiquities to the ill-fated Archduke Ferdinand Max of Austria, the future Emperor Maximilian of Mexico, which is why Vienna's Kunsthistorisches Museum has more Serapeum sphinxes than the Louvre.)[48]

Conveniently for Mariette, this discovery occurred while the inspectors, now down to two, were absent; thus, he saw no need to inform them. For the next three months, Mariette and a select group of assistants worked secretly by night, concealing the entrance to the catacombs beneath a trap door that they covered with sand. The excavators found themselves in a vast subterranean gallery some 195 meters (640 feet) long from end to end, flanked by vaulted side chambers staggered at right angles to the main passage. The aggregate length of the principal passage and side crypts was 350 meters (about 1150 feet). The side chambers housed enormous stone sarcophagi measuring on average 4 meters

(13 feet) long, 2.3 meters (7 feet 8 inches) wide, and 3.3 meters (11 feet) high, and weighing about 65 tons each. No larger sarcophagi were ever made in Egypt. In later times, when Mariette staged elaborate dinner receptions in the catacombs, he found that an Apis sarcophagus would comfortably seat ten.[49]

Here were buried the Apis bulls from year 52 of Psammetichus I (612 BC) through year 3 of Cleopatra VII (48 BC), a span of some 570 years. When Mariette entered the burial chambers, he found all was confusion. Every one of the twenty-four sarcophagi had been broken into, their massive lids pushed aside. Beautifully carved and inscribed steles littered the floor, fallen from their emplacements in the walls. Commissioned by kings and private persons participating in the burial of the divine Apis, they record the lifespan, date of birth, year inducted into the temple of Ptah, date of death, and date of burial of each bull. These monuments were to provide the data on which the overall chronology of the period is based.

The need to excavate in secret was lifted on February 12, 1852, when LeMoyne informed Mariette that he now had permission to resume work, although the pasha still reserved the right to all the antiquities. A joint Franco-Egyptian commission was charged with inspecting the crates already packed to verify their contents. The inspection took place on March 25, and all forty-one crates were cleared for export to France.

Successive discoveries took Mariette back in history. On February 15, he entered another catacomb, less extensive but older. Here were buried the Apis bulls from year 30 of Ramesses II (1249 BC) to year 21 of Psammetichus I (643 BC). He called these the Lesser Vaults, to distinguish them from the previously discovered Greater Vaults. Then on March 15 he discovered a third and last group of tombs, the oldest yet, belonging to bulls from the reign of Amenhotep III until year 30 of Ramesses II (1390–1249 BC). These bulls were buried not in catacombs but in separate tombs. One tomb was intact. It contained the burial equipment of two Apis bulls that died in years 16 and 30 of Ramesses II, including a mag-

nificent pylon-shaped openwork pectoral of electrum inlaid with colored glass bearing the name of the ruler.[50]

The jewels of the Serapeum made such an impression back in France that the Ministry of the Interior voted Mariette another fifty thousand francs to continue his excavations. For the next two years, all proceeded without a hitch. French diplomacy had succeeded in persuading the Egyptian government to come to terms with Mariette. In November 1852 a second joint commission met at Saqqara, and even though the pieces selected for Egypt were not of the best, the Egyptian delegates were extremely accommodating. The pasha even lent his men to the crews of the two frigates that came in 1853 to take to France the 230 large crates packed with objects assigned to the Louvre.

Mariette was now a celebrity. On January 1, 1852, he was made associate curator of Egyptian antiquities at the Louvre, and on August 16, chevalier of the Legion of Honor. His wife and children traveled from France to join him in Egypt. Visitors from all over Europe considered it an honor to be shown the Serapeum by Mariette.

One day in February 1853 a group of German tourists showed up at Mariette's house, among whom was a young Egyptologist introduced as Dr. Heinrich Brugsch of Berlin. Brugsch was six years younger than Mariette, and like him, largely self-taught. The two men hit it off immediately. Mariette invited him to stay with him a few days; they got along so well that Brugsch remained for eight months. A brilliant philologist, versed in all phases of the Egyptian language, Brugsch was able to help Mariette decipher the inscriptions and classify the monuments. In his memoirs, Brugsch writes of his colleague:

He was of great height, with a strong body, his face, framed by a blond beard, was burnt red-brown like that of an Egyptian fellah; in his features lay a certain melancholy which, on the other hand, could be displaced instantly by a striking cheerfulness. . . . He possessed a deep worldly wisdom in all his plans which miscarried in

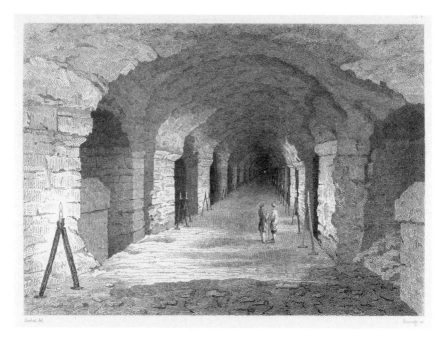

only one point—which in this wicked world is an essential one—
in all money matters which came his way. . . . He possessed all
the ambition of the man who is aware the eyes of the world are
directed upon him as a result of a magnificent discovery favored by
lucky chance, but at the same time he was tormented by the feeling
of his own inadequacy, not to be able to master the countless mul-
titudes of monuments, which he had brought to light. . . . He con-
fessed to me openly and honestly, in our dialogues no less than in
our written communications, that he possessed absolutely no gift
for the philological side of our science, and this he deeply deplored.
He was, so he explained to me, much more an artistic nature, which
feels its only satisfaction in form. . . . At best, he understood how to
organize, to arrange a museum and to exhibit harmoniously and
to catalogue the pieces belonging together; beyond that he lacked,

Barbot del.

Aug. Guillaumot sc.

The Greater Vaults housed burials of sacred Apis bulls, with each animal laid to rest in an enormous sarcophagus in its own chamber.

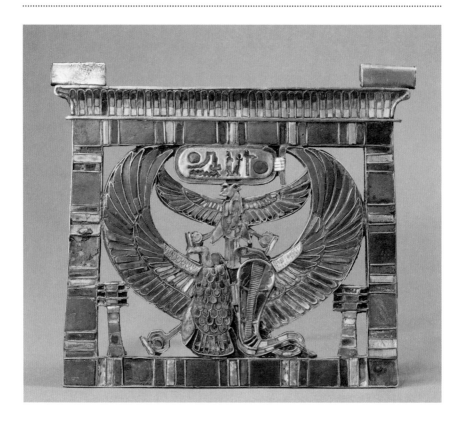

not the good will, to be sure, but indeed the requisite strength for scientific exploration. . . .With his confession he had hit the nail on the head, for his spirit was tender and susceptible to the most delicate feelings. . . .Where he was free to fulfill a poetic task, then he reveled in the enjoyment of the favorable moment and . . . told stories with the pleasure of the poet by the grace of God.[51]

These two weaknesses, fiscal and scholarly, would often bring him into trouble—with the viceregal court for financial irresponsibility, and with the academic establishment for his dilatoriness in publishing the

Mariette found this magnificent pectoral, or chest ornament, with the burial equipment of two Apis bulls that died during the long reign of Ramesses II.

results of his explorations. His plans were impracticably ambitious, and he was distracted by working on several projects at once. The consequence was that the results of Mariette's excavations at the Serapeum remained mostly unpublished at the time of his death.

A colored drawing of remarkable sensitivity, made a few years later in 1859 well captures the "certain melancholy" Brugsch described (see p. 14).[52] It was made by Théodule Devéria (1831–1871), a promising young Egyptologist from the Louvre, who was sent to Egypt in 1858 to assist Mariette after he had become director of antiquities.

Mariette and Brugsch remained friends for life. Both would look back on their time at the Serapeum with great fondness and nostalgia. In his memoirs, Brugsch vividly recalls his eight months in the desert in a tiny, sparsely furnished room crawling with snakes, spiders, and scorpions, where he could barely sleep at night on account of the bats fluttering around inside and wolves, jackals, and hyenas howling outside, not to mention the mosquitoes.

> I would not have given up my life in the wilderness for anything in the world, not even for a palace, because the inscribed stones which were being brought to light by the excavators; in indescribable abundance, under the sand of the desert and out of the subterranean tombs of the sacred Apis bulls, sweetened my existence by their hieroglyphic and demotic yields. . . . It was a harvest such as never again in my life fell to my lot, a precious spring at which I sat, in order to quench my insatiable thirst for knowledge in long draughts.[53]

On September 12, 1854, a wistful Mariette left Alexandria for Marseille. His funds had run out, and he could find no excuse for prolonging his stay. He had made a great discovery for the glory of France and enriched the Egyptian collection of the Louvre with some six thousand objects. As he noted in his report: "I did not find any Coptic or Syriac monuments, I did not make the inventory of any library, but, stone by stone, I brought back a temple."[54]

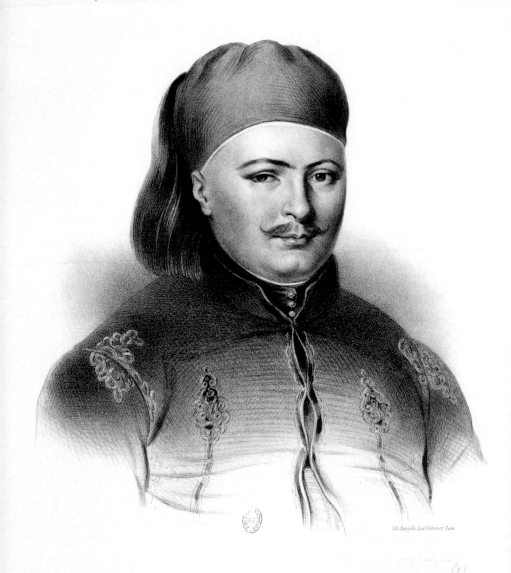

SAYD-PACHA
FILS DE MOHAMMED-ALY,
VICE ROI D'ÉGYPTE.

THE PASHA

When Mariette came to Egypt in 1850, it was a province of the Ottoman Empire, subject to the sultan in Constantinople (Istanbul) and administered by a governor, or viceroy, with the rank of pasha. But Egypt was not like any other province. To understand why, we must go back fifty years to Napoleon Bonaparte's brief but epoch-making Egyptian expedition.[1] On July 1, 1798, some thirty-six thousand French troops under the command of General Bonaparte landed at Alexandria. Like a modern-day Alexander the Great bringing the blessings of Greek civilization to Asia, Bonaparte believed he would carry the spirit of the Enlightenment and the ideals of the French Revolution to the benighted and moribund East. He would liberate Egypt from the Turks, make it a French colony, dominate trade in the Mediterranean, and strike at Britain by obstructing British land communication with India.

On July 21, 1798, the newly christened Army of the Orient met the Egyptians at Imbaba across the Nile from Cairo, and, with "forty centuries watching over them," in Bonaparte's immortal words, defeated the native force in the Battle of the Pyramids. The Egyptian military leaders, the Mamluk beys, fled—some north to Syria, some south to Upper Egypt—and on July 24, the French entered Cairo. Just eight days later, the British Admiral Horatio Nelson surprised the French fleet as it lay at anchor at Abuqir, east of Alexandria, and annihilated it in the Battle of the Nile. (Imbaba is miles away from the Pyramids, and Abuqir is nowhere near the Nile. Both Bonaparte and Nelson were shrewd self-promoters; these high-sounding names were meant to heap glory on the victors by conjuring up iconic images of ancient Egypt.) The French were now marooned in a country they controlled. In August 1799, after an unsuccessful attempt to invade the Holy Land, Bonaparte returned to France in secret, leaving his troops behind. They remained in Egypt until September 1801, when they surrendered to the British, who had come to

Portrait of Muhammad Said Pasha, viceroy of Egypt. In 1858, he appointed Mariette Egypt's first director of antiquities.

the aid of the Turks against a common enemy. The campaign had lasted three years and two months.

The French invasion had a profound effect on Egypt, though not the one Bonaparte had intended. In addition to his regular troops, Bonaparte had brought a squadron of scientists, artists, engineers, and architects, 151 in all, called the Commission of Science and Arts. It included a few big names—the mathematicians Gaspard Monge and Joseph Fourier, the chemist Charles-Louis Berthollet, and the zoologist Etienne Geoffroy Saint-Hilaire—but most were young engineers in their twenties, students or recent graduates of the École Polytechnique and School of Bridges and Roads in Paris.[2] They came to map and survey the country and assess its natural resources to gauge its potential for development as a French province. One of their first tasks was an expedition to the Isthmus of Suez to look for traces of the ancient canal linking the Mediterranean and the Red Sea and explore the feasibility of reopening the passage.

Antiquities came later. It was Dominique-Vivant Denon, at fifty-four the oldest member of the expedition, who first revealed the wonders of Egypt's ancient monuments to the Commission. An odd man out among his fellow commissioners, Denon was a courtier, artist, diplomat, and a survivor of the Old Regime who nonetheless had his greatest successes after the French Revolution. He traveled with the French army for nine months as they pursued the Mamluk beys south all the way to Aswan, sharing the soldiers' discomfort and much of the danger, sketching merrily all the way. Bonaparte was so impressed with Denon's reports that he ordered a systematic survey of the antiquities of Upper Egypt. The squadron of engineers and architects applied their expert mapping and drawing skills to the monuments of ancient Egypt, accumulating a mass of documentation whose eventual publication would constitute the most enduring achievement of the Egyptian campaign. After the French surrender to the British, the artists and scientists were allowed to keep their notes and drawings but had to relinquish the antiquities they had collected—among them the famous Rosetta Stone, which would pro-

vide the basis for Champollion's deciphering of the hieroglyphic alphabet twenty-one years later. Donated to the British Museum in 1802, the stone still bears the inscriptions "Captured in Egypt by the British Army in 1802" and "Presented by King George III."[3]

While French arms did not succeed in turning Egypt unto a French colony, French science did reveal the monuments of ancient Egypt to Europe. A handful of travelers' accounts of ancient Egyptian monuments had appeared in the eighteenth century, and a taste for Egyptian motifs had already begun to manifest itself in European art (think Wedgwood), but nothing equaled the effects of Bonaparte's Egyptian campaign. In 1802, Denon published his *Voyage dans la Basse et la Haute Egypte, pendant les campagnes du general Bonaparte* (*Travels in Upper and Lower Egypt during the Campaigns of General Bonaparte*). It was an instant bestseller and was translated into English in 1803. Then, beginning in 1809, came the official publication, the *Description of Egypt*. The twenty-two volume set—nine volumes of text in small folio, ten volumes of plates in large folio, and three mammoth atlases, divided into antiquities, modern times, and natural history—was a monument in itself. Subscribers could order a sumptuous mahogany cabinet in the latest Egyptian Revival style specially designed to house the gigantic tomes.[4] A second edition, somewhat more economically produced, began to appear in 1821 even before the first edition had been completed.

Meanwhile, the evacuation of the French left Egypt in chaos, with the returning Mamluk beys vying with the new Ottoman governor for control. In 1805 an Albanian commander in the Ottoman army named Muhammad Ali emerged as pasha and founded the dynasty that ruled Egypt for the next century and a half.

Muhammad Ali, known as the "founder of modern Egypt," was born sometime between May 1768 and September 1771 in the Macedonian town of Kavala in northern Greece, at the time also part of the Ottoman Empire. In later years, he liked to claim he was born in 1769, the same year as Napoleon, whom he greatly admired.[5] Muhammad Ali

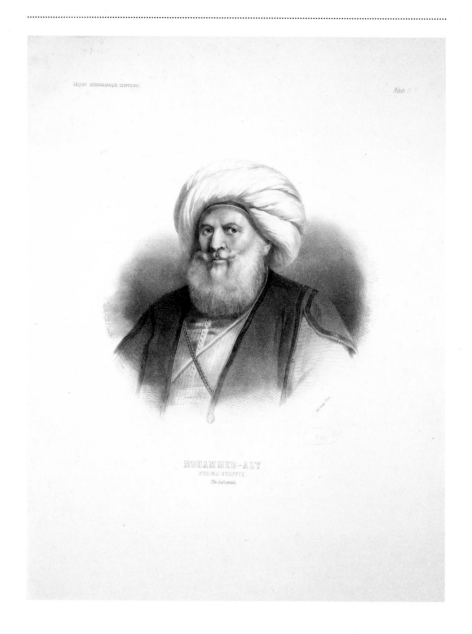

Portrait of Muhammad Ali Pasha, known as the founder of modern Egypt.

was of humble origin, the son of an Albanian soldier who sidelined in the tobacco trade. The only language he spoke fluently was Albanian, though he also knew some Turkish. Arabic he disdained, even when he became master of Egypt. He never learned to write, and did not learn to read until he was in his forties. But he was brilliant, crafty, patient, intelligent, and shrewd.

Most Ottoman governors stayed in Egypt for only a few years, as a stage in their upward career path. In the 281 years between the establishment of Turkish rule in 1517 and the arrival of the French in 1798, Egypt had seen 210 viceroys come and go.[6] But Muhammad Ali had not trained for government service; he was a self-made man, from outside the system. Having virtually imposed himself upon the Ottomans, he was determined to keep Egypt for himself and his heirs.

Muhammad Ali had seen the Europeans at firsthand and admired their technical expertise. He realized that in order to stay in power he needed to increase the state's revenue and build a modern military. In the years following the end of the Napoleonic Wars in 1815, many Europeans, particularly the French, eagerly sought careers abroad. Muhammad Ali welcomed them into his service. We have already met Linant de Bellefonds (Linant Bey), who came to Egypt in 1817 and rose to be chief engineer of bridges and roads and then Minister of Public Works. In 1820 Muhammad Ali hired a former officer under Bonaparte, Colonel Octave-Joseph-Anthelme Sève (better known as Sulayman Pasha after he converted to Islam) to train and organize his new army along European lines. Dr. Antoine Barthélemy Clot (later Clot Bey) came in 1825 to found the military hospital and introduced modern medical practice to Egypt.

In foreign affairs Muhammad Ali relied on the advice of the European consuls and particularly the French consul Bernardino Drovetti. In return for their assistance in political matters, Muhammad Ali was happy to grant *firmans* authorizing them to collect antiquities and ordering local officials to provide the needed manpower. The first great European collections were formed at this time amid a hotbed of competition.

The major collectors were Drovetti and the British consul Henry Salt. In 1818 the great bust of Ramesses II known as the Younger Memnon arrived in London, the gift of Salt and the Swiss explorer Johann Ludwig Burckhardt.[7] This colossal sculpture, the upper portion of a seated figure of the king, measures eight feet nine inches tall and weighs seven and a quarter tons. A hole bored in its right shoulder was said to have been made by the French for separating the head from the body.[8] Salt's agent, Giovanni Belzoni, a former circus strongman and jack-of-all trades who excelled in the removal of colossal-size monuments, achieved what the French army could not by successfully removing the whole thing. This was too much: first the Rosetta Stone, now the Younger Memnon. The French had to even the score.

In 1820 Sébastien-Louis Saulnier, a French collector and antiquarian with business connections in Egypt, conceived the idea of removing

Muhammad Ali, seated cross-legged on the divan, receives European visitors in his palace at Alexandria in an 1840s lithograph.

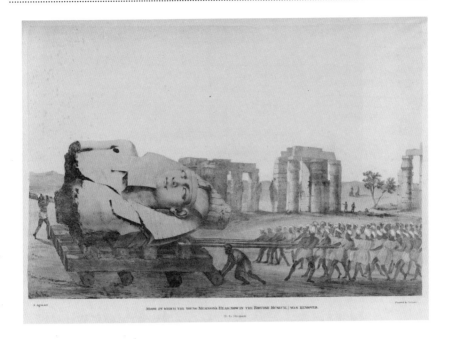

and bringing to France the Zodiac of Dendara. The Zodiac is a circular diagram of the heavens that was carved on the ceiling of a chapel of the temple of Hathor at Dendara, one of the best-preserved Egyptian temples. Discovered during Bonaparte's Egyptian expedition, the Zodiac became instantly famous, both as a record of ancient Egyptian astronomy and on account of its purported great age—some scholars suggested it might be as much as fourteen thousand years old, making it older than creation itself according to biblical chronology. Saulnier sent a stonemason, Jean-Baptiste Lelorrain, to Egypt with all the tools necessary to extract the stone. Lelorrain properly obtained a *firman* for antiquities and headed to Dendara. By mutual consent the English and French consuls had divided the antiquities of Egypt between them: Salt took the west bank of the Nile, with the royal memorial temples and Valley of the Kings; Drovetti the east bank, with the temples of Karnak

Belzoni's workmen transporting the Younger Memnon in 1818 from the temple of Ramesses II to the Nile on its way to the British Museum.

and Luxor. Dendara, on the west bank, was thus in Salt's territory. The presence of a group of English tourists prevented Lelorrain from carrying out his task at once, so he continued on to Luxor and Aswan, where he let it be known that he was headed to the Red Sea to collect seashells.

Returning to Dendara he succeeded in removing the Zodiac with the aid of chisels, saws, jacks, and a judicious use of gunpowder, and hauled it to the Nile. It was a hard job. The ceiling was composed of three slabs of sandstone three feet thick, each weighing about twenty tons. The Zodiac took up the whole of one slab and about half the adjacent slab. Even after trimming the width of the second slab and reducing the thickness of both slabs, the weight of the two huge blocks amounted to approximately three tons. It took twenty-two days to remove the stones and sixteen days to drag them to the Nile, a distance of four miles. Meanwhile, a passing traveler, Luther Bradish of Massachusetts (a rare American on the Nile in those days), had alerted Salt that something was afoot. The outraged Salt tried and failed to intercept Lelorrain on the river and seize the stones. When the matter was brought before the pasha, Muhammad Ali simply asked whether Lelorrain had obtained a *firman* for antiquities. Informed that he had, the pasha allowed him to keep the stones, despite the British consul's objections. Saulnier maintained that Salt had been preparing to detach the Zodiac himself, though Salt denied it, wishing to distance himself from what he called an act of blatant vandalism.[9]

The arrival of the Zodiac in France in 1821 was such a sensation that Louis XVIII purchased it the next year for the royal library for the extravagant sum of 150,000 francs. (It is now in the Louvre.) Not everyone, however, was enthusiastic: in October 1821, Jean-François Champollion wrote an anonymous letter to the editors of the *Revue Encyclopédique*.[10] In it, he applauds the patriotic zeal that motivated his countrymen to remove the Zodiac but warns of the consequences of their action. France has done so much to make known the monuments of ancient Egypt to the world that she deserves to have a worthy specimen of Egyptian art to call her own, and she must rejoice that she finally has a monument

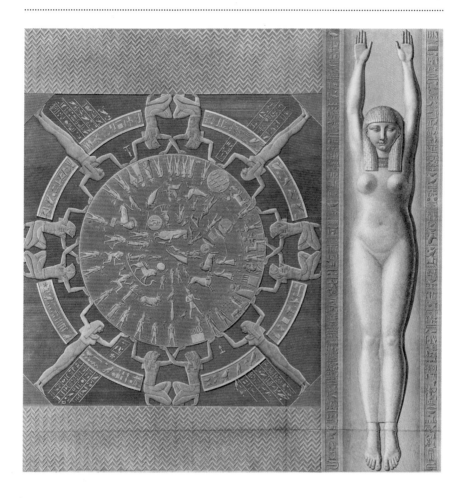

The *Description of Egypt* shows the Zodiac of Dendara before it was
removed from the temple ceiling and shipped to France.

to compensate for the loss of the Rosetta Stone. But although Saulnier and Lelorrain have ensured that the Zodiac would be "transported from the banks of the Nile to the banks of the Seine, and not to the Thames," have they not thought about the bad example they have presented to the rest of the world? Do we in France wish to follow the example of Lord Elgin (whose removal of the Parthenon marbles was even then a matter of controversy)? Of course not. The temple of Dendara had survived the centuries structurally intact; by removing the Zodiac, we have initiated its destruction. "It is as though the Allies had ripped away part of the ceiling of the Grand Gallery of Versailles for the sake of a few paintings. What would happen to the rest of the ceiling and to the whole room?" When the ancient Romans looked for Egyptian monuments to take home to Rome, they chose obelisks, "noble trophies, proper ornaments of a great capital." As for the Zodiac, it is of no use as a public monument or to science; removed from the building of which it formed an integral part, "it will lose a great part of its meaning, of its value, of its interest."

Both the Younger Memnon and the Zodiac appear among the spoils of Egypt in the frontispiece of the original 1809 edition of the *Description of Egypt*. At that time, the Memnon lay on the ground at the Ramesseum and the Zodiac was still in place in its rooftop chapel. By the time the second edition of the *Description* appeared in 1821, with a new color frontispiece based on the original black and white engraving, the Memnon was in London and the Zodiac had just been brought to Paris.

Meanwhile Salt and Drovetti were amassing huge collections of Egyptian art, which they then put up for sale in Europe. Although Salt's first collection went to the British Museum in 1823 as he intended, Drovetti's first collection was turned down as too costly by Louis XVIII of France, to Champollion's chagrin, and was purchased in 1824 by Carlo Felice, King of Sardinia. Thus the first great Egyptian collection on the European continent went to Turin, Italy. In 1826, with Champollion now in charge, the Louvre did acquire Salt's second collection, followed by Drovetti's second offering in 1827. The British Museum was the major

buyer at the sale of Salt's third collection, at Sotheby's in 1835. Drovetti's third assemblage enriched the holdings of the Berlin museum in 1836. Is it any wonder that Muhammad Ali, when called upon to protect Egypt's antiquities, responded, "How can I do so, and why should you ask me, since Europeans themselves are their chief enemies?"[11]

Some of these collectors believed that removing monuments was the only way to preserve them, some pretended to believe that, and some did not even bother to pretend. But the sites had other predators. Since the days of the pharaohs, rulers of Egypt had used the monuments of their predecessors as ready sources of quarried stone. Abandoned temples, empty shrines, tombs of individuals long forgotten, remnants of a dead civilization, were meaningless to them. Decorated stones were built into churches, mosques, and fortifications.[12] Muhammad Ali allowed his agents to pull down entire temples in order to build factories and barracks. In 1829 Champollion submitted a plea to the viceroy for the preservation of the monuments of Egypt that catalogued some fourteen ancient sites that had been still standing at the time of the French expedition and had been destroyed since.[13] Even the Pyramids were not safe. Linant Bey recalled that the pasha, concerned about the rising cost of building a dam at the head of the Nile Delta, asked him to calculate whether it would be cheaper to take stone from the Great Pyramid than to quarry new stone: "I made a very conscientious report on the expense of removing the Pyramid, and also on that of quarrying the stone at Toora, the finest quarries in the world. Happily it turned out that the latter expedient was far the least expensive."[14]

Muhammad Ali needed to please the Europeans if he wanted their help in instituting reforms. If in the 1810s and 1820s that meant giving the consuls permission to collect as they pleased, in the 1830s it meant responding, or at least pretending to respond, to a growing concern among Europeans that the antiquities of Egypt were rapidly disappearing. Therefore, on August 15, 1835, the pasha issued an edict banning the export of antiquities and calling for the formation of a national museum

The frontispiece of the *Description of Egypt* showing the Memnon and the Zodiac among the booty from Egypt. At the time of the first edition (1809, left) both monuments were still in Egypt, but by the time of the second edition (1821) they were in Europe.

of antiquities in Cairo.[15] In it, he points out that Europeans do not allow antiquities to leave their own countries, but instead assiduously collect them and proudly display them to visitors from all lands. Pending the construction of a museum building, all antiquities were to be delivered to the School of Languages and placed under the care of its director.[16]

While the law against destroying the ancient monuments to reuse their stone could only be praised, the consuls criticized the ban on exporting antiquities because it interfered with free trade: the pasha was merely extending over antiquities the much-resented monopoly he already held on all of Egypt's export crops (notably cotton) and manufactured goods.[17] In any case, the law was not enforced. The edict of 1835 was followed shortly by an order to build eighteen saltpeter factories. According to the American consul George Robins Gliddon, the period from 1836 to 1841 saw the worst destruction of all.[18]

As for the museum, it was a total failure. In 1843, John Gardner Wilkinson, the father of British Egyptology, who had spent twelve years in Egypt striving to document and preserve the monuments others were attempting to destroy or carry off, observed sadly that "the formation of a museum in Egypt is purely Utopian; and while the impediments raised against the removal of antiquities from Egypt does an injury to the world, Egypt is not a gainer. The excavations are made without knowledge or energy, the Pasha is cheated by those who work, and no one there takes any interest in a museum; and it would not be too much to predict that, after all the vexatious impediments thrown in the way of Europeans, no such institution will ever be formed by the Pasha of Egypt."[19]

In 1841 the Sultan had issued a *firman* granting hereditary rule over Egypt to Muhammad Ali and his family, with the succession passing not from father to son, but from the ruler to the oldest male member of the family. Thus, when Muhammad Ali died in 1849 at the age of seventy-nine, he was succeeded by his thirty-six-year-old grandson Abbas Hilmi I (1813–1854), and not by his oldest living son, Muhammad Said, who was only twenty-seven.

Abbas had been raised by Muhammad Ali after his father died when Abbas was only four. The pasha was a stern taskmaster with high expectations. Lacking a formal education himself, Muhammad Ali prescribed a rigorous course of study for his sons and grandsons. Abbas's lessons began at eight in the morning and finished at nine in the evening and included mathematics, geometry, calligraphy, grammar, and Arabic. A military man, Muhammad Ali also strove to make soldiers of his sons. The embodiment of discipline and self-control, Muhammad Ali prized modesty and abhorred arrogance, and tried to instill these values in his children.[20] Both as a scholar and a soldier, Abbas proved a big disappointment, for he was selfish, lazy, and disobedient; his grandfather told him: "You have dashed my hopes in you. . . . Truly your indolence has pained me exceedingly."[21]

Nobody liked Abbas. He quarreled with his family over the inheritance of Muhammad Ali, and they retaliated by seeking his deposition, pleading their cause before the Sultan in Constantinople.[22] He dismissed from office senior officials, European and Ottoman alike, whose careers had flourished under Muhammad Ali. The French hated him because he favored the British—to the extent that he favored any Europeans at all—developing a special relationship with the British Consul-General Charles Murray, who could speak with him in Turkish, as Abbas knew no European languages. Thus when Mariette came to Egypt, the French no longer occupied their privileged position.

Even before he became viceroy, Abbas had been an outlier among members of the ruling family, as a reactionary who kept aloof from Europeans and criticized the policies of Muhammad Ali.[23] As a ruler, he also departed from Muhammad Ali in his love of ceremony and ritual. Muhammad Ali had been modest in his dress and simple in his ways, whereas Abbas employed conspicuous display to demonstrate his prestige. Elaborate processions accompanied his mother's return from Constantinopole and from the pilgrimage to Mecca, and the celebrations in honor of the circumcision of Abbas's eldest son, Ilhami, lasted fourteen

days, with lavish balls for the court and the elite, feasts of lamb and buffalo for the poor, and a concluding procession through the streets of Cairo.[24] He spent extravagantly. It was said that "a single room in one of his palaces cost 100,000 pounds for furniture and drapery alone" and that he had "upward of 3,000 horses."[25] Indeed, his stable of Arabian horses was one of the finest ever assembled.[26]

Abbas was passionate about building palaces, most erected in the middle of nowhere.[27] Of at least seven such edifices, the most famous were at Abbasiya in the desert northeast of Cairo (now part of the city), which he made into a government center with barracks, a hospital, and military schools; and at Benha in the Nile Delta. To further increase his prestige, he kept a corps of mamluks: slaves purchased as boys from the Caucasus and central Asia, trained as cavalrymen, and then freed.[28] (Abbas's mamluks are to be distinguished from the Mamluks, recruited in the same manner, who ruled Egypt as a self-perpetuating military elite from 1250 to 1517; those were the Mamluks that Bonaparte defeated at the Battle of the Pyramids.)

Abbas was fond of seclusion and secretive in his ways. Superstitious and mistrustful, he was always moving from place to place; Mariette's colleague Brugsch described him as subject to "a kind of travel fever, which was attributed solely to fear of death by an assassin's hand."[29] Stephan Bey, Abbas's Foreign Minister, recalled that he hated contact with Europeans and left all communication to his ministers.[30] Just as Abbas's lack of sociability caused offense, his secrecy gave rise to speculation. It was said that he condemned men to be entombed alive in the walls of his palaces; that he personally sewed shut the mouth of a slave woman in his harem as punishment for smoking against his orders, leaving her to starve; that he had one of his attendants eaten by hounds for having displeased him; that he ordered a soldier's stomach split open to see if it contained stolen milk; that he had the feet of one of his runners hobnailed.[31]

He was not only cruel but also depraved. The consul Murray, sizing up Muhammad Ali's heirs in 1848, reported to Lord Palmerston, the

Abbas Pasha on the front page of the *Illustrated London News*, 1852.

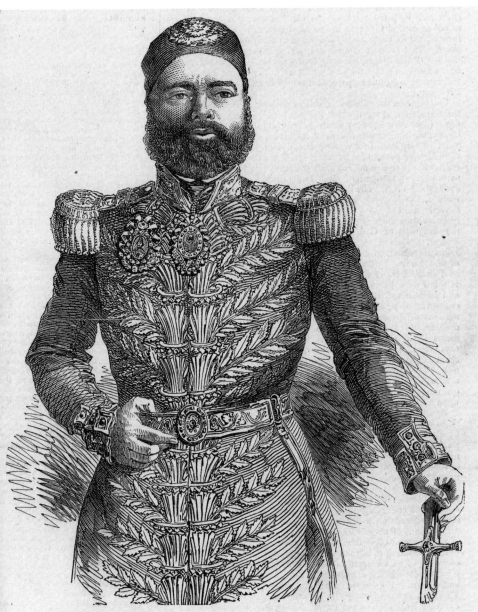

HIS HIGHNESS ABBAS PACHA, VICEROY OF EGYPT.—(SEE NEXT PAGE.)

British Foreign Secretary, that Abbas not only had the reputation of being "selfish and tyrannical in the extreme," but also was "notoriously addicted to the filthy sensualities which degrade so many of his caste."[32] Sir Donald Mackenzie Wallace, foreign correspondent for the London *Times*, later refers in connection with Abbas to "certain private vices regarding which Europeans are much more severe than Orientals."[33]

The "filthy sensualities" and "private vices" are not-so-veiled references to Abbas's alleged homosexuality, which was alluded to for the purpose of further discrediting him. The twenty-eight-year-old Gustave Flaubert, traveling in Egypt at the time, was less diplomatic: "Abbas Pasha, who is fond only of men, makes things difficult for women"—he complains when he is told that music and dancing were not allowed in a certain brothel he was visiting. Female prostitution was prohibited by law, so they had to be discreet.[34] As readers of *Madame Bovary* will know, Flaubert positively relished the sordid details. Of a visit to Cairo's Qasr al-Aini Hospital, founded by Clot-Bey, he writes: "Pretty cases of syphilis; in the ward of Abbas's Mamelukes, several have it in the arse. At a sign from the doctor, they all stood up on their beds, undid their trouser-belts (it was like army drill) and opened their anuses with their fingers to show their chancres."[35]

In a nutshell, Flaubert concluded, Abbas Pasha "is a moron, almost a mental case, incapable of understanding anything or doing anything. He is undoing all the work of Mohammed Ali—the little that remains amounts to nothing."[36] Even his pomp failed to impress the writer:

> The French consul-general arrived in Cairo recently. We saw him present his credentials to Abbas Pasha. It was a rather pathetic ceremony—the "oriental splendor" was decidedly mediocre: for one thing, there was no "splendor," and the "oriental color" was European and shabby at that. His Highness's Mamelukes were dressed like servants supplied by a caterer, and the coffee we were served was execrable. But the Viceroy's pipe was splendid—

encrusted with enough diamonds to satisfy the lust of a hundred marquises. Nonetheless, on the whole, it was exceedingly flat.[37]

Whatever his faults as a person, it was acknowledged by British observers that Abbas had abolished monopolies, reduced taxes, improved the conditions of the *fellahin* (peasants), developed transport facilities, and ensured internal security. Murray urged the British ambassador in Constantinople to advise the Ottomans not to interfere in the affairs of Egypt until they "can show any other Province under their own immediate Government in which once or twice a month a string of 200 camels can cross 84 miles of desert with no guard other than the ordinary Arab camel drivers, and bearing the richest, Indian merchandise, and sometimes four, five or six hundred thousand dollars in specie without the loss of a dollar."[38]

Abbas's attitude toward antiquities originated in the desire to assert his authority in the face of European influence. Only a few months after he took office, in 1849, Abbas issued a series of orders to preserve Egypt's heritage and prevent archaeological sites from being looted, asserting that "the archaeological remains and other antiquities found in the territory of Egypt bring the country both beauty and pride; they [also] serve to discover and study the conditions of the past."[39] He appointed two engineers to conduct a survey of all archaeological sites in Upper Egypt and compile a detailed register of them. Provincial governors were charged with the protection of sites in their jurisdiction. Monuments in danger of being taken away by either tourists or dealers would be sent to the museum, still in its provisional quarters in the School of Languages. Every year the Ministry of Public Instruction would send an engineer to check on the condition of the sites. Those close to Cairo, such as Giza and Saqqara, were entrusted to the care of the Ministry. If the engineer reported anything damaged or stolen, the governor would be held responsible. So, when in June 1851 the governor of Giza Province sent his men to close down Mariette's excavations and confiscate the finds,

he was both following the law and acting in his own best interest. And it was to uphold that law that in September 1851 Abbas notified LeMoyne (through Stephan Bey, of course) that all the antiquities discovered by Mariette were to be turned over to the Egyptian government.

As we have seen, however, Abbas did not enforce the law consistently. He allowed certain dealers and collectors to excavate unmolested, and even granted some of them permission to export antiquities.[40] Nor did he show much concern for the museum. In October 1849, Abbas closed the School of Languages in Ezbekiyeh and transferred the collection to the Citadel.[41] There it languished. One of the engineers sent to inspect the monuments in 1849 was Linant Bey. As Gaston Maspero, Mariette's successor as director of antiquities in Egypt, reports:

> Linant might well try to accomplish his mission with diligence; the museum did not become any richer. The objects he collected either were lost on the way or, if they reached their destination, they soon disappeared: the Pasha gave them away indiscriminately to distinguished travelers from Europe, and the galleries emptied as quickly as they were filled. The collection became so impoverished that, transferred from Ezbekiyeh to the Citadel, it occupied only one poorly filled room in the Ministry. It had neither curator nor even a guard, and the employees of the other bureaus used it as a place to drop off their coats and their lunches.[42]

On July 12, 1854, Abbas was found dead in his palace at Benha. Although the official cause of death was apoplexy, rumor had it that he was murdered by two of his mamluks, either as vengeance for the humiliation of their being banished to work in the stables as punishment; or out of fear, because Abbas had threatened to have them killed the next day; or because they had been dispatched to do so by his aunt in Constantinople.[43] In the words of Abbas's great-grandnephew Hassan Hassan, "the only thing that is certain is that the crime was not committed for political reasons, but was of a personal nature."[44] The pasha was

not mourned: "The exercise of his power had been so odious that, as the heat was excessive at the time he died, the Fellahs affirmed that the gates of hell had opened to receive his soul."[45]

After Abbas died he was succeeded by his uncle Muhammad Said (1822–1863), the fourth son of Muhammad Ali. No greater contrast can be imagined than that between Abbas and Said. Where Abbas was taciturn, guarded, and suspicious, Said was outspoken, jovial, and friendly. Everyone liked Said. Where Abbas was uncomfortable around Europeans, Said was in his element with them. A fine student, by age eleven he had learned Turkish, Arabic, and Persian, as well as English and French. In this he pleased his father. But in another way he did not: Said was grossly overweight. At the age of thirteen he already weighed almost two hundred pounds. An exasperated Muhammad Ali admonished him about his "hateful corpulence," threatening: "I shall put you in charge of a rough man and make you walk every day. . . . I will not permit people to humiliate me and say that I am incapable of educating my sons when I educate the sons of all the others."[46] To force him to reduce, Muhammad Ali sent Said to the navy, where he had to climb up and down the ships' masts two hours a day, jump rope, row, and run around the city walls. It was all to no avail: by age thirty-five, Said weighed some three hundred pounds.[47] "I am certainly the fattest sovereign that ever ruled over Egypt," he joked.[48]

He was also, in his youth, rather shy. Muhammad Ali encouraged Said to spend time with the European consuls, so as to make him feel more comfortable around them and also to practice his English and French. Said became particularly close friends with the French consul, Ferdinand de Lesseps, who won him over by indulging the famished prince, suffering under the strict regime imposed by his father, with macaroni. This relationship would have important consequences.

Meanwhile, back in Europe, the restless Mariette thought only of returning to Egypt. Four years in the field had taught him that a scholar's life was not for him. He would never be a philologist; he had no patience

for poring over inscriptions. At his desk in the Louvre, he dreamed of Saqqara, of opening up new sites at Abydos and Thebes, of organizing a service for the protection of the monuments of Egypt and establishing a proper museum of antiquities in Cairo with himself at its head.

His chance came in 1857 when Prince Napoleon, the cousin of Emperor Napoleon III, announced his intention of traveling to Egypt. For the passionately pro-French Said, the prince's visit was a historic occasion. The grandson of Muhammad Ali would prepare to receive the nephew of Napoleon in a manner befitting the occasion.[49] In 1855 Archduke Ferdinand Maximilian, brother of Emperor Franz Joseph I of Austria, had paid a state visit to Egypt. Maximilian was an avid art collector, so as a gift Said had allowed him to take home his pick of the national antiquities collection in the Citadel. He could do no less for Prince Napoleon, a collector as well: he would send the prince up the Nile. Who better to guide him than Mariette, the discoverer of the Serapeum?

Mariette's friends had already spoken to Lesseps's secretary Jules Barthélemy Saint-Hilaire, who recommended the archaeologist to his superior, who in turn recommended him to the pasha.[50] Lesseps had left the diplomatic corps in 1849 and taken up the cause of building the Suez Canal, but had failed to elicit interest from Abbas. As soon as he heard of Said's accession, he wrote to congratulate his old friend, who duly invited him to Egypt. Lesseps hastened to Alexandria, where he was warmly welcomed by the new viceroy. In a few days he had his endorsement to build the canal.[51]

Lesseps now had the pasha's ear. A seasoned diplomat, he ingeniously connected Mariette's plans for an antiquities service to the prince's impending visit. He not only wished to keep Said happy, but he was also eager to please Prince Napoleon so as to enlist his support for the Suez Canal project. On Lesseps's recommendation, Said summoned Mariette back to Egypt to prepare for the impending visit and to form a collection to uncover in the presence of His Imperial Highness: "Every step of the

visiting prince was to sprout antiquities, and to assure a fertile crop and to save time, Mariette was to proceed upriver, dig for antiquities and then bury them again all along the route."[52]

In September 1857 Mariette submitted to Lesseps for the pasha's consideration a plan for the preservation of the monuments of Egypt, underlining its urgency by noting that in the course of four years he had seen some seven hundred tombs disappear from the desert between Abusir and Saqqara.[53] The plan also called for a museum of antiquities, but there would be no talk of that for the moment; Mariette was going to prepare for the prince's trip up the Nile, and that was all. Perhaps it seems odd that Mariette, who had concealed from Abbas the finest objects from the Serapeum for fear the pasha would give them away to the first passing prince, was now going to Egypt at Said's request to form a collection to give away to another passing prince. But it was his ticket back to Egypt, and he took it. Before he left, he was shrewd enough (or well advised) to dedicate to Prince Napoleon the first installment of what was intended to be the definitive publication of the Serapeum, with an appropriately florid tribute to the prince's patronage of French arts, letters, and science.[54]

By November, Mariette was back in Egypt. Said gave him a government steamer, letters to all the provincial governors ordering them to provide manpower for his excavations, and a bodyguard. Accompanied by his old friend Brugsch, Mariette started digs simultaneously at Giza, Saqqara, Abydos, Thebes, and Elephantine.[55]

Meanwhile, the prince remained in Paris. On October 18 the prince's aide-de-camp, Camille Ferri Pisani, wrote that the prince was still determined to go to Egypt but had not yet set the date of departure. People in France began to joke about it: "Prince Napoleon is resolved to go to Egypt," so they said, "the moment the Luxor obelisk [in the Place de la Concorde] goes back."[56] On January 31, 1858, Ferri Pisani wrote that "important considerations" compelled the prince to cancel the trip he had

set his heart on, adding that the prince regretted it all the more because he had not been able to accomplish the goal he shared with Mariette: the establishment of a service for the protection of the ancient monuments.[57]

Recalled to France on February 8 to resume his duties at the Louvre, Mariette managed to prolong his stay by suggesting that the prince might appreciate a few souvenirs of the trip upon which he had set such store. On March 9 Ferri Pisani let him know that the prince would be delighted to receive a few choice items—not a scientific collection: no steles, no papyri, but maybe a few jewels, statuettes, or other objets d'art collected during Mariette's mission of 1857–58, with some indication of where they came from and how they were found—to add to his cabinet of curiosities.[58] The pasha, still eager to accommodate the prince, was happy to give permission for their export. The gratified prince asked Mariette to convey his thanks to Said personally. "By this gesture," wrote Ferri Pisani, "the prince intends for the viceroy to understand all the friendship he feels toward you." Even more important, the prince would like the viceroy to know that "should His Royal Highness wish to ask France for the assistance of a scholar to establish an Egyptian museum, the French government would certainly not recommend any other man but yourself."

That did the trick. On June 1, 1858, Said appointed Mariette *mamur al-antiqat,* director of antiquities, with a salary of eighteen thousand francs a year.[59] He was now Mariette Bey, an official in the service of the pasha. "You will watch over the safety of all the monuments," Said charged him: "You will tell the governors of all the provinces that I forbid them to touch a single ancient stone; you will send to prison any *fellah* who steps foot inside a temple."[60] Mariette's dreams had come true. From here on he would serve Egypt as faithfully as he had ever served France.

Meanwhile Prince Napoleon's Egyptian collection arrived in France. Mariette had arranged for it to be sent on a government ship free of cost. Among the choice objects was the little green head of a priest. And as we shall see, the prince had just the place to put it.

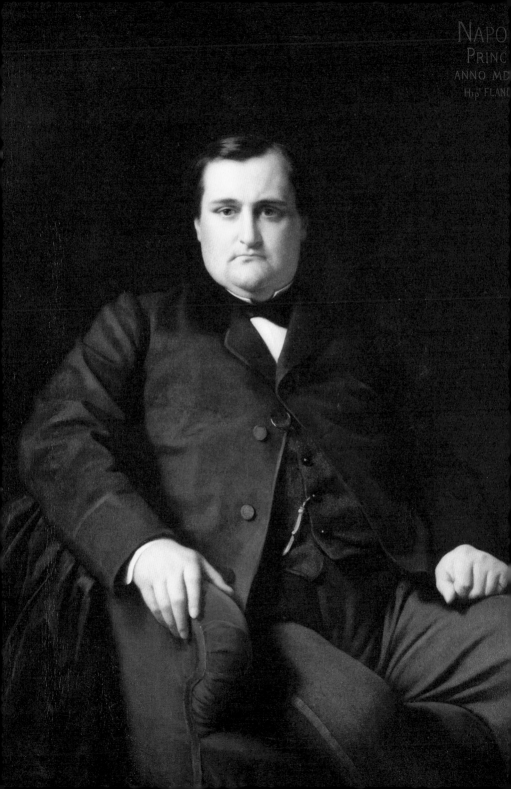

THE PRINCE

Napoleon-Joseph-Charles-Paul Bonaparte was born on September 9, 1822, in Trieste, at the time a city in the Austrian Empire. His father, Prince Jerome, was the youngest brother of Emperor Napoleon I, under whom he had reigned briefly as King of Westphalia; his mother was Princess Catherine of Württemberg, the daughter of Frederick I, King of Württemberg (in southern Germany). The story goes that one day his grandmother Letizia, the formidable "Madame Mère," matriarch of the Bonaparte clan, asked the young prince to say his name. The child, who evidently found "Napoleon" a mouthful, responded "Plon-Plon."[1] The nickname followed him his entire life. It was generally agreed that of all the men in the Bonaparte family, Plon-Plon bore the greatest physical resemblance to his uncle Napoleon I.

As the Bonaparte family had been banished from France in 1816, Prince Napoleon spent the first twenty-two years of his life in exile. When the baby was six months old, Prince Jerome took the family to Italy to join Madame Mère and other members of the family who had settled there. After his mother's death in 1835, Plon-Plon stayed for a few months in Arenenberg, Switzerland, with his aunt Hortense, the former Queen of Holland, and her son Louis-Napoleon, the future Emperor Napoleon III. The close attachment that developed between the two cousins continued throughout their lives, even though Plon-Plon was often a thorn in Louis-Napoleon's side on account of his willful behavior and liberal political views. Plon-Plon could always be relied on to say the wrong thing, and to say it in public; nonetheless, his cousin always forgave him.

In 1836 Jerome sent the fourteen-year-old Plon-Plon to join his elder brother Jerome-Napoleon at military school in Ludwigsberg, Württemberg. Although he did well in school, his brother complained to their father that "Plon-Plon's opinions are unfortunately very far-fetched; he is a republican and believes that the only possible and desirable

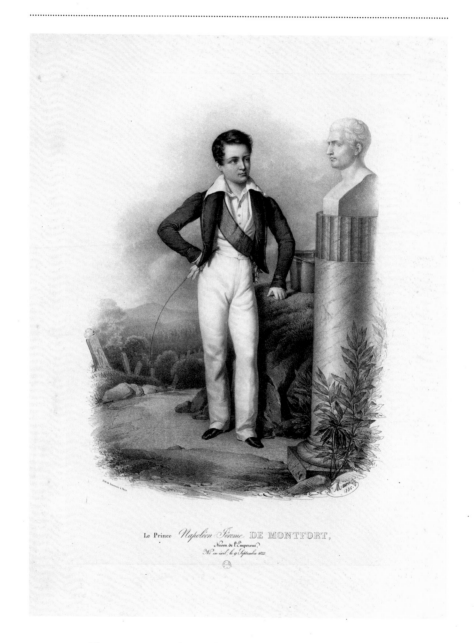

Le Prince *Napoléon Jérôme* DE MONTFORT,
Neveu de l'Empereur,
Né en 1814, le 9 Septembre 1822

The young prince at the age of fourteen, contemplating a bust of his uncle, Napoleon I.

government is a republic. . . . Though he is not disobedient he finds discipline stupid and contrary to the rights of man; this is another consequence of his far-fetched democratic ideas. He always maintains that there are no ranks, that all men are equal."[2] After school his father wished him to pursue a career as an officer in the Württemberg army, but five years in Germany were quite enough for Plon-Plon. At the first opportunity he returned to his family in Florence, where he spent the next few years gambling and chasing after women.

Meanwhile in France feelings against the Bonapartes had begun to soften. In 1840 King Louis-Philippe obtained permission from the British to bring the remains of Napoleon I from St. Helena, where he had died nineteen years earlier, to France; they were reburied with great pomp and ceremony to the strains of Mozart's *Requiem* in the church of Les Invalides in Paris. In 1841 Plon-Plon's sister, Princess Mathilde, had married a Russian nobleman and settled in Paris with her husband. In 1844 through her efforts Plon-Plon obtained permission to visit Paris, where he met many Bonapartists, and where his resemblance to Napoleon I caused a sensation at the Invalides, with old soldiers shouting "Vive l'Empereur!"[3] Meanwhile Jerome was maneuvering to get the French government to repeal or revise the exile law so the Bonapartes could once again make their home in France.

The Revolution of 1848 that swept across much of Europe led to the rehabilitation of the Bonaparte family. Our young Prince Napoleon was elected to the new French Constituent Assembly as the representative for Corsica. A few months later, his cousin Louis-Napoleon, who was living in England, having recently escaped from prison following two failed coup attempts, was welcomed back to France like a savior and elected President of the Second Republic in a landslide victory. At twenty-six the youngest member of the legislature, Plon-Plon distinguished himself by his oratory and his republican (anti-monarchist) views. He earned the nicknames "Prince of the Mountain" (after the high benches on which the opposition sat) and the "Red Prince."

At this time Plon-Plon was living with his father at the Invalides, the magnificent hospital and home for war veterans built by Louis XIV, where Jerome was now governor. During this period Plon-Plon acquired his lasting reputation for debauchery. Some said he turned the Invalides into a brothel.[4] There is no denying Plon-Plon had a way with women; among his numerous conquests was the opera singer Rosine Stolz, who created the roles of Ascanio in Berlioz's *Benvenuto Cellini* (1838) and Léonore in Donizetti's *La favorite* (1840)—and who was also the mistress of the director of the Paris Opera.[5] Perhaps his most renowned paramour was the great tragedienne Rachel. Born February 28, 1821, in Mumpf, Switzerland, to itinerant Jewish peddlers, Elisa-Rachel Félix, known to the world simply as Rachel, was the most celebrated actress of her day. Before a public that had been infatuated with the romantic plays of Victor Hugo and Alexandre Dumas *père*, Rachel performed the classical seventeenth-century tragedies of Corneille and Racine, singlehandedly reviving the waning fortunes of the Comédie-Française. Her greatest triumph was in the title role of Racine's *Phèdre*, which is to French theater what *Hamlet* is to the English stage. Rachel's love affairs were even more talked about than Plon-Plon's. She had a penchant for Bonapartes, having had relationships with Count Alexandre Walewski (Napoleon I's illegitimate son by his Polish mistress, Countess Marie Walewska) and Louis-Napoleon both before and during her affair with Plon-Plon. The personification of the tragic muse, Rachel loved classical antiquity and shared her taste for Greek and Roman art with the prince, who commissioned for her from the prominent Beaux-Arts architect Jacques Ignace Hittorff a scale model of a temple at Selinunte, one of the major Greek sites in Sicily.[6] Even after they had ceased to be faithful to one another, Plon-Plon and Rachel remained close friends.

As an ardent and outspoken republican, Plon-Plon had nothing to do with the coup d'état of December 2, 1851, which led directly to the creation of the Second French Empire and Louis-Napoleon's ascent to the throne as Emperor Napoleon III a year later. But although he

Rachel appears as the muse of tragedy in this 1854 painting by Eugène Emmanuel Amaury-Duval. Her penchant for the antique influenced the taste of her royal paramour.

The actress in Racine's *Phèdre*, her greatest role, in a drawing by Edouard Baille from about 1850.

initially opposed the coup, he was willing to benefit by it. Plon-Plon was named senator, councilor of state, and divisional general, with a generous income and splendid quarters in the Palais-Royal.

As Napoleon III pursued an aggressive foreign policy, Plon-Plon soon had a chance to make a glorious name for himself when the Crimean War broke out in 1854. After Britain and France declared war on Russia in March of that year, Plon-Plon hoped to be named commander in chief; but it was as a general in command of the 3rd division in the Army of the Orient that he went off to war in April 1854. Although he distinguished himself in the first battle of the war, in which the Anglo-French forces defeated the Russians at Alma, north of Sebastopol, the soldier's life was not for him. Against his cousin the emperor's wishes, he returned home early, claiming illness—leaving it to others to wait out the long siege of Sebastopol. This unbecoming conduct for a Bonaparte led critics to remark that instead of Plon-Plon he should be called Craint-Plomb (scared of bullets). He never lived it down. But it was not bullets he was scared of: "No one was braver, more careless of danger, or had so much contempt for death," his commander-in-chief explained, "but what frightened him was the mud, the discomfort, sleeping on hard ground, the rain, the dirt, the vermin, the lice. . . ."[7]

Plon-Plon regained some standing with the French public with the Paris Universal Exposition of 1855, his nation's answer to London's Great Exhibition of 1851.[8] He had been appointed president of the organizing commission and had supervised the preliminary planning before he left for Crimea; when he returned from battle he threw himself into the work with gusto, acting as guide and host to distinguished visitors that included Queen Victoria and Prince Albert. There were two main exhibition halls: a glass-roofed Palais de l'Industrie on the Champs Elysées and a Palais des Beaux-Arts on the Avenue Montaigne. Favored painters Jean-August-Dominique Ingres, Eugène Delacroix, Horace Vernet, and Alexandre-Gabriel Decamps each had a major retrospective exhibition in the Palais des Beaux-Arts, where they showed their most famous works.

The exposition, which ran from May 15 through November 15 and attracted more than five million visitors, failed to cover its costs but was considered a great *succés d'estime* and the great art event of the decade.[9] In July 1857, Prince Napoleon was elected a member of the French Academy of Fine Arts, the only Bonaparte ever so honored.[10]

The prince's appreciation for the arts seems to have been genuine. Arséne Houssaye, a prolific writer, director of the Comédie-Française, and quintessential man-about-town, wrote in his memoirs that the prince loved ancient art as much as contemporary art. He claimed there was not an artist in all of France who knew the history of art as well as he did, nor was there a painter or sculptor at the French Academy in Rome who knew as much about Greek and Roman art.[11] These joint interests found their perfect expression in the Maison Pompéienne (Pompeian House) at 18, Avenue Montaigne, which the prince began to build in 1856.[12] Designed and built by the architect Alfred-Nicolas Normand, the house had a plan based on the so-called Villa of Diomedes in the Via dei Sepolcri outside the walls of Pompeii. Diomedes (or whoever lived there), however, would have been surprised at the modifications to accommodate the Parisian climate and the habits of modern Parisian society. Facing the street, an Ionic portico doubled as a porte-cochere; inside, as in a Roman house, the principal rooms opened off an atrium complete with central pool (*impluvium*) and pierced ceiling (*compluvium*), glassed over to afford protection from the weather and presided over by a figure of Napoleon I clad in a toga.

The interior decoration juxtaposed imitation Pompeian wall paintings with pictures by Jean-Léon Gérôme and Gustave Boulanger in the latest Néo-grec (Neo-Greek) style, then in its heyday.[13] Led by Gérôme, the Néo-grecs (also called the Pompéistes) specialized in scenes of everyday life, set in ancient Greece; costumes and props were reproduced with painstaking archaeological accuracy, copied from Greek vase paintings and the latest finds at Pompeii. Although they sometimes ventured into allegory—for the Pompeian House, Gérôme painted allegorical

Maison antique de S. A. I. le prince Napoléon, dans l'avenue Montaigne.

figures representing Homer's *Iliad* and *Odyssey*—in general the Néo-grecs eschewed the gravity and high moral seriousness of Jacques-Louis David and his Neoclassical followers; instead of the *Death of Socrates* they showed us *Young Greeks Attending a Cockfight*; and in place of *Oath of the Horatii* they gave us *Anacreon, Bacchus, and Cupid.*[14] Theirs was an eclectic and lighthearted view of antiquity, perfectly in tune with the spirit of the times, and also manifested in the operettas of Jacques Offenbach; his *Orphée aux enfers* (*Orpheus in Hades*), with its titillating cancan, debuted in 1858, the same year the prince inaugurated his Pompeian House with a performance of Émile Augier's play *The Flute Player*—inspired by a painting in the House of the Tragic Poet in Pompeii—in the presence of Napoleon III and Empress Eugénie.

The façade of the prince's Pompeian House in Paris.

In the atrium of the Pompeian House, marble busts representing the family of Napoleon I were displayed like ancient Roman ancestor busts, as seen in this photograph taken about 1866.

The spirit, as well as the look of the house, is captured in Gustave Boulanger's painting *Rehearsal of "The Flute Player" in the Atrium of the House of H.I.H. the Prince Napoleon.*[15] The painting is based on an actual event, when the painter dropped by during a dress rehearsal. Depicted, from left to right, are the noted Comédie-Française players Edmond-François Got, Joseph Isidore Samson, and Marie Favart; the author and critic Théophile Gautier; Augier himself (seated); and the actress Madeleine Brohan and (reclining) the actor Edmond Geffroy.

Invitations to the Maison Pompéienne were eagerly sought. Here the prince liked to unwind, free from the stuffiness and formalities of the court. Oftentimes, Houssaye recalls, the prince and his companions— who on any night might include the writer himself, along with Gautier, Delacroix, the philosopher and historian of religion Ernest Renan, the critic Charles Augustin Sainte-Beuve, and the theater director (and celebrated wit) Nestor Roqueplan—would stay up late discussing an ancient fresco, relief, or bronze, while passersby who saw the lights burning in the windows imagined some wild orgy taking place.[16]

The prince's enthusiasm for the arts was equaled if not exceeded by his passion for travel. After undertaking a scientific expedition to the Arctic Ocean in the summer of 1856, he conceived the idea of the Egyptian voyage.[17] The prince's aide-de-camp, Lieutenant Colonel Ferri Pisani, describes his motivations in lofty (and typically highfalutin) terms:

> Still full of the sight of those solitary continents of lava buried under the snow, the spectacle of those immense movements of ice, and the memories of the worst natural disasters our planet has ever witnessed, it seemed to him a good idea to visit that marvelous country where the soil had been gently deposited to accommodate the dwellings of men and ripen their crops, illuminated and warmed by an eternally splendid sun, that land so privileged where nature regulates and moderates the most devastating extremes in its favor in order to make it a source of fertility and life.[18]

FOLLOWING SPREAD: Players from the Comédie-Française rehearse Émile Augier's historical drama *The Flute Player* in the atrium of the Pompeian House in 1860, as painted by Gustave Boulanger.

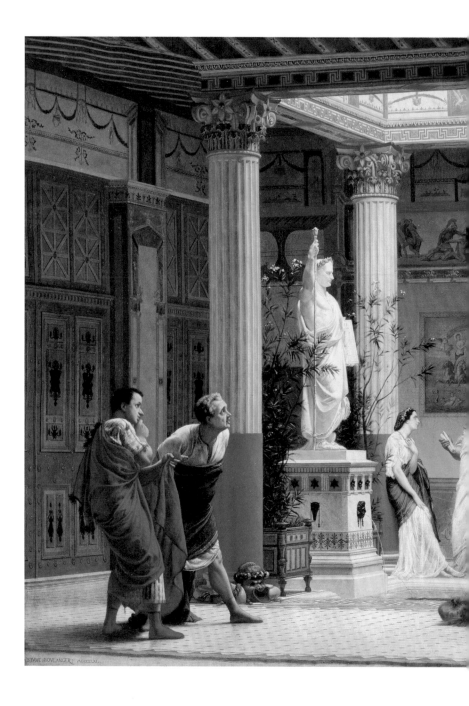

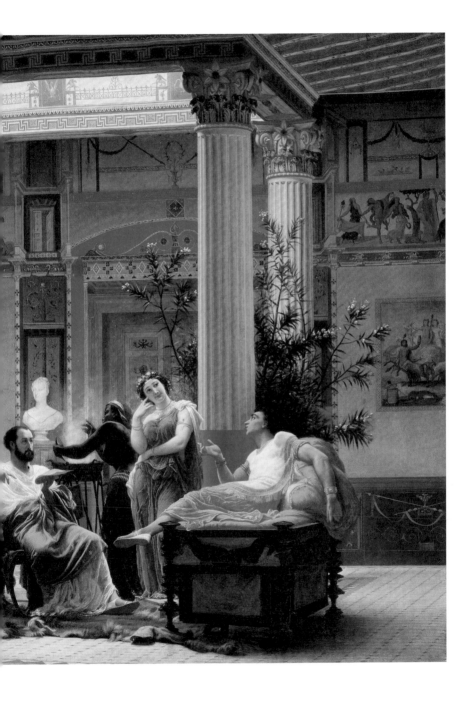

The expedition also offered the allure of the past: Egypt was the best place to trace the history of humankind back to its origins. And there was perhaps one more draw. There was Rachel.

In October 1856 Rachel had gone to Egypt on her doctor's advice, hoping that the warmth and dry air would afford her some respite from advancing tuberculosis. On March 10, 1857, she wrote in a letter from Luxor, "If my lungs do not kill me, surely I shall die of boredom."[19] She had attempted to divert herself with tourism, but found the Egyptian sights overwhelming:

> These piled up ruins of marvelous temples, these gigantic colossi carved into the sides of mountains of granite, so many works and masterpieces marred by the hand of centuries and toppled from their pedestals by earthquakes, this whole spectacle laid bare to the eye, not to mention how the imagination makes it even more frightening, is too heavy a burden for weakened bodies and broken spirits to bear. Therefore I could not for long follow in the steps of Champollion. . . . After having been carried in a litter to the foot of the famous pyramids, seen the tombs of the kings, after having seen the famous statue of Memnon . . . and after, by a moonlight such as exists only here, having contemplated silently and intelligently the ruins of Karnak, I went back to my camp, vowing that I had had enough. . . . From that day my curiosity abated, and . . . I feel mindless, broken, and good for nothing.

Rachel returned to Paris in June of that year to set her affairs in order and then retired to a friend's villa near Cannes, on the French Riviera. The prince's yacht had transported her from Marseilles to Cannes. Plon-Plon himself interrupted a scheduled trip to see her in December as she lay on her deathbed, and promised to protect her two sons. Rachel's passing at the age of thirty-seven on January 3, 1858, affected the prince profoundly. On his return to Paris he ordered the Pompeian House to be dressed in mourning.[20]

That same January the prince called off his trip to Egypt. It was indeed a busy time for him. For one thing, negotiations were under way for the prince's marriage to Clotilde, daughter of Victor Emmanuel II, King of Sardinia (later King of Italy), and a leader of the Italian Risorgimento; Prince Napoleon and his cousin Napoleon III (for once in agreement) supported the cause of Italian independence and the marriage would cement the alliance. The pious and demure Princess Clotilde was only fifteen years old, twenty-one years younger than her designated husband, and there could be no question of the prince's becoming a faithful spouse; with no illusions about her intended's character, she accepted his hand willingly and with grace in the interests of her family. To everyone's surprise, the couple got along quite well. They were married on January 30, 1859.

Meanwhile the prince's Egyptian collection had arrived in Paris. There was only one logical place to install it:

> This beautiful collection is now in the Greek house of the prince, surrounded by works of art from all sources and every period. . . . The statues, sphinxes, and lions adorn the gardens and avenues of the house; the steles are arranged along the walls of that unique and charming room whose moveable floor conceals a pool capable of holding sixty cubic meters of hot water, which so strongly excites the curiosity of visitors; finally, the bronzes and small objects are displayed in a large vitrine on one side of the Picture Gallery, opposite the Greek temple of Mr. Hittorf, the pastels of Maréchal and the *Marat* of David, beside the large Cimmerian canvases of Pils and Vernet.[21]

Quite an eclectic assortment! And we know just what it looked like. A page in the weekly paper *L'Illustration* shows two interior views of the gallery. The upper panel depicts the Picture Gallery converted into an ancient theater for the performance before Their Imperial Majesties of Augier's *The Flute Player*.[22] The room, with the stage on the left, is filled

with men in black coats and women in crinolines. Hittorff's scale model of the temple of Selinunte, which Plon-Plon commissioned for Rachel, but which the actress never lived to see, is on the right. The lower panel shows the play in performance. We see the guests from behind as they sit facing the stage in the background. One can just make out David's *Death of Marat* (a copy of the original in Brussels) hanging on the wall to the right. On the opposite wall is the vitrine, and somewhere in there is the Green Head.

The Green Head appeared in print for the very first time in an 1859 article by Ferri Pisani in the inaugural issue of the *Gazette des beaux-arts*, from which we have already quoted several times. It is somewhat misleadingly entitled "Egyptian Bronzes from the Collection of Prince Napoleon," as the article covers the whole collection, not just the bronzes. The author begins by explaining that the Egyptians considered the sand of the desert unclean, so before building upon the sand, they purified the ground by burying images of deities in the foundations. Ferri Pisani got this straight from Mariette.[23] Of the hundred or so bronzes in the collection, Ferri Pisani describes and illustrates three representative examples: an Osiris-Iah (a lunar form of Osiris), an Apis bull, and a sacred cat.[24] All, he says, were found at Saqqara, in the foundations of a tomb of an Apis bull built by Apries, the fourth king of Dynasty 26 (ruled 589–570 BC). Therefore, he assumes (or was told by Mariette) that all the bronzes were made in the time of Apries.

Though we no longer believe the Egyptians considered the sand unclean—quite the contrary, pure desert sand was poured into the foundation trenches of buildings both to provide a level surface for laying the stones and to symbolize the first ground that rose up out of the primeval waters at the time of creation—they did occasionally bury bronzes in the foundations of buildings. It is to this custom that we owe the preservation of the most remarkable piece in the entire collection: "a head of a man, half life-size, in green basalt of the finest grain":

At the performance of *The Flute Player*. Upper panel: the reception for the Emperor and Empress. Lower panel: the play, watched by the fashionable audience as well as by the Green Head, very likely in the vitrine at the far left.

FÊTE DONNÉE A L'EMPEREUR ET A L'IMPÉRATRICE PAR S. A. I. LE PRINCE NAPOLÉON, DANS SA MAISON POMPÉIENNE.
— LL. MM. SE RENDANT A LA PINACOTHÈQUE, CONVERTIE EN THÉATRE ANTIQUE.

REPRÉSENTATION DEVANT LL. MM. DU *Joueur de flûte*, COMÉDIE DE M. ÉMILE AUGIER, PAR LES ARTISTES DU THÉATRE FRANÇAIS.

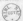

The nose is broken; if not for this regrettable fracture the head would be in a perfect state of preservation, the surface of the basalt showing not the slightest scratch. There can be no doubt about the nature of this piece of sculpture: it is a portrait; the features that it reproduces are those of an elderly man with flabby flesh and a physiognomy common but intelligent, somewhat approximating the type of a eunuch. The perfection of the modeling, the truth of the details, the expression of life, are beyond belief, and are combined with a sobriety of line and an incredible simplicity of means; the sculptor's art can go no further.[25]

The engraving, printed several pages later, shows the head reversed, and is none too flattering, as the piece (labeled "Head of a Eunuch") sits flat on its break, so the head appears to be tilted up and slightly to one side.[26]

According to Ferri Pisani, who presumably got his information from Mariette, the head was found "mixed in with the bronzes in the substructure of the funerary chapel of an Apis built by Apries." This is an important clue to the origin and date of the head. An object found in the foundations of a building is logically of the same date or earlier than the building above it. Since no scholar today would place the Green Head any earlier than the fourth century BC, Ferri Pisani's report that the head was discovered in the foundations of a burial chapel of an Apis bull built by Apries requires qualification. Furthermore, the burial chambers of the Apis bulls of the Twenty-sixth Dynasty were not built upon the sand surface but rather were excavated in the bedrock. Mariette did not find the mixed deposit of bronzes there, in the Greater Vaults, which contained only stone sarcophagi and steles. He found the bronzes (and presumably the Green Head as well) outside: beneath the dromos, by the northern and southern enclosure walls, and along the unpaved road that led north to the Sacred Animal Necropolis and the catacombs of the Mothers of Apis.[27]

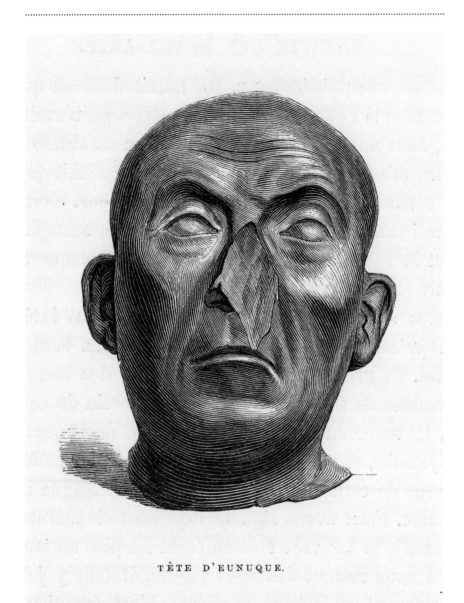

TÊTE D'EUNUQUE.

The first publication of the Green Head, labeled "Head of a Eunuch," in the *Gazette des beaux-arts*, 1859.

A look at the Sacred Animal Necropolis at North Saqqara, excavated by British archaeologists in the 1960s and 1970s and incomparably better documented than Mariette's excavations at the Serapeum, helps solve the puzzle. The Sacred Animal Necropolis contains not only the catacombs of the Mothers of Apis but burial complexes of other species, including ibis, falcons, and baboons.[28] The Serapeum and the Sacred Animal Necropolis constituted one overall sacred landscape and developed in tandem. Caches of bronzes were found in the Sacred Animal Necropolis as well. Most were found close to the enclosure wall of the Main Temple, either below the foundations or in construction debris against the wall.[29] The objects could have been buried in the sacred precincts as foundation deposits, as redundant temple offerings, "which by reason of their sanctity could not be destroyed," or for safekeeping in the wake of a foreign invasion.[30]

One of these pits mixed statues of kings and officials made of wood, stone, and faience in with the usual bronze statuettes of deities.[31] Some of these figures had originally been quite large, and all had been broken or damaged in some way. They include some of the artistically finest pieces found in the excavations. The absence of the missing pieces of the damaged objects indicates that they were already broken when buried. Those sculptures that could be dated by their cartouches bear the names of Ramesses II, Ramesses IX, and Amasis; others can be dated by art-historical criteria to the New Kingdom (1550–1070 BC) or Dynasties 26–30 (664–332 BC). Few have any obvious connection with the Sacred Animal Necropolis, though some have associations that suggest they originated in one of the shrines of ancient Memphis. If they had been damaged during an attack on the city and then buried in the sacred precincts to save them from further damage, the most likely occasion, given the history of the site and the date of the latest pieces, would have been the Persian invasion of 343 BC, which put an end to Dynasty 30.

An analogous scenario can be envisioned for the Green Head. Although by no means large, the statue to which the head belonged

would have been considerably bigger than the average bronze; clearly it has been broken; and its artistic quality speaks for itself. The inscription on the back pillar mentions the Memphite god Ptah-Sokar-Osiris, suggesting the statue originated in a temple in Memphis. Such a history would account for this fine head of stone being found together with earlier Twenty-sixth Dynasty bronzes, some of which may have borne the name of Apries, in a pit in the Serapeum.[32]

Leaving aside the clues that Ferri Pisani gives to the head's date and findspot, his account is also fascinating for its genuine recognition of the sculpture's qualities, which he finds impossible to reconcile with the prevailing aesthetic of his time that placed Greek art—and specifically Classical Greek art—above any other, ancient or modern.

This undisputed masterpiece demonstrates to the fullest degree that the ancient Egyptians, alongside a conventional art based on formulas endlessly repeated without variation or development, also cultivated an art inspired by nature and truth. This realistic style was present from the very beginning, as early as the third millennium BC, as demonstrated by the famous *Seated Scribe* and the Old Kingdom statues of Sepa and Nesa, now in the Louvre.[33] That it continued to exist together with the official style throughout Egyptian history is proved by the numerous realistic thirteenth-century BC portraits of Ramesses II, but it reached its apogee with the Saite Renaissance beginning in the seventh century BC. Under Psammetichus I and his successors, Egyptian art regained that incredible finesse it had lost for some six hundred years; as Ferri Pisani asserts: "Beautiful statues multiplied, characterized to an eminent degree by the suppleness of articulations, the truth of detail, and the variety of facial expression and bodily types. But, it has to be said, no known piece of sculpture presents these qualities in a state of perfection comparable to that evidenced by the head of which we speak."[34]

With the Green Head, he appears to say, Egypt has attained the highest degree of truth in art that study and the imitation of nature can provide. But there he stops short, as though before an insuperable barrier:

"Let us refrain, however, from setting it on that pedestal where the spirit of Greece alone has the right to show its radiant form to posterity."³⁵ For if in the sixth century BC Greek art still lagged behind Egyptian art, following along the path that the Egyptians had been walking for thousands of years already, in the fifth century the Greeks overtook the Egyptians by reaching beyond study and the observation of nature to grasp something higher: the ideal conception of beauty. Egypt never experienced this spiritualization of art; just as, for all its seeking after eternal life, its countless inscriptions, it never developed a proper sense of history as Herodotus understood it and bequeathed to us; just as it never developed a philosophy; or, for all its wild and fantastic stories, never transformed its dreams into poetry. "The last verse of the *Iliad* rises up from the midst of the works of the past to a height that the pyramids could not attain."³⁶

While Greece reached for the skies, Egypt remained condemned by the primary nature of its people to be stagnant and earthbound. "It is not to secondary causes that the fundamental superiority of Greece over Hamitic Egypt as well as the Semitic people that surrounded it is due." For Ferri Pisani, it was simply a matter of race. "The mystery of genetic predestination appears here in all its power. As for the first emanation of the divine breath that Greece spread over the surface of the world . . . it is on the summits of ancient Aria that the firstborn of the Caucasian race received it with their life, to the exclusion of their disinherited brothers, and it is with their blood, through the Celts and the Germans, that it has come to us"—that is, to the French.³⁷

Ancient Aria, where Ferri Pisani locates the origin of the Caucasian race, was a province of the Persian Empire, occupying roughly the same area as present-day Herat province in western Afghanistan. Nineteenth-century European scholars subdivided the Caucasian race into three groups: Aryan (or Indo-European), Hamitic, and Semitic. These writers ascribed to the Aryans or Indo-Europeans characteristics attributed to the ancient Greeks, whose energy and intellectual gifts prefigured the

progress of Western civilization.[38] Greek art just had to be superior to Egyptian art.

Who was Ferri Pisani, and what made him qualified to write about such subjects? Marcel-Victor-Paul-Camille Ferri Pisani was born on July 28, 1819.[39] His father, Paul-Félix Ferri Pisani, served as councilor of state under Napoleon I, who made him a count, and again under Louis-Philippe. Young Camille studied to be an artillery officer at the École Polytechnique and embarked on a military career that included a tour of duty in Algeria. In 1852 he became Prince Napoleon's aide-de-camp and served with him in Crimea. Ferri Pisani also accompanied the prince on his Arctic voyage in 1856 and made arrangements with Mariette for Plon-Plon's projected journey up the Nile.

In 1861, by now a lieutenant colonel, he accompanied the prince and Princess Clotilde on a tour of North America. His often amusing reports home were published as a book the following year.[40] At their first official stop, the prince was appalled by the lack of ceremony at Lincoln's White House: "You walk straight in, like in a café." For all his liberal pretensions, the prince expected to be treated like a prince. His aide exclaimed: "Heaven forbid that I complain of the simplicity of habits and mores of anyone, even of the chief of a great Nation! I cannot, however, prevent myself from noticing that it is illogical to live in a great palace and not to have a doorman." From the first, the meeting did not go well:

> The president shook our hands, after shaking the Prince's. I feared, for a moment, that the interview would end with this silent demonstration. . . . Finally the President took the risk of speaking of Prince Lucien, his father. Mr. Lincoln was on the wrong track and he was warned [Lucien was Prince Napoleon's uncle, not his father]. . . . A few words were then exchanged on the rain, the weather, and our crossing. The Prince still maintained his polite but cold front—as he customarily does when he does not care to help the conversation. Finally, Mr. Lincoln once more resorted to

the handshaking; as we were seven on our side, and they were two on the other, the ceremony lasted long enough so that we soon reached the time limit usually assigned to this kind of meeting.[41]

After Washington the prince visited New York, Cleveland, Detroit, Chicago, Niagara Falls, Montreal, and Quebec. The last stop was Boston. Plon-Plon was most eager to speak with the biologist and geologist Louis Agassiz at Harvard, where they had a nice discussion about glaciers, geology, and the philosophical implications of Agassiz's scientific discoveries. On their last day in Boston, the city gave a banquet in the prince's honor. Agassiz was there, Emerson was there. Edward Everett delivered a speech, and Oliver Wendell Holmes recited a poem. The prince left feeling very gratified.

Ferri Pisani's article on Prince Napoleon's Egyptian collection seems to have been his only excursion into art criticism. He would have been acquainted with the learned and literary men of the prince's circle, and to his credit, he shows some familiarity with the latest developments in French Egyptology; he even cites Emmanuel de Rougé's translation of the Tale of the Two Brothers, the first continuous translation of an ancient Egyptian literary text (though Ferri Pisani brings it up only to find it inferior to Greek epic poetry), and speaks knowledgably about the Egyptian collection of the Louvre.[42] As the pièce de résistance of the prince's collection, the Green Head would have often come up for consideration as the prince and his friends sat up late at night discussing the relative merits of Egyptian and Greek art. Ferri Pisani was privy to these conversations, and his article on the prince's collections seems to reflect the intellectual currents of the day.

In 1855 Jules Barthélemy Saint-Hilaire—a member of the Academy of Moral and Political Sciences, former professor of ancient philosophy at the Collège de France, translator of Aristotle, journalist, and politician—went to Egypt with Lesseps as part of the international commission to explore the feasibility of building the Suez Canal. It was Barthélemy

Saint-Hilaire who first put Mariette in touch with Lesseps. From Egypt he wrote home a series of letters in the form of essays, which were collected and published as a book. Most had to do with contemporary Egypt, but one chapter is devoted to Egyptian architecture.[43] The first item on the agenda is the relationship between Egyptian and Greek architecture. Did Greece have anything to learn from ancient Egypt? Although the author admires the size, solidity, and technical achievements of Egyptian architecture, in the end, he says, when you have seen one temple, you have seen them all. Egyptian art was incapable of change, and deliberately so; all originality was crushed by the tyranny of kings and priests. Therefore, Egyptian art cannot be true art, because true art can only be created by free artists in a free society, such as existed in ancient Greece.

In support of his observations, he turns to the Greek philosopher Plato, who is said to have visited Egypt and studied with the Egyptian priests. According to Plato, the Egyptians had laws about what was good and what was bad in art, and no deviation was allowed: "These they prescribed in detail and posted up in the temples, and outside this official list it was, and still is, forbidden to painters and all other producers of postures and representations to introduce any innovation or invention . . . over and above the traditional forms. And if you look there, you will find that the things depicted or graven there 10,000 years ago (I mean what I say, not loosely but literally 10,000) are no whit better or worse than the productions of today, but wrought with the same art."[44] Plato regarded this as a good thing, as it ensured a consistent level of quality, but Barthélemy Saint-Hilaire disagreed. Artistic quality cannot be determined by legislation: "Under the law that carefully prescribed its every aspect, Egyptian art vegetated rather than lived."[45]

At the end of his chapter on architecture, Barthélemy Saint-Hilaire turns to sculpture, or rather to one particular sculpture: the *Seated Scribe*, discovered by Mariette in an Old Kingdom tomb at Saqqara as he excavated the alleyway of sphinxes that led to the Serapeum.[46] This statue, he observes, is executed in a style unknown in Egyptian art. It is art based

The *Seated Scribe*, the most famous Egyptian statue in the Louvre, was discovered by Mariette at Saqqara in 1850.

on a study of nature and the human body, sculpture such as the Greeks conceived it, and as we conceive it after the Greeks, worlds away from Thebes, Dendara, and the Pyramids: it is our world, not the world of the Pharaohs. "What is this apparition that contradicts everything we know and everything we can see of Egyptian art?" This figure, whose every feature is so strongly stamped with individuality—a true portrait, in other words—predates the Egyptian art that Plato knew by thousands of years. It means that before there existed Egyptian art as we know it, totally subject to conventions, without freedom, without hope of progress, there existed an entirely different kind of Egyptian art: "true art, because it was free, that walked on the road that leads to the beauty of the Greeks and the perfection of Phidias."

And there the author stops, having reached his own insurmountable barrier: "For this irrevocable surrender of the genius of art to the orders of despotism would be a phenomenon unheard of in the history of the human mind and one of the most astonishing anomalies that history can submit to the consideration of philosophy."

The French philosopher and historian Ernest Renan visited Egypt in 1864 on his way to Syria and Greece, in the footsteps of Saint Paul. Whereas Barthélemy Saint-Hilaire admired Egyptian art, in spite of its not being true art (in the Greek sense), Renan did not. Mariette himself showed the visitor the scenes of daily life in the decorated tomb chapels at Saqqara and Beni Hasan, so lively and animated, so natural and unpretentious. Renan particularly admired two wooden statues, of a man named Kaaper and his wife, that Mariette had discovered in another Old Kingdom tomb at Saqqara.[47] So lifelike was the image of Kaaper both in face and body that the workmen who found the statue saw in it the spitting image of their local headman, and ever since the statue has been known as the *Sheikh el-Beled*, or village sheikh. In his account of the visit, Renan proposed his own comparison: "The expression of naïve contentment spread over the smiling faces of these two good people is indescribable. They could be two Dutchmen of the time of Louis XIV."[48]

The tombs at Beni Hasan, later than those at Saqqara, showed that true art survived in ancient Egypt through the Middle Kingdom. If Renan had seen the equally spirited paintings in the tombs of the nobles at Thebes, he would have conceded the existence of true art in the New Kingdom as well. Instead, he contrasted the scenes of daily life at Saqqara and Beni Hasan with the solemn religious scenes in the Valley of the Kings, with their endlessly repeated gods and demons and incomprehensible rituals, charmless and utterly lacking in humanity. He believed that all originality was suppressed under the despotic rule of the New Kingdom pharaohs: "Of all countries Egypt has been the most conservative. Not a revolutionary, not a reformer, not a great poet, not a great artist. Not a scholar, not a philosopher, not even a great minister is to be found in its history. If men capable of filling such roles arose there, they were stifled by the routine and overall mediocrity. The king alone existed; the king alone had a name."[49]

For Renan, there was no development in Egypt, no progress. Egyptian civilization was born adult, fully formed, and remained stagnant thereafter. Such an Egypt served as a foil to justify the rise of Europe, whose success Renan projected back to the ideal culture of ancient Greece. As he put it, speaking of the art of his own time, "Our art is but an attempt, doomed from the start to inferiority, to reproduce in an ugly and bourgeois world what Greece produced under the influence of a ray of divine grace in a younger, nobler, and more beautiful world."[50] A conception of Egyptian art that challenged the supremacy of Greek art amounted to a threat to the world order.

This threat was also felt in Britain. The British Museum trustee Sir Joseph Banks, who had first encouraged Salt to collect Egyptian antiquities for the glory of the British nation, yet felt it necessary, upon the arrival of the Younger Memnon in London, to remind him that though the statue was "a *chef-d'oeuvre* of Egyptian sculpture, yet we have not placed that statue among the works of *Fine Art*. It stands in the Egyptian Rooms. Whether any statue that has been found in Egypt can be brought

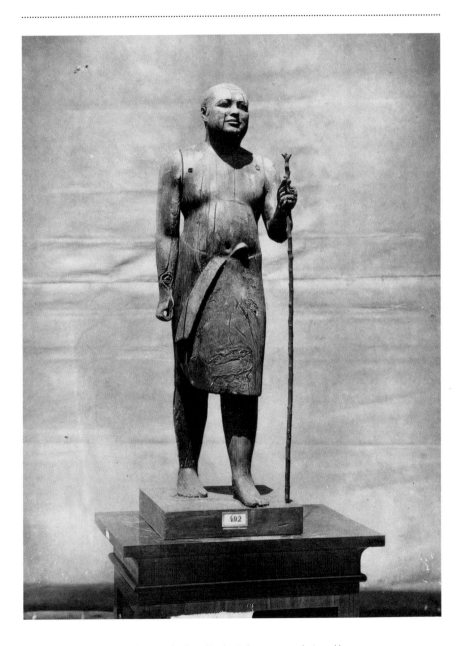

The *Sheikh el-Beled*, shown here as displayed in the Bulaq museum designed by
Mariette, seemed to break free from the strict rules of Egyptian portraiture.

into competition with the grand works [of Greek and Roman art] of the Townley Gallery remains to be proved."[51]

The prevailing hierarchy of artistic value is made clear in a remarkable 1845 watercolor by James Stephanoff, entitled *An Assemblage of Works of Art, from the Earliest Period to the Time of Phydias*, in which the works (largely drawn from the collections of the British Museum) are arranged in tiers according to their relationship to Classical Greek art.[52] Pre-Columbian and Asian art are grouped together at the bottom, not because of any supposed affinity, but because both are equally remote from the ideal: Athens in the fifth century BC. Above them the art of the ancient Near East is represented by the reliefs from Persepolis. Egypt occupies the next level up, with the Younger Memnon at the far right, balanced at the far left by the colossal limestone bust of Amenhotep III from the first Salt collection. In between are the two granite lions of Amenhotep III donated by Lord Prudhoe in 1835, two seated colossi of Amenhotep III from the first Salt collection, and in the center, a painted relief of Ramesses II in his chariot (cast from the temple of Beit el-Wali in Nubia). Etruscan art occupies the next rung up with tomb paintings, sarcophagi, and Greek vases found in Etruscan tombs (and believed to be Etruscan). Next comes Archaic Greek art, represented by figures from the Temple of Aphaia at Aegina; the sculptures from the Nereid Monument (later than the Parthenon, but at that time dated to the Archaic Period); and the reliefs from the Temple of Apollo at Bassae, which although known to be chronologically later were regarded as "aesthetically prior" to the Parthenon.[53] Crowning all are the Parthenon marbles, with the so-called Theseus from the east pediment presiding at top center against the background of the Panathenaic procession.

If the French were less focused on the Parthenon marbles—which were, after all in the British Museum, not in the Louvre—they no less regarded the Greeks as the summit of human civilization. Although the rehabilitation of Egypt redounded to the glory of France, the homeland of Napoleon, Champollion, and Mariette, the veneration of Greece was

James Stephanoff's 1845 watercolor arranges ancient art in ascending order of aesthetic merit.

too ingrained, and France, to claim its place at the pinnacle of Western culture and civilization, had to identify with Greece.

In 1827 the Musée Charles X, a suite of rooms on the south side of the Cour Carrée of the Louvre renovated to house the Egyptian antiquities arranged by Champollion—as well as ancient bronzes, Etruscan vases, and medieval and Renaissance decorative arts—opened to the public. One of the paintings commissioned to decorate the ceilings was François-Edouard Picot's *Study and Genius Unveiling Ancient Egypt to Greece*.[54] Athena, Greek goddess of wisdom, stands on a cloud, accompanied by the Genius of the Arts, nude and bearing a flaming torch, and the robed Study, while four cherubs lift a veil to reveal the figure of an Egyptian queen, topless, wearing a vulture headdress, seated comfortably on a throne flanked by a granite lion and a reclining Nile god. Clearly here Athena is France, the link between ancient Egypt and modern civilization.

Whatever his thoughts on these matters, Prince Napoleon's Egyptian collection was a large and important one. In Ferri Pisani's review article, having expatiated on the Green Head, the author moves on to other highlights of the collection. Sharing the honors in the vitrine were a magnificent bronze dagger, its pommel of wood covered with gold sheet and attached by gold nails to a grip of silver, and three elements from a bracelet, consisting of two little gold lions meant to be set on either side of a gold cartouche inscribed for "the son of Ra, Ahmose."[55] Mariette recovered these from inside an intact coffin he found at Dra Abu el-Naga on the west bank of Thebes, the mummy in the coffin having crumbled to dust at the excavator's touch.[56] Although he did not realize it at the time, Mariette had found the burial equipment of Kamose, the celebrated hero of the wars of liberation against the Hyksos, a foreign dynasty that ruled over northern Egypt from 1640 to 1540 BC and was reviled in later Egyptian tradition. The coffin was of a distinctive type that Mariette believed dated to the earlier Eleventh Dynasty (2140–

1998 BC), and because it was rustic in appearance, not the sort of thing to appeal to the prince, it remained in Egypt.[57]

Among the larger objects displayed outside the vitrine, Ferri Pisani singled out two limestone sphinxes and a lion, all three from the Serapeum.[58] One of the sphinxes eventually replaced the statue of Napoleon I in the atrium. The largest works were placed in the garden. These included a seven-foot-high granodiorite statue of the god Amen protecting King Tutankhamen, from Karnak; a limestone pair statue from Giza; and a sandstone block inscribed in beautiful hieroglyphs with a festival calendar and list of offerings, from the temple of Sothis at Elephantine

François-Edouard Picot's 1827 allegory, *Study and Genius Unveiling Ancient Egypt to Greece*, embodies the French conception of the relative position of the two cultures.

in the reign of Thutmose III, an important document for the study of Egyptian chronology.[59]

Prince Napoleon finally did come to Egypt in 1863 to inspect the work on the Suez Canal, of which he was an outspoken supporter. Mariette took him up the Nile in the steamer *Menchiéh*, luxuriously outfitted for his imperial pleasure.[60] It was summer, however, and very hot. Plon-Plon hardly left the boat, overcoming his lethargy only to see the inscription carved on the entrance pylon of the temple of Isis on the island of Philae commemorating the French victory over the Mamluks:

> Year 6 of the Republic, 15 Messidor [1 July 1798], a French army commanded by Bonaparte landed at Alexandria. Twenty days later, the Army having put the Mamluks to flight at the Pyramids, Desaix, commanding the first division, pursued them beyond the cataracts, where he arrived 18 Ventose of Year 7 [3 March 1799].

Someone had hacked out the words "French army" and "Bonaparte." An indignant Plon-Plon had them recarved at once, declaring, "One does not defile a page of history."[61]

The Universal Exposition of 1867, Paris's second world's fair, oddly enough provided the occasion for the Green Head's second appearance in print, again in the *Gazette des beaux-arts*. It is reproduced in the second of three articles written by Mariette's old friend Lenormant on the Egyptian antiquities on display at the fair, although as far as we know, the Green Head was not exhibited there.[62] Illustrated on the first page of the article (in the same reversed image used in Ferri Pisani's article, eight years earlier), it is neither identified by a caption nor mentioned in the text, which is concerned solely with the antiquities sent over from Egypt to be exhibited in the "Egyptian Temple," designed by Mariette as the pharaonic component of the Egyptian display.

Mariette had been busy since his appointment as director of antiquities, overseeing excavations at Edfu, Thebes (Karnak, Medinet Habu,

Deir el-Bahri, and Qurna), Abydos, and Memphis (Giza and Saqqara) with a workforce of fifteen hundred men. He dreamed of a purpose-built museum in central Cairo to display his finds, but for the time being he had to make do with temporary quarters in Bulaq, the port of Cairo, in some abandoned buildings that had belonged to the Egyptian Transit Company. At least the location was convenient for offloading heavy monuments. Putting to good use the skills he had learned during his days as a painter and set designer, Mariette transformed these ramshackle buildings into a museum in the neo-pharaonic style, the first such building in Cairo.[63] Said Pasha's sudden death in January 1863 at the age of forty-one, just as Mariette was getting ready to open the museum, appeared to threaten the enterprise, but the new viceroy, Ismail, Said's nephew, assured Mariette of his continued support, and the museum opened in October 1863. Mariette filled it with one great discovery after another from his excavations: the jewelry of Queen Ahhotep (Thebes, 1858), the *Sheikh el-Beled* (Saqqara, 1860), the statue of Chephren (Giza, 1870), the geese of Maidum.

Ismail Pasha was just as pro-French as Said, and far more talented and ambitious. He was determined to secure even more independence from the Ottomans and worked hard to impress the European powers. The Paris Universal Exposition of 1867 gave him an opportunity to make a splash in France. The Egyptian display encompassed a *selamlik* (men's reception area), with private quarters for the viceroy; a *wikala* (caravansary), where traditional handicrafts were exhibited; and an Egyptian temple designed by Mariette.[64] In the process he vowed to "do for Egyptian art what Prince Napoleon has done for the art of Pompeii."[65] Just as the Pompeian House was described as "a learned treatise on archeology written in stone, in which one can actually live," the Egyptian Temple was not just a museum but "a sort of living archeological study."[66]

An alleyway of sphinxes led from a monumental gateway to a temple building inspired by one of the temples of Philae. The parts of the

building were decorated so as to present the visitor with a synopsis of the main phases of Egyptian art. The interior represented the art of the pyramid age; the exterior walls of the room, the art of the New Kingdom; and the colonnade, the art of the Ptolemaic and Roman periods. The result was "a museum, which is at the same time a temple; and a temple, which from its center to its circumference, provides a chronological survey of Egyptian art from its beginnings until the advent of Christianity."[67]

Inside, against a backdrop of Old Kingdom reliefs, Mariette displayed the masterpieces of Egyptian art he had discovered since his appointment as director of antiquities in 1858: the *Sheikh el-Beled*, the statue of Queen Amenirdis, the jewels of Queen Ahhotep. Many in France, including Prince Napoleon and the Emperor himself, underestimating the strength of Mariette's commitment to Egypt, assumed that one day these treasures discovered by a Frenchman would belong to France. Empress Eugénie was so taken with the jewels of Queen Ahhotep that she asked Ismail Pasha to let her have them on the spot. Ismail, who could refuse the Empress nothing, referred her to Mariette: "There is someone at Bulaq even more powerful than I am; it is he who must give you the final word."[68] She offered Mariette the directorship of the Imperial Press, a seat in the Senate, a curatorship at the Louvre, but Mariette would not give in, although it cost him the support of the Emperor and severely compromised his standing with the viceroy.

Meanwhile, the prince had begun to tire of his antiquities. In 1864 the Louvre received as gifts of His Imperial Highness the Calendar of Elephantine, a Fourth Dynasty drum lintel, a Sixth Dynasty limestone false door, and a limestone block inscribed for Ramesses II of the Nineteenth Dynasty.[69] In 1866, he put the Pompeian House up for sale. When his friends heard about this, a group of them, including Houssaye, got together to buy the house and its contents, including the art collection.[70] They tried operating it as a museum and charging admission, but the novelty soon wore off and the enterprise failed.

The Egyptian Temple at the Paris Universal Exposition of 1867 presented visitors with
a total experience of Egyptian art, designed by Mariette.

The sale of the prince's antiquities took place at the Hôtel Drouot, Paris, on March 23–26, 1868.[71] Of the 537 lots, the first 315 were Greek and Roman antiquities, with a smattering of Phoenician and Etruscan objects. Egyptian antiquities comprised the next 222 lots. There were 102 bronzes; 39 objects of faience (scarabs and funerary figurines); 13 terracottas; 10 objects of wood; 16 objects of Egyptian alabaster; an odd assortment of 28 glasses, semiprecious stones, and monuments in basalt and granodiorite; and 14 monuments of limestone. The statue of Amen protecting King Tutankhamen is listed (lot 520), along with the Old Kingdom pair statue (lot 533) and the lion and sphinxes from the Serapeum (lots 534–36). The Louvre eventually purchased the statue of Amen protecting King Tutankhamen in 1920, from the Paris art dealers Feuardent Frères. The museum had passed up the chance to acquire it in 1868, and it went unsold. For some fifty years this monumental work remained hidden from view, unknown to scholars; the prince had taken it to his estate on Lake Geneva in Switzerland, his primary residence after the fall of the Second Empire in 1870.[72] The fate of the Old Kingdom pair statue is unknown. Conspicuously absent from the sale catalogue are the Green Head and the burial equipment of Kamose. The Louvre acquired the Kamose bracelet elements in 1881 from Rollin and Feuardent. The dagger turns up in Rome in 1884, in the posthumous sale of the collection of noted jeweler and art dealer Alessandro Castellani; it was bought by the coin collector Baron Lucien de Hirsch and ultimately bequeathed to the Royal Library of Belgium.[73] As for the Green Head, we lose sight of it entirely until 1903.

THE COLLECTOR

Not the least mysterious part of the Green Head's modern history is that it goes into hiding between 1867, when it last appeared in the *Gazette des beaux-arts*, and December 30, 1903, when it arrived at the Museum of Fine Arts, Boston. It is significant, however, that the same man who sent to Boston the finest specimens of Greek and Roman art ever seen in this country also provided it with the best example of late Egyptian portrait sculpture in America, if not the world.[1]

Edward Perry Warren was born in Waltham, Massachusetts, on June 8, 1860, the fifth child of Samuel Dennis Warren and Susan Cornelia Clarke Warren. The Warrens were an old New England family (they had come over from England in 1630 with Governor John Winthrop on the *Arabella*), but they were not merchant princes. Dennis Warren was a self-made man, a peddler's son from Grafton, Massachusetts, who came to Boston in 1832 to work for a paper-selling firm. He worked hard and became a partner. In 1854 he bought the Androscoggin Paper Mill at Westbrook, Maine (outside of Portland), renamed it the Cumberland Mills, and went into business on his own; within a short time, S. D. Warren and Company had become the most successful paper manufacturer of its day.[2] In 1863 the Warrens moved to 67 Mount Vernon Street, in the heart of Boston's Beacon Hill neighborhood. Edward Warren, known as Ned, grew up in this house with his older siblings Samuel Dennis II (Sam), Henry, and Cornelia, and his younger brother, Fiske.[3] All were to have interesting careers: Sam as the law partner of Louis Brandeis (the future Supreme Court justice) and president of the Museum of Fine Arts; Henry as a scholar of Pali and Sanskrit Buddhist texts; Susan as a philanthropist, particularly as a patron of women's and educational organizations; and Fiske as an agitator for, and practitioner of, radical and sometimes outlandish political and social causes such as anti-imperialism, vegetarianism, and nudism. But Ned stood out. As later

Left to right: John Marshall, Ned Warren, and an unidentified workman in the garden of Lewes House. Warren holds the Roman statue of Mercury he sent to the MFA in 1895.

biographers put it, he had the misfortune to be "born in the nineteenth century with a pre-Christian soul" and was therefore "bound to suffer."[4]

The Warren parents were early supporters of the Museum of Fine Arts.[5] In 1877, just one year after it opened, they gave the Museum a major canvas by Jean-François Millet, the *Young Shepherdess*.[6] Dennis Warren served as a trustee of the MFA from 1883 until his death in 1888. In collecting, however, Ned's mother took the lead, assembling a group of works that was called "one of the art wonders of Boston."[7] Her taste in paintings was not limited to contemporary French painters of the Barbizon School, such as Millet and Jean-Baptiste-Camille Corot, so much admired in Boston at that time.[8] In later years, she also collected Old Masters, many acquired with Ned's assistance while he was living in Europe. In fact, it was to Susan Cornelia Warren that the connoisseur and art advisor Bernard Berenson first offered Titian's celebrated *Europa* in 1894. Mrs. Warren did not act on his proposition, leaving the way open for the rival Boston collector Isabella Stewart Gardner, who snatched up the painting for $100,000; it is now the prize of Fenway Court.[9] Mrs. Warren was more fortunate a few years later with Filippino Lippi's tondo painting *Holy Family with John the Baptist and St. Margaret*, which Ned was able to acquire for her with Berenson's help.[10]

Young Ned grew up surrounded by paintings, porcelain, and bric-a-brac.[11] He loved his mother's china so much he would take his favorite pieces up to his room and hide them under the bed, where the maid would find them the next morning. He also had his own little collection of plates and cups that he bought himself, or which his mother bought for him, kept in a cabinet in his room; he would stay up past his bedtime arranging and rearranging them.[12] At school the other boys made fun of him, and when bullies pushed him around he did not fight back, but following Jesus's example turned the other cheek. For Ned was religious. His family were old-time New England Congregationalists, but Ned was early drawn to the Episcopal Church—partly for the aesthetic pleasures of the elaborate ritual and its trappings. At home he used to dress up as a

priest in a nightgown and, for a priest's stole, a broad pale-blue Japanese scarf embroidered with fans and read services to his mother.[13]

Ned hated arithmetic and preferred reading to sports. He loved music and learned to play the piano. Above all he loved Latin and Greek; he liked to roam about the country "anticking," as his family put it, dressed in a makeshift toga.[14] "In short," he sums up in an autobiographical fragment published as part of his biography, "I was a boy cloistered from the American world in a domestic museum on the top of Beacon Hill, yearning for those things of which I had inadequate evidence at home."[15]

Trips to Europe with his family in 1868, when Ned was eight years old, and again in 1873, opened up vistas of another, more beautiful world. At museums, while the rest of the family went to see the pictures, Ned preferred to remain alone in the galleries of sculpture or plaster casts. "My interest in the sculpture," he recalls, "was not wholly artistic. I cared mainly for the nude, male or female, the male as much as the female. . . . Of a piece with this was my desire to become a missionary. It was thought, I dare say, a very creditable ambition, but no one knew that I had chosen the career because the Indians wore no clothes."[16]

He carried around with him photographs of his favorite statues (all nudes, of course)—the *Venus de' Medici*, in the Uffizi Gallery in Florence, one of the most admired of all statues from antiquity, and the Neoclassical Venuses of Antonio Canova and Bertel Thorwaldsen—as well as a small silver replica of the *Venus de Milo*. Of male statues he liked best the *Hermes* in the Belvedere, in Rome; though, he confessed, the cast of the *Ludovisi Ares* in the Boston Athenaeum (whose original he would later try, unsuccessfully, to get for the MFA) produced in him "no small excitement," and he coveted a photo of Myron's *Discobolus* (*Discus Thrower*) that belonged to his Aunt Jenny.[17]

Ned had crushes on some of the boys at school. He watched them from a distance and wrote poems in their honor. One he compared to the Emperor Hadrian's beloved boyfriend Antinous, who drowned in the Nile.[18] Of another schoolmate he managed to procure a photograph,

which he kept among his most treasured possessions, along with some of the boy's Greek exercises salvaged from the wastebasket. Although Ned could not have been the only boy in Boston to have had such feelings for other boys, it is remarkable that many years later he saw fit to write them down for his official biographers.

Ned's photographs, his love of art, his spirituality, and his dislike of sports set him apart from most other boys, and, though he made no effort to blend in, he still longed for acceptance. At Harvard, which he entered in the fall of 1879, he suffered in comparison with his brother Sam, who excelled at sports and moved easily among the scions of old Boston families. Ned was all too conscious of not having been "born in the purple" and yearned to be admitted to the Porcellian Club, to which Sam had belonged—not for the company, for he cared for them not at all, he said, but as "a stamp of social correctness."

While at Harvard he dreaded the impending approach of what his mother called "real life," which for Ned meant a job working in his father's office at the Cumberland Mills, where he would have no more time to read.[19] He could not bear seeing his education come to an end and so postponed his fate by going to college a second time. In the fall of 1883 he entered New College, Oxford, as an undergraduate again, to study Classics. It was at Oxford, the college of Shelley and Swinburne, his favorite poets, and the home of the Aesthetic Movement, that Ned felt comfortable and accepted for the first time in his life: "I had come home; I had found people who did not damn my ideas as incorrect but, on the contrary, found them interesting; I was at one with others, and seemed to be patted on the back."[20] Already at Harvard he had experienced a sort of religious crisis touched off by the influence of his favorite poets. Though he still loved the beauty of the Christian service, particularly the singing at New College, he felt unable to pray. His former faith had died in him, and he was now an infidel: "Not for many years could I go . . . to church with pleasure and without disturbance, as I might sympathetically attend a sacrifice to Apollo."[21]

At the start of his third year at Oxford, in 1885, his eyesight, always weak, became so much worse that he was not even able to read. So instead of remaining at university, he and his childhood friend and fellow Oxford classics student William Amory Gardner (the nephew of Isabella Stewart Gardner, who had brought him up after his parents died), went off on a trip to Greece. They stayed in Athens and visited Mycenae, but the high point of their journey was an excursion to Delphi, as yet unexcavated. On their return through Boeotia they passed by Mount Helicon and the Valley of the Muses and drank from the Hippocrene spring, celebrated in Greek mythology as the source of poetic inspiration. Permessus, where the Muses bathed, and Thespiae, sacred to Eros, remained etched in Ned's memory. During the trip he collected Greek coins, which he studied with his friend: "We 'worshipped' them every night."[22] Greek coins, particularly well-preserved examples chosen for their beauty rather than for their historical importance, would become a Warren specialty. In Athens he purchased a terracotta statuette of a youth, probably Eros, descending through the air, which his father presented to the MFA the following year.[23] This was the beginning of Ned's collecting for the Museum.

Back in Oxford, his eyesight was still not good enough to allow him to study. In the summer of 1886, Ned's father, mother, and brother Sam came to visit. He allowed his parents to persuade him to come home for the winter, ostensibly to help his ailing father, but Ned was unhappy back in Boston and missed his Oxford companions. In February 1887 he wrote to his friend John Marshall: "My Neo-paganism seems here like a dream of the past. . . . Here with cold winds and snow, the traditions of Puritanism, the ugliness of the men and the absence of aesthetic sympathy, all Greece is frozen out."[24] Ned returned to New College in the fall of 1887, having spent the year in Boston and without taking his final exams. He was allowed to graduate with a pass degree, awarded when a student is unable to be present for examinations due to illness or other circumstances beyond his control.

Samuel Dennis Warren died in May 1888. Ned did not go home for the funeral, pleading illness; for now, he was happy to leave financial matters to his brother Sam. Ned's share of his father's inheritance and the profits from the Cumberland Mills assured him of a steady income. In 1890, he found the house of his dreams, "huge, old, and not cheap," as he described it to John Marshall, in the town of Lewes in East Sussex, near the coast of southeast England.[25] Within a short time he succeeded in attracting to Lewes House, as it was called, some half dozen like-minded homosexual or bisexual young men, mostly Oxford graduates, who lived completely off his largesse.[26] It was a group that only Warren could have put together. Its members' activities revolved around him: some helped with the collecting, others with running the household, and others were not much help at all.

Life at Lewes House was an odd combination of grandeur and monastic austerity.[27] The men dined at a richly carved oak Tudor table on pews salvaged from an old church in Lancashire. The setting lacked a tablecloth and seat cushions, let alone rugs or curtains, but the men ate and drank well from old silver and fine china. Art was everywhere, and not just antiquities. Filippino Lippi's *Holy Family with John the Baptist and St. Margaret* (inherited by Ned upon his mother's death in 1901), and Lucas Cranach's *Adam and Eve* hung in the dining room; an over-life-size marble version of Auguste Rodin's sculpture of a nude man and woman embracing, *The Kiss*, which Warren commissioned from the artist in 1900 (with special instructions to make the male genitals more explicit), stood in the coach house for years.[28]

The aesthetes spurned modern conveniences. Rooms were lit by candlelight, and only the halls and staircases had electric lighting. Warren kept a stable of fine Arabian horses, befitting a company of gentlemen, but few of the young men could ride well. According to John Fothergill, one of the few accomplished riders among them, it was a local industry in Lewes to catch and return strayed Lewes House horses.[29] Half a dozen St. Bernards, unfortunately not housebroken, had the run of the place.

Women were not welcome, except as servants. A few local residents gained entry, including household staff or the carpenter and stonemason who were always needed for repairs. But the house on the High Street in the center of town might as well have been on another planet, so little contact did the average Lewesian have with the "mad millionaire" and his brotherhood of aesthetes.[30]

Of all the Lewes House men, the closest to Warren was John Marshall. Like Warren an undergraduate at New College, the two met there in 1884. Ned was two years older. Like Warren, Marshall had been early drawn to the priesthood but ultimately sought salvation in classical antiquity. In 1889, after a long and elaborate courtship, Marshall accepted Warren's offer to live with him and be his secretary. In Marshall, Warren had found his soul mate. Ned and Johnnie looked alike, dressed alike, walked alike, and talked alike; in photographs they resemble Tweedledum and Tweedledee.

More important, it was in the male-dominated society of Classical Greece that Warren and Marshall found the paradigm for their relationship. They called it Pausanian love, or Uranian love, after Plato's dialogue *Symposium*. In this philosophical text, each of the guests at a symposium (an all-male dinner and drinking party) is called upon to deliver a speech in praise of love, personified as the god Eros. Pausanius, the third speaker, distinguishes two forms of love, corresponding to two forms of Aphrodite: Heavenly Love, born of Aphrodite Urania; and Common Love, born of Aphrodite Pandemos. Whereas Common Love includes love between men and women as well as between men and boys and is strictly physical, Heavenly Love is spiritual as well as physical and is confined to love between two men—ideally a mature man and a younger man or even a teenager, but not a boy. Heavenly Love is superior to Common Love because it is pure, not driven by lust: both partners enter into the relationship knowingly and discriminatingly.[31] This was not Plato's own vision of ideal love—that comes later in the dialogue—but its "eroto-educational" message clearly appealed to Warren and Marshall,

as well as others at the time (a cult of Uranism also existed in Germany, for instance). In Greek mythology, Aphrodite Urania was born of the foam that collected around the severed genitals of the sky god Uranus when his son Cronus cast them into the sea; thus she has a father but no mother and is totally male in origin. That made her the ideal patron of love between males.

For Warren, the Classical Greek ideals of beauty, nobility, and manliness were embodied in Classical Greek art. Greek art was a religion to Warren, and collecting Greek art for America, which for him meant Boston, became his mission. John Beazley, the great connoisseur of Greek vase painters and painting, who knew Warren well in later years, recorded his claim to be doing "the work most needed of all works, supplying eventually the terrible gap that exists in this new continent, the absence of that which delights the eye and rests the soul."[32]

He was a born collector with a great eye for quality as well as market value. Warren and Marshall made their first major foray into the art market in June 1892 at the Paris sale of the Belgian connoisseur Adolphe van Branteghem's collection of Greek vases. To the amazement of seasoned museum curators, collectors, and dealers, they made off with the cream of the crop, including a large drinking cup signed by the potter Euphronios, which Ned immediately placed on anonymous loan in the MFA.[33] These loans joined a group of vases, gold earrings, and pendants that Ned, who would not be identified except as "a Boston gentleman at present residing in Europe," had given the Museum in 1890.[34] Also in 1892 Ned's brother Sam was elected a trustee of the MFA. It was as if willed by the gods.

Until that time the Museum's collecting of classical antiquities had been largely confined to plaster casts of statues and reliefs. The founders were skeptical about the possibility of acquiring original works of art, which they assumed were either too rare or too expensive. Casts would have to do, and for teaching purposes, they would do just as well. The Museum did acquire some original works. In 1872, it purchased more

than five hundred Cypriote antiquities from Luigi Palma di Cesnola, at that time United States Consul in Cyprus and soon to become the first director of the Metropolitan Museum of Art in New York. In 1884, the MFA received from the Archaeological Institute of America a large share of the finds from the Institute's excavations at the ancient site of Assos on the Aegean coast of Turkey. These even included some monumental sculpture.[35] More archaeological material came in 1885 and afterward from the Egypt Exploration Fund's digs at the Greek trading post at Naukratis in the Nile Delta. But how could these fragments, important as they were from a historical point of view, compare in the minds of the trustees to life-size plaster casts of the greatest monuments of Greece and Rome: the marbles from the Parthenon, the Porch of the Maidens from the Erechtheum, and the most famous statues in Rome?[36] In 1886, J. Elliot Cabot summed up the opinion of the Committee on the Museum:

> Original works of art will generally be beyond our reach, or else of doubtful or inferior value; but through casts, we can acquaint ourselves with the best, the standard examples, in their most essential qualities. A collection of casts such as we have, at a very moderate cost, and without any danger of wasting our money through mistakes of judgment, would be in some respects of more value for study than any existing collection of originals; since there is none that affords the means of comparison which the student needs.[37]

Meanwhile in 1885 the MFA had hired its first professionally trained classical archaeologist. Edward Robinson (1858–1931) was a fine scholar who had studied in Berlin and excavated at Assos. In 1887 a separate department of classical antiquities was established, with Robinson as its first curator. Robinson loved casts and throughout his career believed in the importance of their role in the art museum. Yet still he yearned for originals. In his 1888 report he wrote:

So far as sculpture alone is concerned, we can hardly hope for any considerable collection of really fine Greek originals; and yet I need hardly remind you of the value which even one first rate specimen, if it were only a head or torso, would have for our Museum. It would fill a place which an entire collection of casts fills but imperfectly, both in attracting, interesting, and instructing the public, and as an inspiration for artists and students of art of our community.[38]

The opportunity for change came in the early 1890s when Sam Warren became a trustee and Ned began collecting in a big way. Sam pro-

Plaster casts of Greek and Roman sculpture displayed in the original Museum of Fine Arts on Copley Square.

vided the leadership; Ned, Johnnie, and Robinson the expertise. More important, funds from unrestricted bequests became available for the purchase of works of art.[39] In September 1894 Robinson paid his first visit to Lewes House. It was the start of a ten-year relationship between Warren and the Museum that "transformed the Classical Department from a great assembly of casts to a first-rate and highly varied collection of original works of art."[40]

Warren's first "sending" reached Boston in March 1895, comprising fifty-nine vases, eighty coins, ten gems, and various objects in gold, bronze, and marble. It was the first substantial group of Classical antiquities purchased by the Museum since the Cesnola collection in 1872 and far more important. Two sculptures—including the beautiful Mercury (Hermes)—arrived the following year.[41] The trustees were most interested in sculptures, but Warren was determined that the Museum should offer a broad selection: "This collection, to be intelligible, should contain, not sculpture only, but gems, vases, coins and good examples of all the minor arts. It does not provide exclusively for the demands of existing laymen; it rather supplies a field for thorough students of art."[42]

All said, the trustees must be congratulated for giving Warren such a free hand—not only going along with his ideas of what constituted a proper collection, but also tolerating subjects so often depicted in Greek art that might seem to have been deliberately chosen to challenge their Puritan sensibilities. His very first sending included an erotically charged cup painted by Douris with a winged Eros clasping a youth in embrace, their naked bodies quivering in air, as well as a cup by Nikosthenes with explicit depictions of youths and courtesans having sex.[43] Just think that the proposed gift, in 1896, for the courtyard of the Boston Public Library, of Frederick MacMonnies' fairly anodyne nude statue of *Bacchante and Infant Faun* caused a scandal.[44] Even Charles Eliot Norton, Harvard's— and America's—first professor of art history, founder of the Archaeological Institute of America, and an advocate for Warren among the MFA trustees—sided with the philistines, commenting in the press that the

Museum might be a more suitable place for the statue.[45] The sculpture was decried as a "menace to the Commonwealth," and the reaction to it on the part of certain members of the clergy threatened a backlash against "the intolerable indecencies of the antique in the Art Museum."[46] In the Museum, of course, the offensive parts of vase decorations could be painted out (fortunately with easily removed water-soluble paint), and the statues adorned with fig leaves. Nonetheless, Warren's gifts, subversive as they were, did find a home. He once stated: "I have always said and believed, that it was hate of Boston that made me work for Boston. The collection was my plea against that in Boston which contradicted my (pagan) love."[47]

For five years all went smoothly, until the Museum's attention and funds were diverted to the project of constructing a new building and relocating to the Fenway. By this time, Warren and Marshall had cornered the market in classical antiquities: the British Museum, Berlin, the Louvre could not compete against him. As Ned saw it, "Building could be done at any time; but his organization, allowed to decline, could not be reconstructed, and the market, once lost, could never be recovered."[48] Sam was on the Building Committee, and naturally Ned held that against him, even more so after Sam went on to be elected President of the Museum in 1901. Francis Bartlett's generous donation of $100,000 expressly for the purchase of classical antiquities provided a reprieve. The Bartlett Collection, which came in 1903, was recognized as "the largest and most valuable gift of works of art which the Museum has yet received." It consisted of almost 300 pieces, among them 20 marbles, 66 vases, 60 fragments of vases, 39 terracottas, 20 bronzes, 62 coins, 13 gems, and 8 objects of gold and silver.[49] The undisputed pride of the collection was the beautiful marble Head of Aphrodite or "Bartlett Head."

The Bartlett Collection was such a success that the trustees appropriated funds for another sending from Warren in 1904. This included an exceptionally fine marble head of Homer, a rare terracotta coffin from Klazomenae, and—most valuable of all—more than thirteen hundred

Greek coins from a famous English collection. But Sam Warren made it absolutely clear that this accession would be the last:

> The purchases of classical antiquities, begun in the year 1895, have come to an end. . . . A collection of works of classical art has been made which serves worthily to illustrate the expression in art of the Hellenic genius. . . . To amass a series of works in marble, bronze, terra-cotta, and precious metals equal to that in our possession has required, on the part of the collectors, the expenditure of such an amount of time, money, and patience directed by great knowledge, that it is difficult to believe the happy combination could ever exist or recur.[50]

In 1905 Robinson, who had become the MFA's second director, departed to lead the Metropolitan Museum of Art in New York. John

This drinking cup by the great Athenian vase painter Douris epitomizes Warren's taste for erotically charged subjects.

Marshall left Lewes House to become an agent for the Met as well. And then in 1906, Marshall married, of all people, Warren's cousin Mary Bliss. "Poor Ned!" exclaimed Bernard Berenson to Isabella Stewart Gardner, summing up the feelings of many who knew him.[51] But Warren took it well. It was part and parcel of his philosophy of Uranian love that the senior partner in the relationship should help the junior if the latter wished to marry, as he almost inevitably would. Warren even settled an income on Marshall, to supplement his meager salary.[52] Ned and Johnnie continued to work together; now Robinson could boast that he had transferred to the Met "the men and methods by which the collection of Greek and Roman antiquities in the Boston Museum of Fine Arts had been so successfully built up."[53] During those years between 1894 and 1904, Warren had achieved something remarkable, nothing less than a revolution: he implanted in Boston a taste for classical art, based on original works rather than reproductions.

The Green Head came with that last great sending of 1904. In his annual report, Albert M. Lythgoe, the curator of Egyptian art, lists among the year's acquisitions: "Head, of green basalt, 26th dynasty. An example of the finest work of this period."[54] Warren, usually good with provenance, gave no indication of where or when he acquired the head. Where it was for the past thirty-six years we may never know. It is exactly the sort of object to appeal to a collector of refined taste, one interested not only in Egyptian art—a Charles Lang Freer, a Calouste Gulbenkian, a Henry Walters—and perhaps someone whose primary interest lay in other areas. As we know from the memoirs of Arsène Houssaye, a group of Prince Napoleon's friends got together to buy the Pompeian House and its contents in 1866.[55] Before this sale, the prince had given Houssaye a limestone sphinx (possibly from the Serapeum), which Houssaye still had twenty-five years later when he was writing his memoirs. Could the Green Head have passed to another one of the prince's friends?

Whatever its path to Warren's hands, presumably the head had spent some time at Lewes House, where the monastic all-male environment

would have been a big change from the Parisian gaiety of the Prince's Pompeian House. Each setting had its farcical elements. If life with Plon-Plon was an Offenbach *opéra-bouffe*, existence among the aesthetes was a Gilbert and Sullivan operetta. If only we knew half of what the old priest saw in such surroundings!

The Green Head arrived in Boston without any context: Warren's sending list says only "Small head of an old man, smooth face." There is no mention of Prince Napoleon, let alone of Mariette or the Serapeum. Its past had been forgotten. When the Green Head appeared in Richard Delbrück's 1912 study *Antike Porträts* (Ancient Portraits), its provenance was stated only as acquired "in the trade."[56] That takes us back no further than Warren. It was not until 1960, when the head appeared in Bernard V. Bothmer's epoch-making catalogue *Egyptian Sculpture in the Late Period*, that the connection with Prince Napoleon, Mariette, and the Serapeum was reestablished.[57]

So what is it about the Green Head that makes it so compelling? Even today, most viewers' first reaction to the Green Head is that it does not look Egyptian. Of course there is no doubt that it is: the remains of a back pillar—a feature unique to Egyptian sculpture—with a hieroglyphic inscription gives it away. Like the *Seated Scribe* and the *Sheikh el-Beled*, it appealed to scholars and connoisseurs who did not fully understand Egyptian art on its own terms. Instead they singled out those pieces that seem to embody the qualities they admire in Greek art, the most admirable art.

So well does the head stand alone as a portrait, it is easy to forget that it once had a body. If the statue had been preserved complete, it would have met with a different reaction, as it would have followed all the rules of Egyptian sculpture in stone: the stance rigidly frontal, the extended limbs connected to the body by a web of stone (intended to be read as negative space), and an inscribed pillar running down the figure's back. Moreover, whereas the *Seated Scribe* and the *Sheikh el-Beled* have realistic bodies as well as heads, our priest probably did not. The Green

Head likely belonged to a striding or kneeling figure holding a *naos*, or shrine, containing the image of a deity—one of the most common types of Egyptian statue in the Late Period. An excellent example, complete except for the feet and base, is a striding statue in the British Museum inscribed on the back pillar for the priest Sematawy.[58] It represents an elderly man with shaven head and strongly individualized, realistically carved facial features: furrowed brow, deep-set eyes, sunken cheeks, prominent cheekbones, and deep lines from the nose to the lips. Not only is the head disproportionately large, so different is the treatment of head and body they might belong to different sculptures. Whereas the head is skillfully modeled to reveal every nuance of the underlying bony structure of the skull, Sematawy's ankle-length wraparound skirt completely masks the contours of his body. A superbly delineated head has been set on top of a chunky, nondescript lump.

This typical discrepancy between body and head was jarring to early connoisseurs. Even someone as knowledgeable about Egyptian art as Gaston Maspero (1846–1916), Mariette's successor as director of antiquities in Egypt, could write:

> Our museums contain examples of these disconcerting statues, in which the feebleness of the body is in such striking contrast to the truth of the face. The wrinkles of the forehead are emphasised with scrupulous insistence, the sunken eyes and the crows' feet at the corners, the muscles which encircle the nostrils, the laughing lines of the mouth. . . . [It] is the unflattered portrait of a Memphite citizen, whose ugliness has been transferred to green schist or serpentine with the mechanical precision of a photographic plate. The skull of the shaven priest . . . is as minutely modelled as if the sculptor had been commissioned to make an anatomical model for a medical school; it shows every bump, every depression, all the asymmetries, and a doctor could tell at a glance if there were congenital defects in the original.[59]

When complete, the Green Head may have had a body such as this statue of the priest Sematawy holding a *naos*, or shrine.

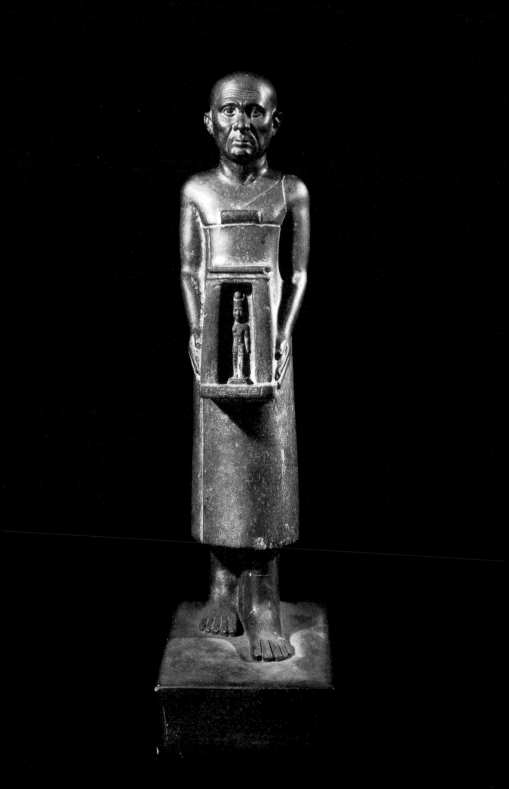

Maspero is describing the Cairo Museum's kneeling statue of Psam-tiksaneith, but he might as well be talking about the Boston Green Head.[60] It is easy to see why classically oriented collectors like Warren, accustomed to Roman portraits, were drawn to realistically sculpted Egyptian heads like these. But it was only the heads that they valued; they thought the roughly modeled bodies detracted from the classical quality of the heads. In some cases the heads were even broken off in modern times to make them more saleable, causing the irretrievable loss of information about the sculptures' origins and dates.[61] From the collec-tors' point of view, these heads were well rid of their bodies.

The same Eurocentric bias leading to what we now consider cultural vandalism is evident in the early reception and treatment of the so-called Faiyum portraits. These are painted wooden panels inserted into the wrappings of Egyptian mummies of the Roman Period (1st–4th cen-turies AD) in place of the traditional three-dimensional face mask. They are prized as the only painted portraits of individuals in the Hellenis-tic Greek style to have survived from antiquity.[62] In 1887, the Viennese antiquities dealer Theodor Graf acquired some three hundred painted portraits, ripped from their mummies, from the site of el-Rubayat in the Faiyum, a large oasis southwest of Cairo. He put together for sale an exhibition of ninety-six of the portraits, which traveled all over Europe and North America, notably to the 1893 World's Columbian Exhibition in Chicago, where they were displayed incongruously in the Town Hall of the Old Vienna grounds.[63] A shrewd marketer, Graf knew better than to advertise his wares as Egyptian mummy portraits; instead, he called them Greek portraits of the Hellenistic Period. General Charles Greeley Loring, the first director of the MFA, had been interested in acquiring one of Graf's portraits for some time. On October 17, 1893, the trustees allocated one thousand dollars for the purchase of one or two of the less expensive portraits. Rather than send Loring to Chicago, they asked Graf to bring the whole collection to the MFA after the fair closed.[64] Loring was able to acquire for eleven hundred dollars two examples—one of

a man, one of a woman, the latter particularly haunting.[65] These portraits were the first Egyptian antiquities acquired by the MFA through purchase rather than as gifts. Tellingly, they are not the sort of thing we normally associate with Egyptian art.

The portraits would have been received very differently if they had been still attached to their mummies. A mummy of a boy, from Hawara in the Faiyum, acquired by the Museum in 1911, is a fine example of a complete portrait mummy.[66] The mummy is elaborately wrapped in layers of linen bandages decorated with gilded stucco studs. The portrait is placed over the head, with the edges of the panel inserted into the bandages. The wrapped feet of the mummy are enclosed in cartonnage (a material resembling papier-mâché), modeled in relief with the sandaled feet of the deceased, painted pink with gilded toes, resting on a checkered floor. The resulting ensemble of painted portrait, linen bandages, and cartonnage foot case has been called "a spectacle of ugliness, mediocrity, and incongruity."[67] The Roman portrait mummy is a monstrosity; we might as well be looking at a jackal-headed Anubis or an ibis-headed Thoth. How much more preferable the portrait of the boy alone, so touching, so lifelike, so familiar—so Western. Indeed, Roman mummy portraits have always been popular with collectors not otherwise interested in or attracted to Egyptian art. In a museum setting, removed from their bandages, mounted and framed and hung on the wall, "Faiyum portraits" are as likely to appear in a classical gallery as in an Egyptian gallery.[68]

It's the same with the Green Head. Even today, it is worth asking whether we would like the Green Head so much if it were still joined to its body. Ironically, the very aspects that made the Green Head so appealing as a work of art have interfered with modern-day viewers' ability to look at it objectively and scientifically, to date it, and to place it in its proper context.

In 1904, when the Green Head was acquired, the Museum did not yet possess any of the objects for which it is most famous today, the Old

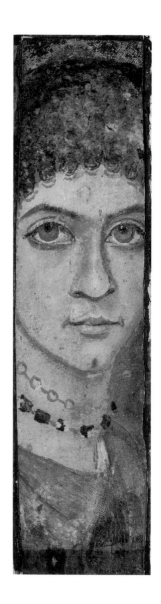

The combination of classical-style painted portraits and Egyptian wrapped mummies was distasteful to many collectors, who preferred to view the portraits alone.

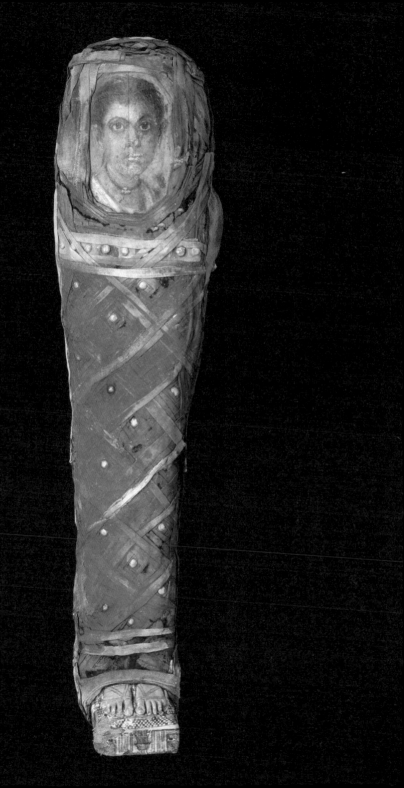

Kingdom masterpieces discovered by the pioneering American archaeologist George Andrew Reisner at Giza, but it already had the largest and most important collection of Egyptian art in America.[69] Just two years after the Museum was founded, the fledgling institution had received as its first major gift of art some forty-five hundred Egyptian antiquities, mainly objects of daily life and funerary objects, including seven mummies, which had been collected in Egypt in the 1820s and 1830s by the Scottish nobleman Robert Hay. In 1875 the Museum received a group of monumental sculptures that included two obelisk fragments, two statues of the lioness-headed goddess Sekhmet, and a colossal head of Ramesses III.[70]

Eager to augment its Egyptian collection with genuine and well-provenanced antiquities, the trustees turned to the London-based Egypt

The Egyptian galleries in the original MFA building were jam-packed from floor to ceiling with antiquities.

Exploration Fund, founded in 1882 to support archaeological work in Egypt. An American Branch opened in Boston in 1884.[71] Because the majority of subscribers were New Englanders, Boston received the largest share of the finds sent to America in return for their contributions. The distribution of the finds followed a certain pattern: "The Keeper of the Egyptian Department of the British Museum preferred monuments calculated to throw additional light upon the philology and history of Ancient Egypt, whereas objects of artistic interest were preferred by the trustees and Director of the Museum of Fine Arts at Boston."[72]

In 1889 the funds raised by the American branch equaled the amount raised in Britain, and the MFA received its most impressive donation yet. Boston's share of the finds from Bubastis in the Nile Delta included the great Hathor-head capital, the papyrus-bundle column, and the upper part of a colossal statue of Ramesses II, all of monumental red granite.[73] Photographs of the old Copley Square building show the Egyptian galleries jam-packed with these and other antiquities. Albert M. Lythgoe, who had been hired in 1902 as the first curator of Egyptian art, set about methodically filling gaps in the Egyptian collection; among his more important acquisitions were two complete Old Kingdom mastaba chapels from Saqqara, which the Egyptian government was selling off in order to preserve them.[74] In addition he secured several important objects from the excavations of Theodore M. Davis in the Valley of the Kings.[75] In 1903, Davis presented a selection of objects from the tomb of Thutmose IV; in 1904 he gave the sarcophagus of Thutmose I, the only Eighteenth Dynasty royal sarcophagus ever sent out of Egypt. Although Late Period sculpture was not on Lythgoe's wish list, he could not possibly have done any better than the Green Head.

THE PRIEST

"Elsewhere, priests of the gods wear their hair long, but in Egypt they shave their heads."[1] So Herodotus, who visited Egypt in the mid-fifth century BC, in a famous passage in which he lists the ways the manners and customs of the Egyptians are different from those of all other people: women urinate standing up, men sitting down; women go out to market and do the selling, men stay home and do the weaving; men carry loads on their heads, women on their shoulders; whereas other people cut their hair as a sign of mourning, Egyptians let theirs grow out; they practice circumcision; they write from right to left, and so on.

For Herodotus, the Egyptians were the most pious of all peoples, and he reports that the clerics followed elaborate rules:

Their priests shave their entire bodies every other day to prevent lice or any other vermin from hiding on their bodies as they worship the gods.

Their priests wear only linen garments and sandals made of papyrus; they are not permitted to acquire any other kinds of garments or sandals. They bathe with cold water twice daily and twice nightly, and they must perform an incredible number of religious observances. They do, however, receive a considerable number of benefits. For example, they don't have to pay anything of their own for their living expenses. Their food, which is considered sacred, is cooked for them, and each one of them receives a generous allowance of beef and goose meat every day; they are also provided with wine made from grapes. Fish, however, they are not even permitted to taste. . . . The priests, who believe [beans] to be unclean, cannot even endure the sight of them. Many priests serve each of the gods, although there is a chief priest for each deity, whose son succeeds them in that office when he dies.[2]

In this late-fourth-century BC temple relief, shaven-headed priests in long garments shoulder poles for carrying the portable boat containing the sacred image of the god in procession.

The life of an ancient Egyptian priest was very different not only from the Greek practices familiar to Herodotus but also from how we may think a priest performs today.[3] In theory, the king of Egypt was the chief priest of every god. Scenes on temple walls always show the king alone presenting incense, food and drink, clothing, jewelry, and other items to the gods. By offering to the gods, the king upheld the order of the universe established at the dawn of creation. In practice, of course, even the divine pharaoh could not be in all places at once, so priests substituted for him in the local temples. There were many classes of priest in ancient Egypt. The most common were called *hemu-netjer*— literally "god's servants," usually translated as "prophets"—and *wabu*, "pure ones." An ancient Egyptian temple was literally the god's house (in Egyptian, *hut-netjer*). The deity, incarnate in a cult statue made of precious metal, rested in the furthermost recess of the temple, concealed within a *naos* (shrine) with wooden doors bolted shut.

Every morning the priests entered the holy of holies to perform the god's daily ritual, waiting on the divine image like privileged courtiers at the levee of a king. First they burned incense and sprinkled water and natron to purify the room. Then, to the accompaniment of hymns and prayers, they opened the doors of the shrine, served the god his meal, washed him, and changed his clothes. Finally, they closed up the shrine until the next morning. On holidays the priests placed the statue in a portable boat and carried it on their shoulders in stately procession through the courtyards and colonnades of the temple and out into the streets. Even then the divine statue remained hidden from view in his shrine, which was further draped, like the priests themselves, in white cloth, so the people never saw the sacred image. Only the priests (and the king) ever had direct contact with the deity, only they had access to his private chamber. Small wonder then that Egyptian priests were credited with secret knowledge and special wisdom.

Most priests served for only part of the year, typically one month out of every four. It was only then, when they were "on duty," that they had

to shave their heads and observe the other rules of ritual purity. The high priests served year-round, and those of the most ancient cults had special titles: the high priest of Ptah in Memphis was the "greatest of directors of craftsmen," the high priest of Ra in Heliopolis was the "greatest of seers," and the high priest of Thoth in Hermopolis was the "greatest of the five." The high priest of Amen in Thebes (a relative newcomer) was simply called the "first prophet of Amen."

Who then was our priest, and when did he live? Over the past century, a number of scholars have attempted to answer those questions.

When the Green Head was published in the very first MFA *Handbook* in 1907, it was dated to the Saite Period, that is, the seventh to sixth centuries BC. Scholars of the time recognized as one of the hallmarks of Late Period style "a realism which flinches at nothing," which the Green Head appeared to epitomize:

> The masters of [this period] set themselves, in sculpture, to produce, as it were, a photograph in the round. To what an astounding degree they met with success is seen in [the Boston Green Head]. The traces which care, intrigue, and the performance of severe religious duties have left in his face, are all faithfully rendered. The sculptor will not even omit the crow's feet, or the wen below the left eye, and he truthfully reproduces the rather ugly ears. The piece is ruthless in its fidelity.[4]

The Green Head reached an international audience when it appeared in the German archaeologist Richard Delbrück's 1912 monograph on ancient portraits. There, for the first time, it was illustrated alongside another, better-known green head, acquired by the Berlin Egyptian Museum in 1895.[5] Since then the two heads have been inseparable; to mention one is to conjure up the other—at least for art historians. At eight-and-a-quarter inches (twenty centimeters) high, practically life size, the Berlin Green Head is twice as large as the Boston example. All that is

known of its origin or history is that by 1887 it was in the collection of Prince Ibrahim Hilmy (the son of Ismail Pasha) in Cairo.

For Delbrück, the Berlin and Boston heads represented "the highest point of the Egyptian art of portraiture."[6] He was unaware of the Boston head's connection with Mariette, Prince Napoleon, and the Serapeum—as were the MFA's curators at the time. Delbrück observed that both pieces might even have originated in the same ancient sanctuary, so similar did they appear to him.[7] In the absence of direct evidence by findspot or inscription, he had to fall back on dating them by style. He considered two possible dates: if they were Saite (7th–6th centuries BC), their style would be a direct outgrowth of the naturalism shown in other strikingly individualized portraits from the period.[8] If early Ptolemaic (4th century BC), the style would show the influence of Greek sculpture. But Delbrück, a classical art historian, could not think of a stylistically similar sculpture from the Greek world, and therefore opted provisionally for the earlier date.[9]

Although the Green Head was recognized early on as one of Boston's greatest treasures, appearing regularly in successive editions of the Museum *Handbook*, it had to wait until 1937 to be published in an article in the MFA *Bulletin*, by Dows Dunham. It was paired with a newly acquired granodiorite head of a man in a bag wig—another beautifully carved, extraordinarily sensitive portrait, more subdued than the Green Head, whose date has occasioned almost as much discussion as that of the Green Head.[10] In this article, Dunham dated both pieces "Saite to Ptolemaic."

One of the few scholars in the 1930s and 1940s who could distinguish between the work of the Saite Dynasty and what came afterward was William Stevenson Smith (1907–1969), whose career at the MFA began in 1928 and lasted forty years. Smith first joined the Department of Egyptian Art fresh out of Harvard in 1928 as a volunteer assistant. In 1930 he went to Egypt to join the Harvard-Boston Expedition, becoming Reisner's chief assistant in 1933. Smith was more interested in history and art history, however, than archeological fieldwork, and with Reisner's

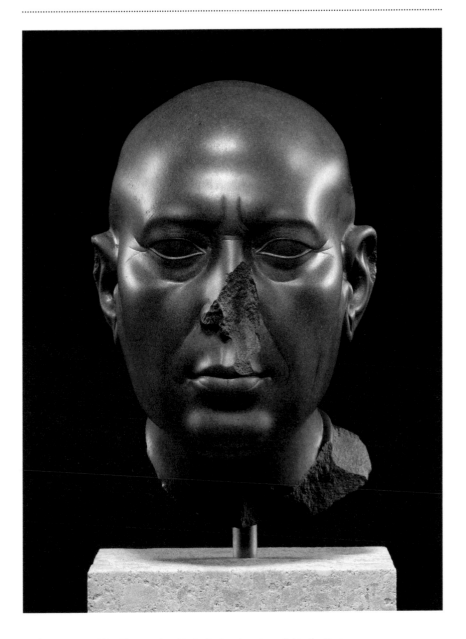

Art historians consider this green head in Berlin the closest parallel to the Boston Green Head.

encouragement, he undertook the study of the sculptures and wall decoration unearthed by the Harvard-Boston Expedition at Giza, which culminated in his magisterial *History of Egyptian Sculpture and Painting in the Old Kingdom*.[11] In his 1942 volume on *Ancient Egypt as Represented in the Museum of Fine Arts, Boston*, he refers to "the remarkable green head of a man" as "one of a limited number of pieces the date of which has been much disputed." Although the Green Head demonstrates the realistic strain in portraiture to be seen in Saite portraits, it is probably later, "possibly falling into that time of Egyptian independence from the Persians which did not long precede the conquest of Alexander"—that is, 404–348 BC.[12]

When he wrote about the head in the *Bulletin* that same year, Smith dated both it and the Berlin head to around 400 BC. He compares them to a group of tomb reliefs in Alexandria and Cairo, showing the deceased before a procession of offering bearers or a group of musicians, where he detects, for the first time in Egyptian sculpture, a hint of Greek influence in the modeling of the figures and treatment of the drapery.[13] Smith—who published the Fourth Dynasty bust of Prince Ankhhaf, the most naturalistic of all Egyptian sculptures—knew that there were earlier precedents for realistic portraiture in Egyptian art as far back as the Pyramid Age, yet it seemed to him that in their approach to form, the Boston and Berlin green heads demonstrated an awareness of Greek art of the fifth and fourth centuries BC.[14] By 1958, when his volume in the Pelican History of Art series was published, his thinking had matured. There he dated the Boston head to the early fourth century BC.[15] As for the Berlin head, the more he thought about it, the more he felt that it had "advanced further in the direction of a new plastic treatment."[16]

Of those who cared for and studied the Boston Green Head, no one loved it more than Bernard V. Bothmer (1912–1993). Born in Berlin, Bothmer worked in the Egyptian Museum there until his ardent anti-Nazism compelled him to leave Germany in 1938. After serving in the United States Army during World War II, he joined the staff of the Egyptian

department at the MFA, where he remained for ten years before moving to the Brooklyn Museum.[17] Bothmer was one of the most influential scholars of his generation. His main interest was in Egyptian sculpture, particularly of the Late Period. In Brooklyn, he was primarily responsible for a groundbreaking 1960 exhibition on Late Egyptian sculpture that was, amazingly, the first international show of Egyptian art presented in the United States.[18] It was there that the Boston and Berlin green heads were exhibited together for the first time in modern history.[19]

Bothmer knew both heads intimately, and much as he admired the Berlin head, wrote that the Boston head was even better, "a jewel the like of which exists in no other collection":

It is no exaggeration to say that nowhere else have bone and skin been so sensitively handled in an Egyptian portrait. For this is a portrait—the portrait of the Late Period. The sculptor who made it was not interested in idealizing his subject, not concerned with giving him an appearance of youth and beauty and a bland smile. On the contrary, he portrayed faithfully the cool, calculating eyes, the large, prominent nose, the harsh mouth, even the blemish of the skin, with an almost cruel accuracy. He has made known to us a canny and probably cunning old priest of the Memphite Ptah, who has kept his name and his secrets from us, yet reveals in his face more than he can hide.[20]

In the exhibition and its catalogue, Bothmer laid out the criteria wherewith to differentiate between the sculpture of Dynasty 26 (the Saite Period) and Dynasty 30 (the reign of Nectanebo), but he did not assign either head to Dynasty 30. Instead he dated both to the Ptolemaic Dynasty: the Boston Head to the middle of the Ptolemaic Dynasty, about 220–180 BC, and the Berlin Head to about 100–50 BC, toward the end of the Ptolemaic Dynasty. In the case of the Boston Green Head, he cites the shape of the back pillar and the spacing of the hieroglyphic signs in the inscription, but one suspects he had further reasons for his proposed

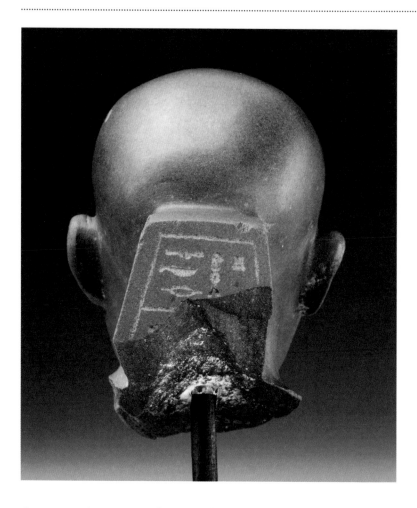

date. For Bothmer saw in the style of these realistic Late Egyptian heads the precursor of portraits of noble Romans that began to appear in the late Republican period, perhaps as early as the second century BC but mainly in the first century, and that are noted for their brutal realism. Physical peculiarities, abnormalities even, are not only faithfully reproduced but dwelled upon. Unusual head shapes of bald or shaven-headed

The remaining inscription on the Green Head's back pillar.

men regularly appear. A fine example is a marble head of an old man in Boston, incidentally also a Warren acquisition.[21]

We have already seen how classically oriented collectors of the nineteenth and twentieth centuries—like Ned Warren—were drawn to Late Egyptian portraits precisely because they looked so Roman, and the terms in which they were described—"a realism that flinches

Some scholars see a relationship between Roman Republican portraits of bald men such as this one and Late Period Egyptian portraits.

at nothing," "ruthless in its fidelity," "almost brutal frankness of treat-
ment"—could perfectly well be applied to Roman Republican portraits.
But where others saw a resemblance, Bothmer saw a causal connection.
For the green heads to have been the precursors of Roman Republican
portraits, they simply could not be as early as the seventh, sixth, or even
the fourth centuries BC; they had to date to the Hellenistic Period—that
is, to the third to first centuries BC.

As for the Berlin Green Head, Bothmer compared it not just to
Roman portraits in general, but to a specific example: a bust of Julius
Caesar, carved of Egyptian graywacke with inlaid marble eyes, in the
Collection of Classical Antiquities in Berlin.[22] That the first head faces
front and was broken off from a complete figure with back pillar, while
the other was made as a bust with the head turned to the side, is beside
the point. The two portraits, in Bothmer's opinion, have so much in com-
mon that they could very well have been made in the same workshop:
"a close comparison shows that the tradition which found expression
in the 'Green Head' was still alive when the bust of the conqueror was
modeled."[23] Bothmer dated the Berlin "Green Caesar" to its subject's life-
time—probably around 48 BC, when Caesar landed in Egypt in pursuit of
his rival Pompey and famously stayed to support Cleopatra against her
brother Ptolemy XIII. That meant the Berlin Green Head could not be
much earlier, so he dated it to the time of Ptolemies X to XII (107–51 BC).

Bothmer was fascinated by the idea of a connection between Egyptian
and Roman realistic portraits, and remained fascinated with it throughout
his career.[24] Today's scholars, who mostly have not followed his lead, place
the Berlin Green Caesar later, about AD 1–50. In any case, the perceived
relationship between Roman Republican portraits and the Green Head
affected, and continues to affect, how it is appreciated and understood.[25]

The Boston and Berlin green heads appeared together once again in
1988, again in Brooklyn, in the traveling exhibition *Cleopatra's Egypt: Age
of the Ptolemies*, the brainchild of Robert S. Bianchi, a student of Both-
mer's. Essentially following Bothmer, Bianchi dated the Boston head to

The Berlin Green Caesar.

..

the second century BC and the Berlin head to the first century BC. But his reason for doing so has nothing to do with Roman art. For Bianchi, the two heads merely represent successive stages in the development (a purely internal, Egyptian development, mind you) of so-called non-idealizing images from a more plastic type in the third century BC to a more linear type in the late first century BC to early first century AD.[26] Yet it struck many who saw them together in Brooklyn, Detroit, or Munich, that the two heads could not have been created a hundred years apart. While not questioning the Ptolemaic date, one scholar felt certain that "one master carved both, since the approach to the masses and the tool-working of surface details are identical on the two heads."[27] Since this exhibition, some connoisseurs of Late Period sculpture have revived the idea of a fourth-century date for both the Boston and Berlin heads, while others have stuck by the Ptolemaic dates proposed by Bothmer and Bianchi.[28] Currently the MFA dates its head to Dynasty 30, 380–332 BC, and the Berlin Egyptian Museum dates its head to about 400–350 BC.[29]

Leaving aside these two recurring stylistic comparisons, there is another line of questioning that might reveal the Green Head's origins. In all the scholarly back-and-forth about the date, the account of where the head was found has received surprisingly little attention—yet it is the one piece of evidence that might provide a solid lead and that does not rely solely on stylistic analysis. In his 1859 article on Prince Napoleon's collection, Ferri Pisani twice states that the head was found with a hoard of bronze statuettes in the foundations of the funerary chapel of an Apis built by Apries at the Serapeum of Memphis. Although Bothmer relished the head's connections with Mariette and Prince Napoleon, he was frankly dismissive of the author of this account: "Though [Ferri Pisani] claims to base his accounts on notes furnished by Mariette when the collection was presented to the Prince, his statements are so obviously based in many instances on—to say the least—a misunderstanding of whatever Mariette meant to convey that, to verify them, it would be necessary to consult Mariette's original notes, which are said to have been

preserved in the archives of the Bonaparte family."[30] Even if Mariette's notes came to light, we might not find there what we were looking for. Mariette was not a careful excavator, even by 1850s standards. His early excavations at the Serapeum were hampered by the need to conceal the scope of his activities from the Egyptian authorities. Later on, as director of antiquities, he was compelled to spread himself thin, working too quickly at too many sites simultaneously. Other contemporary excavators, such as Alexander Rhind at Thebes, worked more methodically and recorded more thoroughly.[31] Like modern archaeologists, Rhind advised doing only what one could do well in a given situation:

If the means be limited, so likewise shall be the field of operation. Instead of a government issuing what may be called letters of marque for a buccaneering raid over a whole country or a whole site, merely to collect . . . the largest number of trophies . . . it would be more to the purpose that when the sum to be expended is decided, such elucidatory work should alone be marked out, within however narrow a compass, as could be accomplished for it thoroughly and well.[32]

But that was not Mariette's way. He never did fully publish his work at the Serapeum. He was always racing against time, afraid that at any moment the pasha would withdraw his support. So it is understandable that Mariette did not always know how to interpret correctly what he found. And in the case of the discovery of the Green Head, we have to rely on a secondhand account by Ferri Pisani. If we conclude from this testimony that the head dates to the time of Apries, then we might indeed dismiss it out of hand. But is that the only possible interpretation, or does this at first glance implausible narrative lead us to a plausible reconstruction of the Green Head's source?

Let us suppose the head was found at the Serapeum—not in the tomb chapel of an Apis bull, but in a cache, perhaps under the dromos or beneath a pylon or mud-brick enclosure wall. Let us suppose it was in a

mixed deposit containing not only fragments of stone sculpture but also bronze statuettes and cult objects, and that one or more of the objects were inscribed with the name of Apries. This is not so farfetched. At least one bronze statuette discovered by Mariette at the Serapeum bears the ruler's cartouche.[33] Mariette might well therefore have assumed that all of the objects dated to the time of Apries. Let us suppose that the statue to which the head belonged was originally set up not in the Serapeum but in one of the sanctuaries of central Memphis. (Although it could have been a tomb statue, perhaps from one of the tombs laid bare by Mariette along the Serapeum Way, it was more likely a temple statue, which far outnumber tomb statues in the Late Period.) Let us further suppose that the temple in which our priest's statue stood was looted by the Persians in 343 BC, at which time the statue was broken. The Greek historian Diodorus Siculus tells us that after the conquest of Egypt, the Persians demolished the walls of the most important cities and plundered their shrines.[34] The temples themselves bear witness to this, both at the Serapeum proper, where the reconstruction work of the early Ptolemies suggests that the buildings of the Nectanebos had been defaced, and at the Sacred Animal Necropolis at North Saqqara, where a cache of broken and burned statues of various dates (but none later than Dynasty 30) was found buried beneath a pavement of Ptolemaic date.[35] On the basis of that analogy, therefore, let us suppose that the head, salvaged by the priests, was buried in the sacred precinct of the Serapeum with a group of bronzes as a pious gesture during the restoration work that followed the ouster of the Persians by Alexander the Great.

That is a lot to suppose, but it agrees with the historical record as well as the archeological evidence from the Sacred Animal Necropolis, a site analogous in every way to the Serapeum. It also happens to agree with the date proposed for our priest on stylistic grounds—in the short period of independence, corresponding to Dynasties 28–30 (404–363 BC), between the two Persian occupations—while allowing us to distill a ker-

nel of truth from the only account of the Green Head's discovery that has come down to us.

Assuming, then, that our priest lived in the fourth century BC, what can we say about him? That he was probably a citizen of Memphis, attached to one of the gods of that great city, perhaps even the High Priest of Ptah himself.

If only the statue were complete. At the very least, the back pillar inscription would have told his name and titles, and perhaps much more. The statue of the chief physician Udjahorresne in the Vatican presents a case opposite to that of our priest: a body without a head, it is rich in information about the man it portrayed.[36] Masterfully carved from the same greenish graywacke, the subject strides left foot forward, wearing a long-sleeved jacket under an ankle-length, wraparound skirt, holding a *naos* with a figure of Osiris. When the piece was discovered in the seventeenth century, it was mistaken for a female figure, and as at that time headless statues were routinely restored, it was fitted with a woman's head with corkscrew curls.[37] Sometime afterward, that fixture was replaced with a more Egyptian-looking, male head, which has now also been removed. But as though in compensation for the loss of his features, the skirt, back pillar, *naos*, and base of the statue are covered with inscriptions, which not only give the subject's name and titles but also are a mine of information regarding his life and times.[38]

Udjahorresne had been Admiral of the Fleet under earlier rulers, but it was as chief physician that he entered the service of the Persian King Cambyses, who conquered Egypt in 525 BC. He advised the Great King on his choice of an Egyptian name as pharaoh: the result, Mesutyra, "offspring of (the sun-god) Ra," could hardly have been more appropriate, for despite the horrible stories that later sprang up about him Cambyses was eager to present himself as a proper king of Egypt.[39] Udjahorrsene instructed the Persian ruler in Egyptian religion and advised him how to behave as king. When Udjahorresne complained that foreign soldiers had occupied the temple of Neith of Sais and profaned the sacred

precinct, Cambyses evacuated the troops and reestablished the divine service in all its former splendor: "His majesty did this because I had let his majesty know the greatness of Sais, that it is the city of all the gods [and] because I had let his majesty know how every beneficence had been done in this temple by every king."[40]

Udjahorresne's career continued to prosper during the reign of the next Persian ruler, Darius the Great. In the inscription he tells how Darius commanded him to restore the House of Life or temple school, where scribes learned medicine, temple administration, and ritual. Although later historians have portrayed him as an arch-collaborator, Udjahorresne presents himself as the protector of his town during the Persian conquest: "I rescued its inhabitants from the great turmoil when it happened in the whole land."[41] For his loyal service, Udjahorresne was presented with gold jewelry, and indeed his statue shows him wearing heavy bracelets of Persian design.[42]

Sadly, we have no such detailed biographical inscription to rely on for the Green Head, but a review of Egyptian history from the Kushite invasion to the conquest of Alexander the Great may help to place our priest's life in the context of his times. The Late Period saw Egypt successively invaded and conquered by the Kushites (or Nubians), Assyrians, Persians, and Greeks, with intermittent periods of native rule. About 728 BC the Kushite King Piankhy led his army in triumph from northern Sudan all the way to Memphis, where he received the homage of the Egyptians as pharaoh. A second invasion in 712 BC by Piankhy's successor Shabaka consolidated Kushite authority, and for the next fifty years, he and his successors ruled over Egypt and northern Sudan. To students of Egyptian history, this period is known as Dynasty 25. The Kushites' aggressive foreign policy in western Asia soon brought them into conflict with the Assyrians. The conflict came to a head in the reign of Taharqa (690–664 BC), the third and greatest Kushite pharaoh. The Assyrians twice invaded Egypt, in 672 and again in 666 BC. Each time Taharqa fled south, only to return as soon as the Assyrians had withdrawn. In 664 BC

the Assyrians invaded Egypt for the third time and drove the Kushites out of Egypt for good.

The Assyrians were not interested in ruling Egypt directly. Having eliminated their rivals, they went home with their booty, leaving Egypt in charge of their sworn vassal, Psammetichus, of the Delta city of Sais. Psammetichus soon established his independence and founded the Saite Dynasty (Dynasty 26, 664–525 BC), one of the most brilliant in Egyptian history. Psammetichus I had come to the throne with the help of Ionian and Carian mercenaries, whom he settled in the Nile Delta, giving the Greeks their initial opportunity to experience Egyptian art, history, and culture at first hand. Herodotus clearly states: "It is due to the settlement of these men in Egypt and our contact with them that we Hellenes have precise knowledge of all the events that took place there, beginning with the reign of Psammetichos down to the present."[43]

At the same time, Egypt became more involved in Mediterranean affairs. Necho II, Psammetichus I's successor, equipped the Egyptian navy with Greek war galleys (triremes), the most sophisticated battleships of the day. Egypt became a great maritime power for the first time, with fleets in the Red Sea and the Mediterranean. Necho also began the construction of a canal linking the Nile with the Red Sea, the forerunner of today's Suez Canal.

A hallmark of the art and culture of the Late Period is their frequent reference to the past. The consciousness of a long and glorious history, the presence of so many great monuments of former times, and the desire to maintain cultural identity in the face of so many foreigners, led artists and those who commissioned them to turn to the earlier eras for inspiration. The ancient sites of Giza and Saqqara underwent a revival: the small temple of Isis, Lady of the Pyramids, in the old royal cemetery east of the Great Pyramid, was expanded; the pyramid of King Menkaura was restored and the royal mummy provided with a new wooden coffin; and the Old Kingdom necropolis once again became a burial place of choice for the elite. Huge hard-stone sarcophagi, not used since the

New Kingdom, were in vogue again.[44] At Saqqara, the Step Pyramid of
Djoser and the Serapeum drew antiquarian interest. A broad gallery was
driven into the Step Pyramid from its south face in order to clear the
great central tomb shaft and investigate the burial chambers—a formida-
ble and dangerous task undertaken not for plunder but in order to study
the arrangement and decoration of the earliest known pyramid.[45] Psam-
metichus I inaugurated a new catacomb for the Apis bulls, the Greater
Vaults, at the Serapeum, while Amasis was the first king to provide Apis
with a stone sarcophagus.[46] Along with a renewed interest in ancient
cemeteries such as Giza and Saqqara came a revival of statuary in stone.
Almost invariably these figures are made of hard stones like granodiorite
or graywacke, meant to last for eternity.

After 140 years of Saite rule, Egypt faced another external threat. In
525 BC, the Persians under Cambyses conquered Egypt and took the last
Saite pharaoh back to Persia in chains. For the next eighty years Egypt
was part of the Achaemenian Empire, the largest the world had yet seen.
In Egyptian history, this period is known as Dynasty 27.

The Persian Period received a bad press in later accounts. Tales of
sacrilege, such as the accusation that Cambyses burned the mummy of
Amasis and killed the sacred Apis Bull, are highly exaggerated.[47] (The
Apis bull that died in year 6 of Cambyses' rule was buried with full hon-
ors in accordance with Egyptian tradition.) At first, as the Persians ruled
Egypt with the help of highly placed Egyptian collaborators like Udja-
horresne, the reign went smoothly. Darius I took a particular interest
in Egypt: his palace at Persepolis has Egyptian-style doorways clearly
based on firsthand observation of Egyptian architecture, and a colossal
statue of Darius, made of Egyptian graywacke, was discovered at Susa,
the Persian capital.[48] In this statue the king's dress and accouterments are
Persian, but the striding pose with left foot forward, the back pillar, and
the base decorated with traditional pharaonic motifs like the union of
the Two Lands are purely Egyptian. The statue is inscribed in four lan-
guages (Egyptian, Old Persian, Elamite, and Akkadian) stating that Dar-

ius ordered it to be made in Egypt so that future generations will know that a Persian was once ruler of Egypt.[49] Darius also completed the canal between the Nile and the Red Sea begun in Dynasty 26. The Great King came in person for the inauguration of the canal and sent back to Persia a flotilla of twenty-four ships laden with Egyptian produce. After the relatively harmonious inaugural period, however, the Egyptians began to stage revolts against their rulers, often abetted by the Greeks. The Persians had just put down one such uprising when Herodotus visited Egypt, shortly after 450 BC.

In 404 BC, after more than a hundred years of Persian domination, Egypt regained its independence under Amyrtaeus of Sais, the sole ruler of Dynasty 28. In Dynasties 29 and 30, under the last native pharaohs, Nectanebo I and II, Egypt experienced a splendid burst of cultural and artistic achievement. When Egypt regained its independence from the Persians, no significant temples had been built in Egypt for one hundred and fifty years. The pharaohs soon began a building campaign so extraordinary it would have done even Ramesses the Great proud.[50] Massive mud-brick enclosure walls converted the major temples into mighty fortresses. Karnak, neglected since Kushite times, attained its present appearance with a new entrance (today's First Pylon) facing the Nile and seven hundred sphinxes lining the processional way from Karnak to Luxor.

Nectanebo II repelled an attempted Persian invasion in 351–350 BC but he could not resist them when they returned in 343. The second Persian conquest was much more ruthless than the first. City walls were demolished, the temples sacked, the images of the gods taken back to Persia. But the Persians soon had to cede their rule. In 332 BC Alexander the Great of Macedon marched into Egypt without a struggle. He stayed long enough to found the city of Alexandria, then went off to conquer Persia. In Egypt, the Macedonians strategically resumed the building projects initiated by Nectanebo II and the repair of buildings damaged by the Persians. Alexander the Great as pharaoh may be seen

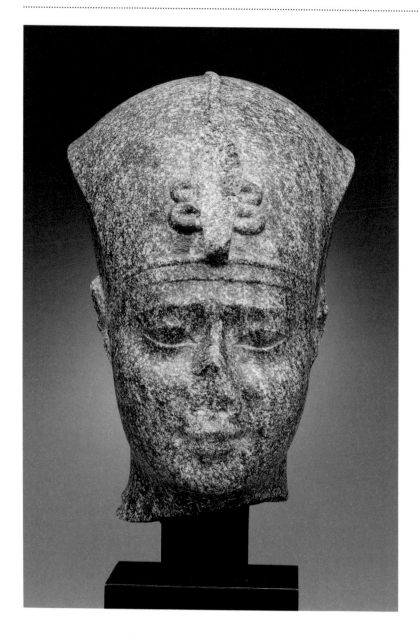

The Green Head priest may have lived around the time of Nectanebo II, Egypt's last native pharaoh; his image provided a model for Alexander the Great and his successors when they appeared as pharaoh.

today at Karnak, where he decorated the central sanctuary of the temple of Thutmose III, and at Luxor, where he rebuilt the boat shrine of Amenhotep III, destroyed by the Persians.[51]

Alexander's immediate successors, Philip Arrhidaeus (323–315 BC) and Alexander IV (316–305), never set foot in Egypt, though work carried out in their name is plainly visible at Karnak, where Philip had the central boat shrine of Amen-Ra, the holy-of-holies, adorned with reliefs (see p. 138); and Elephantine Island, where Alexander IV commissioned the decoration of the granite doorway of the temple of Khnum.[52] Both these projects had been initiated by Nectanebo II, and the later reliefs were designed to be scarcely distinguishable from the original work.

In 305 BC, after the death of Alexander IV, Ptolemy, one of Alexander the Great's generals, declared himself king of Egypt. Thus began the Ptolemaic Dynasty, which ruled Egypt for almost three centuries, until 30 BC. Ptolemy had effectively controlled Egypt on behalf of Alexander's family since 323 BC as satrap, or governor, building up his power base and acting in every way so as to ingratiate himself with the Egyptians. A royal decree records that he "brought back the sacred images of the gods which were found within Asia, together with all the ritual implements and all the sacred scrolls of the temples of Upper and Lower Egypt, so he restored them in their proper places."[53]

Which brings us back to our priest. If he had lived at the beginning of the fourth century, he would have seen the country gain independence from the Persians. A bit later, in the heyday of Dynasty 30, he would have seen the Serapeum complex thoroughly reconstructed under the Nectanebos.[54] Mariette found the name of Nectanebo I by the eastern gateway in the temple wall, above the entrance to the catacombs of the Apis bulls. The two recumbent lions flanking the entranceway are probably his as well.[55] The pair of sphinxes flanking the temple at the eastern end of the dromos, opposite the Serapeum, bear the cartouches of Nectanebo II. Beautifully carved wall reliefs from this temple show Nectanebo standing before Apis, who is represented in the form

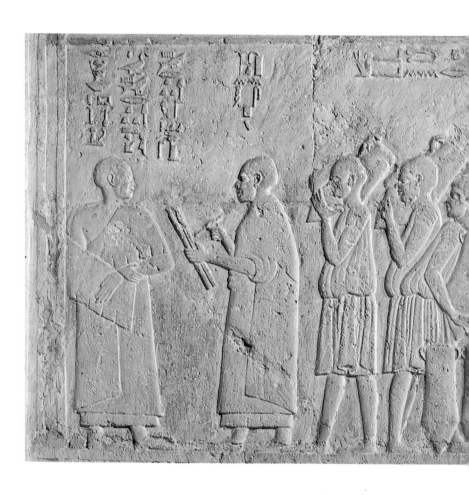

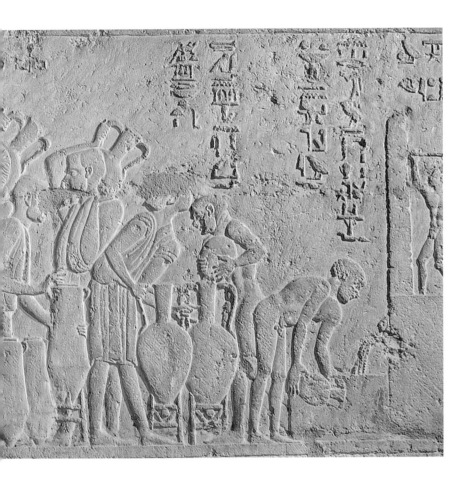

Two artistic traditions meet in a scene from the tomb of Petosiris: The figure of the high priest at the far left combines front and side views in one plane in the Egyptian manner, while the figures of the workmen strive for depth in the Greek style.

of a bull-headed man.[56] The sphinxes along the Serapeum Way, so reminiscent of those flanking the sphinx avenues at Thebes, date either to Nectanebo II or to the early Ptolemies. At the Sacred Animal Necropolis at North Saqqara, the tombs of the Mothers of Apis, the baboon catacombs, the falcon catacombs, the earlier of the two ibis catacombs, and the associated structures aboveground were also begun in the mid-fourth century BC.

King Achoris of Dynasty 29 and both Nectanebos each buried an Apis bull with due ceremony. Perhaps our priest was one of the officials privileged to attend the funerals, and to place memorials in the form of stelae at the entrance to the catacombs. Some of these stelae express the wish to be buried near the tomb of Apis, and it is possible that our priest's eventual tomb was located in its vicinity—huge square shafts sunk deep into the bedrock, the more elaborate ones provided with mud-brick pylons and relief-decorated chapels aboveground. Mariette came across a number of such tombs as he dug along the Serapeum Way; most still await systematic excavation.[57]

After the time of the Nectanebos, our priest would have witnessed the second Persian invasion and seen the temples ransacked and their treasures carried away. He may even have witnessed the destruction of his own statue. Later still, he may have watched the Macedonians restore what the Persians had demolished.

Some insight into these turbulent times, as well as the fortunes of the great priestly families, comes from the reliefs and inscriptions in the magnificent tomb of Petosiris at Tuna el-Gebel in Middle Egypt.[58] Petosiris was high priest of Thoth at nearby Hermopolis (el-Ashmunein) in the Macedonian period. Hermopolis was not Memphis, but it was no backwater either: the city had been a center of priestly learning since the Middle Kingdom (about 2000 BC). Petosiris built his tomb as a final resting place not just for himself but for his family, notably his father and elder brother, both of whom preceded him as high priest, and his son, who died young.[59] The tomb is most famous for its reliefs, which employ both Egyptian

and Greek modes of representation. The funerary offerings and religious scenes in the sanctuary are purely Egyptian, whereas the scenes of daily life in the outer hall are in a mixed Greco-Egyptian style. In the scenes of agriculture and viticulture, the farmers wear Greek-style clothing and appear in three-quarter view as they bend to their chores. But what will do for the servants will not do for their master: whereas the scribe of the vineyard, who is presenting the account of the vintage to Petosiris, and the porters bearing wine jars present their bodies in true profile in the Greek manner, the priest himself is shown with his head in profile and his shoulders frontal according to the age-old Egyptian formula.

Even more interesting are the inscriptions, which give us a window on Egypt in the fourth century BC. Petosiris's father, Sishu, probably served as high priest in the golden years of Nectanebo I and II. Petosiris's elder brother, Djedthothefnakht, likely succeeded Sishu at the end of the reign of Nectanebo II; both brothers would have witnessed the reconquest of Egypt by the Persians and the ensuing period of disorder. Petosiris himself probably came into office under Alexander the Great.[60] The inscriptions, in which excerpts from ancient funerary texts are combined with new compositions, offer a compendium of the religious beliefs of the period. The so-called autobiographical texts take the form of words spoken by the deceased, expressing each priest's thoughts and accomplishments.

Sishu, the father of Petosiris, offers worldly advice—"death comes to us all, enjoy life while you can"—somewhat surprising from a venerable old priest:

O you who are alive on earth,
and you who shall come after;
O every man who reads writing,
come, read these writings that are in this tomb!
I shall lead you to the way of life,
I shall teach you your conduct,
that you may reach the abode of generations!

[. . .]
Drink till drunk while enjoying the feast day!
Follow your heart in the moment on earth!
It profits a man to make use of his goods.
As a man departs his goods depart,
he who inherits them does his wish in turn.
There is no sunlight for the rich,
no messenger of death takes bribes,
so as to forget what he was sent to do.[61]

Thothrekh, the son who died young, tugs at our heartstrings as he
relates his fate:

Who hears my speech, his heart will grieve for it,
for I am a small child snatched by force,
abridged in years as an innocent one,
snatched quickly as a little one.
[. . .]
I was rich in friends,
all the men of my town,
not one of them could protect me!
All the town's people, men and women,
lamented very greatly [. . .]
All my friends mourned for me,
Father and Mother implored Death;
my brothers, they were heads-on-knee [in mourning].

He implores passers-by to say a prayer on his behalf, promising them
health and happiness if they do:

You shall last in life, you shall follow Sokar,
you shall see the face of Ra in the morning,
on the New Year's feast when he rises
in the great house in the temple of Khmun;

you shall follow Thoth,
on that beautiful day at the start of the Inundation,
you shall hear the jubilation in the temple of Khmun,
when the Golden One appears to show her love,
if you say whenever you come to this desert:
"May your ka have all good things,
little child whose time passed so quickly,
he could not follow his heart on earth."[62]

And now for Petosiris himself, "the high priest who sees the god in his shrine, who carries his lord and follows his lord, who enters into the holy of holies, who performs his functions together with the great prophets." His long autobiographical inscription presents him as a paragon of a righteous priest and able administrator, whom the gods themselves had singled out to serve them and to guide his people through troubled times to peace and prosperity.

He starts off solemnly, reminding visitors to the tomb that in the end all will be judged alike, rich or poor, when the baboon-headed god Thoth weighs our hearts in the balance against the feather of truth:

O every prophet, every priest, every scholar,
who enter this necropolis and see this tomb:
Praise god for him who acts (for me),
praise god for them who act (for me).
for I was one honored by his father,
praised by his mother,
gracious to his brothers.
I built this tomb in the necropolis,
beside the great souls who are there,
in order that my father's name be pronounced,
and that of my elder brother.
A man is revived when his name is pronounced!
The west is the abode of him who is faultless,

praise god for the man who has reached it!
No man will attain it,
unless his heart is exact in doing right.
The poor is not distinguished there from the rich,
only he who is found free of fault
by scale and weight before eternity's lord.
There is none exempt from being reckoned:
Thoth as Baboon in charge of the balance
will reckon each man for his deeds on earth.

Petosiris now gets specific and tells us of his service as temple administrator for seven years while the Persians turned the country upside-down, and how he found the temples desolate and abandoned:

He [Thoth] chose me to administer his temple,
knowing I respected him in my heart.
I spent seven years as controller for this god,
administering his endowment without fault being found,
while the Ruler-of-foreign-lands [the Persian king Artaxerxes] was
 Protector in Egypt,
and nothing was in its former place.
Since fighting had started inside Egypt,
the South being in turmoil, the North in revolt;
the people walked with head turned back [in bewilderment],
all temples were without their servants,
the priests fled, not knowing what was happening.

He recounts one by one the temples he put back in order, beginning with the temple of Thoth:

I caused every rite to be as before,
every priest to serve in his proper time.
[. . .]
I did not reduce the offerings in his temple,

I filled his granaries with barley and emmer,
his treasury with every good thing.
I increased what had been there before,
and every citizen praised god for me.
I gave silver, gold, and all precious stones,
so that I gladdened the hearts of the priests,
and of all those who work in the gold house,
and my heart rejoiced in it.
I made splendid what I found ruined anywhere,
I restored what had decayed long ago,
and was no longer in its place.

Next he built the temple of Ra, in fine white limestone with doors of pinewood inlaid with Asian copper, and brought the god's cult statue inside. Acting in the role of pharaoh, Petosiris personally performed the foundation ceremonies. He also rebuilt several chapels within the precinct of Thoth, protecting them with an enclosure wall:

This spot, wretches had damaged it,
intruders had traversed it;
the fruit of its trees had been eaten,
its shrubs taken into intruders' homes;
the whole land was in uproar about it,
and Egypt was distressed by it.

One day, as Petosiris marched in procession with the statue of Heqet, the frog goddess, the goddess halted at the site of her old temple, so eroded by the annual Nile flood that the ground plan was unrecognizable, and ordered him to rebuild it:

I summoned the temple scribe of this goddess,
I gave him silver without counting,
to make a monument there from that day.
I built a great rampart around it,

so that the water could not carry it off.
I was diligent in consulting the scholars,
so as to organize the rites
by which this goddess is served,
and content her till she knew it was done.

Finally Petosiris reaps the just reward of those who follow the word
of their god:

My lord Thoth distinguished me above all my peers,
as reward for my enriching him,
with all good things, with silver and gold,
with harvests and produce in granaries,
with fields, with cattle,
with orchards of grapes,
with orchards of all fruit trees,
with ships on the water,
with all good things of the storehouse.
I was favored by the ruler of Egypt,
I was loved by his courtiers.
May this too be given me as reward:
Length of lifetime in gladness of heart,
a good burial after old age,
my corpse interred in this tomb
beside my father and elder brother
[. . .]
my house maintained by my children,
with son succeeding son!
May he who comes hereafter say:
"A servant of his god till veneration day!"[63]

Nothing mattered more to the ancient Egyptians than that their
names should be remembered by future generations. Graffiti left in the

tomb by Greek tourists in the third and second centuries BC show that Petosiris was venerated as a saint.[64] He still lives on as we read his tomb inscriptions and pronounce his name. Our priest, though he must remain nameless, has achieved immortality of another kind. His face is known around the world, and his compellingly lifelike portrait continues to entrance us, beckoning us across the ages to rethink the way we look at Egyptian art.

NOTES

PROLOGUE: THE BOSTON GREEN HEAD

1 For examples in the MFA's collection, see the colossal seated statue of the king, MFA 09.204 and the head, MFA 09.203.

2 Still, it is generally agreed that the bust of Prince Ankhhaf is a portrait: MFA 27.442. The so-called reserve heads as well, though more summarily modeled, each present a distinctive set of features: MFA 06.1886, 14.717–719, 21.328–329.

3 Examples of likenesses of these two rulers may be found on the websites of the British Museum, the Louvre, and the Metropolitan Museum.

4 See, for example, Robert S. Bianchi et al., *Cleopatra's Egypt: Age of the Ptolemies*, exh. cat. (Brooklyn Museum, 1988), 55–59; Gay Robins, *The Art of Ancient Egypt* (London: British Museum Press, 1997), 245–46.

5 Edna R. Russmann, *Eternal Egypt: Masterworks of Ancient Art from the British Museum*, exh. cat. (London: British Museum Press, 2001), 32–38; see Lawrence M. Berman, "The Image of the King in Ancient Egyptian Art," in Lawrence M. Berman and Bernadette Letellier, *Pharaohs, Treasures of Egyptian Art from the Louvre* (Cleveland: Cleveland Museum of Art in association with Oxford University Press, 1996), 23–29.

6 Barbara G. Aston, James A. Harrell, and Ian Shaw, in Paul Nicholson and Ian Shaw, eds., *Ancient Egyptian Materials and Technology* (Cambridge: Cambridge University Press, 2000), 57–58. Basalt is a volcanic igneous rock made from the solidification of lava, while graywacke is a sedimentary rock made from the cementation of preexisting rock particles.

7 A good example of the dark gray color is the MFA's statue of King Menkaura and his queen (11.1738).

8 Barbara G. Aston, *Ancient Egyptian Stone Vessels: Materials and Forms* (Heidelberg: Heidelberger Orientverlag, 1994), 31.

9 Based on a classic grid of 18 squares from the browline to the soles of the feet for a striding statue and 11 squares for a kneeling statue. The head measures about 3 inches from the browline to the junction of the neck and shoulders, equal to 2 squares.

10 Out of twenty-four statues of priests in *Egyptian Sculpture of the Late Period 700 B.C. to A.D. 100*, by Bernard V. Bothmer with Herman de Meulenaere and Hans Wolfgang Müller, exh. cat. (Brooklyn: Brooklyn Museum, 1960), only six have shaven heads, but out of seven shaven-headed statues only two are not priests. Shaven-headed priests: nos. 14 (Mentuemhat in relief, Kansas City 48-28/2); 56 (Padebehu, Brooklyn 60.11 and Vatican 167); 66 (Family stele, Edinburgh 1956.134); 81 (Ankhpahkhered, son of Nesmin, MMA 08.202.1); 83 (Userwer, head in Brooklyn 55.175, body in Cairo JE 30864); 99 (Prophet of Horemheb, Academy of the New Church Museum, Bryn Athyn, Pa.). Shaven-headed but not priests: nos. 65 (Psamtiksaneith, Cairo CG 726); 74 (relief of Thaasetimu, royal secretary, Brooklyn

..

56.142). In bronze statuary, shaven-headed priests predominate in all periods: Barbara Mendoza, *Bronze Priests of Ancient Egypt from the Middle Kingdom to the Graeco-Roman Period*, BAR International Series 1866 (Oxford: Archeopress, 2008), 25–27.

11 Susan Walker and Peter Higgs, eds., *Cleopatra of Egypt: From History to Myth*, exh. cat. (Princeton: Princeton University Press; London: British Museum, 2001), nos. 340–42, 348, 322–24, 329; Jon Solomon, *The Ancient World in the Cinema*, rev. ed. (New Haven: Yale University Press, 2001), p. 154, fig. 95 (Cecil B. DeMille's *The Ten Commandments*, 1956), and p. 249, fig. 163 (Howard Hawks's *Land of the Pharaohs*, 1955).

THE ARCHAEOLOGIST

1 *Who Was Who in Egyptology*, 4th ed., rev. by Morris L. Bierbrier (London: Egypt Exploration Society, 2012), 359–61. Much has been written on Mariette. I have relied most heavily on Gaston Maspero, *Notice biographique sur Auguste Mariette (1821–1881)* (Paris: Ernest Leroux, 1904).

2 *Who Was Who in Egyptology*, 330–31.

3 Jean-François Champollion, *Lettre à M. Dacier . . . : Relative a l'alphabet des hiéroglyphes phonétiques employés par les égyptiens pour inscrire sur leurs monuments* (Paris: F. Didot, 1822). There is a vast literature on Champollion; see *Who Was Who in Egyptology*, 114–15; Lesley and Roy Adkins, *The Keys of Egypt: The Obsession to Decipher Egyptian Hieroglyphs* (New York: HarperCollins, 2000).

4 Jean Vercoutter, *The Search for Ancient Egypt* (New York: Abrams, 1992), 95.

5 The others were Albert Henry Bertin (1802–1831), Alexandre Duchesne (1802–1869), and Pierre François Lehoux (1803–1883). Bertin and Lehoux were pupils of Baron Gros; *Who Was Who in Egyptology*, 57, 163, 321.

6 *Monuments de l'Égypte et de la Nubie, d'après les dessins exécutés sur les lieux sous la direction de Champollion-le-jeune*, 4 vols. (Paris: Firmin Didot frères, 1835–45); online in the New York Public Library Digital Gallery, *http://digitalgallery.nypl.org* (accessed January 29, 2012). See also J. Vandier D'Abbadie, *Nestor L'Hôte (1804–1842): Choix de documents conservés à la Bibliothèque nationale et aux Archives du Musée du Louvre* (Leiden: Brill, 1963). Some of L'Hôte's beautiful watercolors are reproduced in Alberto Siliotti, *Egypt Lost and Found: Explorers and Travelers on the Nile* (New York: Stewart, Tabori and Chang, 1999), 198–201, figs. 198–201.

7 Christiane Ziegler and Marc Desti, eds., *Des dieux, des tombeaux, un savant: En Egypte, sur les pas de Mariette pacha*, exh. cat. (Paris: Somogy, 2004), 208–9. Contrary to rumor, this coffin was never owned by Vivant Denon; ibid., 19.

8 Robert Curzon, *Visits to Monasteries in the Levant* (London: John Murray, 1849), 86–89; online versions can be found through the Internet Archive, *https://archive.org*.

9 Auguste Mariette-Pacha, *Le Sérapeum de Memphis, publié d'après le manuscrit de l'auteur par G. Maspero* (Paris: Vieweg, 1882), 3.

10 Jean-Philippe Lauer, *Saqqara: The Royal Cemetery of Memphis—Excavations and Discoveries since 1850* (London: Thames & Hudson, 1976), 21–22; Mariette-Pacha, *Le Sérapeum de Memphis*, 4.

11 Auguste Mariette-Bey, *Monuments of Upper Egypt*, trans. Alphonse Mariette (Boston: J. H. Mansfield & J. W. Dearborn, 1890), 113.

12 Lauer, *Saqqara*, 22; Mariette-Pacha, *Le Sérapeum de Memphis*, 5–7.

13 Auguste Mariette, *Choix de monuments et de dessins découverts ou exécutés pendant le déblaiement du Sérapéum de Memphis* (Paris: Gide et J. Baudry, 1856), 7; Arthur Rhoné, *L'Egypte a petites journées: Études et souvenirs* (Paris: Ernest Leroux, 1877), 214, quoting a May 21, 1856, letter from Mariette to M. Egger.

14 *A Handbook for Travellers in Lower and Upper Egypt*, 9th ed. (London: John Murray, 1896), [15].

15 Strab. 17.1.31; *The Geography of Strabo*, trans. Horace Leonard Jones, Loeb Classical Library (London: William Heinemann, 1932), 87.

16 Strab. 17.1.32; ibid., 89.

17 Paus. 1.18; Pausanias, *Description of Greece*, trans. W. H. S. Jones and H. A. Ormerod, Loeb Classical Library (Cambridge, Mass.: Harvard University Press, 1918); online at *www.perseus.tufts.edu*.

18 Paul T. Nicholson, "The Sacred Animal Necropolis at North Saqqara: The Cults and Their Catacombs," in *Divine Creatures: Animal Mummies in Ancient Egypt*, ed. Salima Ikram (Cairo and New York: American Research Center in Egypt Press, 2005), 49.

19 Salima Ikram, "Divine Creatures: Animal Mummies," in *Divine Creatures*, ed. Ikram, 1–15.

20 Juv. 5.15.1–8; *Juvenal and Persius*, trans. G. G. Ramsay, Loeb Classical Library (London: William Heinemann, 1920), 289.

21 David Jeffreys, *The Hekekyan Papers and Other Sources for the Survey of Memphis*, The Survey of Memphis 7, Excavation Memoir 95 (London: Egypt Exploration Society, 2010), 63.

22 Amelia B. Edwards, *A Thousand Miles Up the Nile* (London: George Routledge and Sons, 1891), 66.

23 Edmé François Jomard, "Description générale de Memphis et des pyramides," in *Description de l'Égypte, ou, Recueil des observations et des recherches qui ont été faites en Égypte pendant l'expédition de l'armée française*, 2nd ed., text: Antiquités-Descriptions, vol. 5 (Paris: C. L. F. Panckoucke, 1829), 554–55.

24 Rhoné, *L'Egypte a petites journées*, 418–19.

25 Clot-Bey, Varin-Bey, and Linant-Bey according to one account (Mariette, *Choix de monuments et de dessins*, 6–7); Linant Bey, Varin Bey, and Stephan Bey according to another (Mariette-Pacha, *Le Sérapeum de Memphis*, 5); see Jaromír Málek, "Who Was the First to Identify the Saqqara Serapeum," *Chronique d'Egypte* 58 (1983): 65–66. Antoine Barthélemy Clot, a French surgeon, founded the school of medicine in Cairo and was head of the Department of Health under Muhammad Ali; Varin ran the cavalry school at Giza.

26 Mariette, *Choix de monuments et de dessins*, 6. See also Rhoné, *L'Egypte a petites journées*, 419.

27 The Egyptological community did not know of it until 1983, when Harris's lecture notes housed in the Griffith Institute at Oxford were published; Málek, "Who Was the First to Identify the Saqqara Serapeum?" 65–72.

28 There are countless publications; see the website of the Louvre: *www.louvre.fr/en/oeuvre-notices/seated-scribe*.

29 See *www.louvre.fr/en/oeuvre-notices/processional-way-sphinxes*; Lauer, *Saqqara*, pl. 1.

30 Auguste Mariette-Bey, *Monuments of Upper Egypt*, trans. Alphonse Mariette (Boston: J. H. Mansfield & J. W. Dearborn, 1890), 117n.

31 Jean Philippe Lauer and Charles Picard, *Les statues ptolémaïques du Sarapieion de Memphis* (Paris: Presses universitaires de France, 1955); Lauer, *Saqqara*, pls. 2–4.

32 Lawrence M. Berman and Bernadette Letellier, *Pharaohs, Treasures of Egyptian Art from the Louvre* (Cleveland: Cleveland Museum of Art in association with Oxford University Press, 1996), pp. 86–87, no. 27.

33 Now in the Louvre, N 432 B and C; Lauer, *Saqqara*, pl. 7; Jean-Marcel Humbert, Michael Pantazzi, and Christiane Ziegler, *Egyptomania: Egypt in Western Art, 1730–1930*, exh. cat. (Paris: Éditions de la Réunion des Musées Nationaux; Ottawa: National Gallery of Canada, 1994), no. 208, pp. 345–47; Ziegler and Desti, *Des dieux, des tombeaux, un savant*, no. 60, pp. 122–23.

34 *The Vatican Collections: The Papacy and Art*, exh. cat. (New York: Metropolitan Museum of Art, 1982), no. 95, pp. 178–79; James Stevens Curl, *The Egyptian Revival: Ancient Egypt as the Inspiration for Design Motifs in the West* (London: Routledge, 2005), 75–77.

35 Lauer, *Saqqara*, pls. 3, 5, 8; *La gloire d'Alexandrie*, exh. cat. (Paris: Paris-Musées and the Association Française d'Action Artistique, 1998), p. 257, fig. 2.

36 Lauer, *Saqqara*, pl. 18.

37 It is now in the Louvre, its colors having entirely faded: *www.louvre.fr/en/oeuvre-notices/apis-bull*; Lauer, *Saqqara*, pl. 9.

38 Hdt. 2.144.2.

39 Diod. 1.96.5. *Diodoros of Sicily*, trans. C. H. Oldfather, Loeb Classical Library (Cambridge Mass.: Harvard University Press, 1968), 327.

40 Plut. De Iside 35.; online at *www.perseus.tufts.edu*.

41 Lauer, *Saqqara*, 17–18; Dorothy J. Thompson, *Memphis under the Ptolemies*, 2nd ed. (Princeton: Princeton University Press, 2012), 108–9. For the later date in the reign of Ptolemy XII, see Günther Hölbl, *A History of the Ptolemaic Empire*, trans. Tina Saavedra (New York: Routledge, 2000), 281–83.

42 Thompson, *Memphis under the Ptolemies*, 197; compare 25, 108–9.

43 Christiane Ziegler, "Une découverte inédite de Mariette, les bronzes du Sérapeum," *Bulletin de la Société française d'Egyptologie* 90 (April 1981): 29–45; Ziegler and Desti, *Des dieux, des tombeaux, un savant*, nos. 52–55, pp. 112–16.

44 Maspero, *Mariette*, 30–31, 37. Von Huber (1804–1871), Austrian consul general from 1850 to 1858, sent part of his collection to Vienna in 1857 and sold the rest to the Bulaq Museum in 1858. Lieder (1798–1865) sold his collection of 186 objects to Lord Amherst in 1861. Lanzone (1834–1907), an Egyptologist and Arabist, later joined the staff of the Egyptian Museum Turin, 1872–1895; Heinrich Brugsch, *My Life and My Travels* [English translation of *Mein Leben und Mein Wandern*, 2nd ed., 1894], ed. George Laughead, Jr., and Sarah Panarity (Waban, Mass.: Heinrich George Brugsch, 1992), 97–98, 101–102. *Who Was Who in Egyptology*, 267, 309, 332–33.

45 Brugsch, *My Life and My Travels*, 98.

46 Dia Abou-Ghazi, "The First Egyptian Museum," *Annales du Service des Antiquités de l'Egypte* 67 (1988): 1–13.

47 Mariette, *Le Sérapeum de Memphis*, 112.

48 G. Maspero, *Guide du visiteur au Musée du Caire* (Cairo: Imprimerie de l'Institut français d'archéologie orientale, 1915), p. x. The most intensive study of the Serapeum sphinxes to date is Eva Rogge, *Statuen der 30. Dynastie und der Ptolemäisch-Römischen Epoche*, Corpus antiquitatum Aegyptiacarum, Kunsthistorisches Museum Wien, fasc. 11 (Mainz: Philipp von Zabern, 1999), 1–50.

49 Rhoné, *L'Egypte a petites journées*, 252; Vercoutter, *The Search for Ancient Egypt*, 105.

50 www.louvre.fr/en/oeuvre-notices/ramesses-ii-breastplate; Humbert, Pantazzi, and Ziegler, *Egyptomania*, 352–53; Ziegler and Desti, *Des dieux, des tombeaux, un savant*, no. 36, pp. 90–91.

51 Brugsch, *My Life and My Travels*, 103–104.

52 MFA 1978.571; William Kelly Simpson, "A Portrait of Mariette by Théodule Devéria," *Bulletin de l'Institut français d'archéologie orientale* 74 (1974): 149–50. Charles was the son of the painter Achille Devéria (1800–1857), of whom we have a striking self-portrait ("a l'air fatal") (MFA 1984.417).

53 Brugsch, *My Life and My Travels*, 105–6.

54 Mariette-Pacha, *Le Sérapeum de Memphis*, 84; Lauer, *Saqqara*, 28.

THE PASHA

1 J. Christopher Herold, *Bonaparte in Egypt* (New York: Harper & Row, 1962).

2 Charles Coulston Gillispie, "Historical Introduction," in *Monuments of Egypt: The Napoleonic Expedition, the Complete Architectural Plates from "La Description de L'Egypte,"* ed. Charles Coulston Gillispie and Muchel Dewachter (Princeton: Princeton Architectural Press, 1987), 1–29, esp. 4–12.

3 Richard Parkinson, *The Rosetta Stone* (London: British Museum Press, 2005), 30–31, fig. 11.

176

4 Jean-Marcel Humbert, Michael Pantazzi, and Christiane Ziegler, *Egyptomania: Egypt in Western Art, 1730–1930*, exh. cat. (Paris: Éditions de la Réunion des Musées Nationaux; Ottawa: National Gallery of Canada, 1994) , pp. 264–66, no. 151.

5 The probable date was 1770. Afaf Lutfi al-Sayyid Marsot, *Egypt in the Reign of Muhammad Ali* (Cambridge: Cambridge University Press, 1984), 24–25.

6 Jason Thompson, *A History of Egypt from Earliest Times to the Present* (New York: Anchor Books, 2009), 213.

7 See the website of the British Museum, *www.britishmuseum.org*.

8 Giovanni Belzoni, *Belzoni's Travels: Narrative of the Operations and Recent Discoveries in Egypt and Nubia*, ed. Alberto Siliotti (London: British Museum Press, 2001), 103; Deborah Manley and Peta Rée, *Henry Salt: Artist, Traveller, Diplomat, Egyptologist* (London: Libri, 2001), 90.

9 Manley and Rée, *Henry Salt*, 195–96; *The Quarterly Review* 29 (October 1822): 76–77.

10 Jean-François Champollion, *Lettres et journaux écrits pendant le voyage d'Egypte* ([Paris]: Christian Bourgois, 1986), 154–57.

11 A. Henry Rhind, *Thebes, Its Tombs and Their Tenants* (London: Longman, 1862; reprint Piscataway, N.J.: Gorgias Press, 2002), 263.

12 Heike C. Schmidt, *Westcar on the Nile: A Journey through Egypt in the 1820s*, Menschen-Reisen-Forschungen 1 (Wiesbaden: Reichert, 2011), 172–79.

13 Champollion, *Lettres et journaux*, 443–48.

14 Nassau William Senior, *Conversations and Journals in Egypt and Malta*, vol. 1 (London, 1882; reprint [Boston]: Elibron Classics, 2005), 55–56.

15 Jacques Tagher, "Ordres supérieurs relatives à la conservation des antiquités et á la création d'un musée au Caire," *Cahiers d'histoire égyptienne*, series 3, fasc. 1 (November 1950): 13–26; Dia Abou-Ghazi, "The First Egyptian Museum," *Annales du Service des Antiquités de l'Egypte* 67 (1988): 1–13.

16 Both the museum's intended architect, Joseph Hekekyan, and the director of the School of Languages, Rifaa al-Tahtawi, had studied in Europe. Donald M. Reid, *Whose Pharaohs? Archaeology, Museums, and Egyptian National Identity from Napoleon to World War I*, (Berkeley: University of California Press, 2003), 50–54, 59–63.

17 See George R. Gliddon, *An Appeal to the Antiquaries of Europe on the Destruction of the Monuments of Egypt* (London: James Madden, 1841), 123–31.

18 Ibid., 64–75.

19 Sir Gardner Wilkinson, *Modern Egypt and Thebes: Being a Description of Egypt; Including the Information Required for Travellers in That Country* (London: John Murray, 1843), 1: 264.

20 Marsot, *Egypt in the Reign of Muhammad Ali*, 93.

21 Ibid., 89.

22 Ehud R. Toledano, *State and Society in Mid-Nineteenth Century Egypt*, Cambridge Middle East Library 22 (Cambridge: Cambridge University Press, 1990), 43–46, 136.

23 Ibid., 41–43, 135.

24 Ibid., 57–60.

25 Ibid., 121.

26 Sandra L. Olsen and Cynthia Culbertson, *A Gift from the Desert: The Art, History, and Culture of the Arabian Horse* (Lexington, KY: International Museum of the Horse, 2010), pp. 86–87 and 201, no. 324).

27 Toledano, *State and Society in Mid-Nineteenth Century Egypt*, 53–55.

28 Ibid., 57–60.

29 Brugsch, *My Life and My Travels*, 93.

30 Senior, *Egypt and Malta*, 163–164.

31 Ibid., 151; Toledano, *State and Society in Mid-Nineteenth Century Egypt*, 118, 120–21, 139, 141–42, 279n.30.

32 Toledano, *State and Society in Mid-Nineteenth Century Egypt*, 118–119.

33 Ibid., 126.

34 Francis Steegmuller, *Flaubert in Egypt: A Sensibility on Tour—A Narrative Drawn from Gustave Flaubert's Travel Notes and Letters* (New York: Penguin Books, 1996), 40.

35 Ibid., 65.

36 Ibid., 82.

37 Ibid., 95.

38 Murray to Sir Stratford Canning, July 1851, quoted in Toledano, *State and Society in Mid-Nineteenth Century Egypt*, 281n44.

39 Toledano, *State and Society in Mid-Nineteenth Century Egypt*, 89–90; Tagher, "Ordres supérieurs relatives à la conservation des antiquités," 24.

40 Toledano, *State and Society in Mid-Nineteenth Century Egypt*, 90n47.

41 Abou-Ghazi, "The First Egyptian Museum," says to the School of Engineering in Bulaq; G. Maspero, *Guide du visiteur au Musée du Caire*, 4th ed. (Cairo: Institut français d'archéologie oriental, 1915), p. x, to the Citadel. They appear to have been in the Citadel at the time of Mariette's excavations at the Serapeum.

42 Maspero, *Guide du visiteur au Musée du Caire*, ix–x.

43 Senior, *Egypt and Malta*, 25; Toledano, *State and Society in Mid-Nineteenth Century Egypt*, 58–59, 121, 123, 126, 140.

44 Hassan Hassan, *In the House of Muhammad Ali: A Family Album, 1805–1952* (Cairo: American University in Cairo Press, 2000), 103.

45 Barthélemy Saint-Hilaire, 1857, quoted in Toledano, *State and Society in Mid-Nineteenth Century Egypt*, 124.

178

46 Marsot, *Egypt in the Reign of Muhammad Ali*, 91.

47 Senior, *Egypt and Malta*, 38.

48 Gilles Lambert, *Auguste Mariette, ou l'Egypte ancienne sauvée des sables* ([Paris]: JC Lattès, 1997), 143.

49 C. Ferri Pisani, "Bronzes égyptiens tirés de la collection du Prince Napoléon," *Gazette des beaux-arts* 1 (1859): 274.

50 H. Wallon, *Notice sur la vie et les travaux de François-Auguste-Ferdinand Mariette-Pacha* (Paris: Institut de France, 1883), 29.

51 Zachary Karabell, *Parting the Desert: The Creation of the Suez Canal* (New York: Knopf, 2003), 70–75.

52 H. E. Winlock, "The Tombs of the Kings of the Seventeenth Dynasty at Thebes," *Journal of Egyptian Archaeology* 10 (1924): 259.

53 Wallon, *Mariette-Pacha*, 88.

54 *Le Serapéum de Memphis découvert et décrit par Aug. Mariette* (Paris: Gide, 1857).

55 Emmanuel de Rougé, "Une lettre écrite d'Egypte par M. Mariette," *Comptes-rendus des séances de l'Academie des Inscriptions et Belles-Lettres* 2 (1858): 115–21.

56 Wallon, *Mariette-Pacha*, 39.

57 Ibid., 90.

58 Ibid., 91.

59 Reid, *Whose Pharaohs?*, 100.

60 Auguste-Edouard Mariette, "Notice sur l'état actuel et les résultats, jusqu'à ce jour des travaux entrepris pour la conservation des antiquités égyptiennes en Egypte," *Comptes-rendus des séances de l'Academie des Inscriptions et Belles-Lettres* 3 (1859): 154.

THE PRINCE

1 Edgar Holt, *Plon-Plon: The Life of Prince Napoleon (1822-1891)* (London: Michael Joseph, 1973), 26–27.

2 Ibid., 33–34.

3 Ibid., 41.

4 Ibid., 59–61.

5 *The New Grove Dictionary of Music and Musicians*, 2nd ed., ed. Stanley Sadie (London: Macmillan, 2001), 24: 428–29. Stolz (b. 1815) made her debut in Brussels as Rachel in Halévy's *La juive* in 1836 and her Paris Opéra debut in the same role in 1837. Other famous roles included Donna Anna in Mozart's *Don Giovanni*, Isolier in Rossini's *Le comte Ory*, and Valentine in Meyerbeer's *Les huguenots*. She was the longtime mistress of the Opéra's director, Léon Pillet. She left the stage in 1860 and died a duchess in 1902, having married into the nobility.

6 *The Second Empire 1852–1870: Art in France under Napoleon III*, exh. cat. (Philadelphia: Philadelphia Museum of Art, 1978), 13, 249. Hittorff, who designed the fountains in the Place de la Concorde and the facades of the buildings encircling the Arc de Triomphe, was a noted expert on ancient architecture and particularly on the use of polychromy in Greek architecture and sculpture. He was one of the specialists the British Museum consulted in 1836 to determine whether the Parthenon marbles and other ancient sculptures in the museum had been painted.

7 Holt, *Plon-Plon*, 93.

8 Officially called "Exposition universelle des produits de l'agriculture, de l'industrie et des beaux-arts"; see *www.expositions-universelles.fr/1855-exposition-universelle-paris.html*.

9 Patricia Mainardi, *Art and Politics of the Second Empire: The Universal Expositions of 1855 and 1867* (New Haven: Yale University Press, 1987), 33.

10 Holt, *Plon-Plon*, 115.

11 Arséne Houssaye, *Les confessions: Souvenirs d'un demi-siècle 1830–1880*, vol. 4 (Paris: E. Dentu, 1885), 164, 169.

12 Marie-Claude Dejean de la Batte, "La maison pompéienne du prince Napoléon avenue Montaigne," *Gazette des beaux-arts*, ser. 6, vol. 87 (April 1976): 127–34; Curtis Dahl, "A Quartet of Pompeian Pastiches," *Journal of the Society of Architectural Historians* 14, no. 3 (Oct. 1955): 4–6.

13 Gerald M. Ackerman, "The Néo-Grecs: A Chink in the Wall of Neoclassicism," in *The French Academy: Classicism and Its Antagonists*, ed. June Hargrove (Newark: University of Delaware Press), 168–95.

14 The *Iliad* and *Odyssey* are reproduced in Roger Diederen, *From Homer to the Harem: The Art of Jean Lecomte du Nouÿ* (New York: Dahesh Museum of Art, 2004), p. 80, figs. 78–79. *Young Greeks Attending a Cockfight*, Musée d'Orsay, Paris, *www.musee-orsay.fr*; *Anacreon, Bacchus, and Cupid*, Musée des Augustins, Toulouse, *www.augustins.org*.

15 Versailles, Musée National du Château; *The Second Empire*, pp. 259–60, no. VI–12.

16 Houssaye, *Confessions*, vol. 4, p. 169.

17 Charles Edmond, *Voyage dans les mers du nord à bord de la corvette la Reine Hortense* (Paris, Michel Lévy frères, 1857).

18 C. Ferri Pisani, "Bronzes égyptiens tirés de la collection du Prince Napoléon," *Gazette des beaux-arts* 1 (1859): 270.

19 Jean-Marie Carré, *Voyageurs et écrivains français en Egypte*, vol. 2: *De la fin de la domination turque à l'inauguration du canal de Suez* (Paris: Institut français d'archéologie orientale, 1956), 258–59.

20 Holt, *Plon-Plon*, 118.

21 Ferri Pisani, "Bronzes égyptiens," 271–72. The *Marat* referred to here is Jacques-Louis David's own copy of his celebrated painting of 1793, *The Death of Marat* (original in Brussels, Royal Museums of Fine Arts of Belgium; copy at Versailles, Musée National du

Château). Prince Napoleon commissioned *Disembarkation of the French Army in Crimea* from Isidore-Alexandre-Augustin Pils (1813–1875) in 1855 (Ajaccio, Musée Fesch; *www. musee-fesch.com*), in which the prince is depicted in the center foreground.

22 "Fête donnée à l'Empereur et à l'Impératrice par S. A. I. le Prince Napoléon dans sa maison pompéienne," online at *http://gallica.bnf.*

23 Auguste Mariette, *Choix de monuments et de dessins découverts ou exécutés pendant le déblaiement du Sérapéum de Memphis* (Paris: Gide et J. Baudry, 1856), 8, comparing the Egyptian practice to similar customs observed by Longpérier among the Assyrians and even the Hebrews under Solomon.

24 Ferri Pisani, "Bronzes égyptiens," 272–74, 285.

25 Ibid., 275.

26 Ibid., 281.

27 Christiane Ziegler, "Une découverte inédite de Mariette, les bronzes du Sérapeum," *Bulletin de la Société française d'Egyptologie* 90 (April 1981): 31.

28 Paul T. Nicholson, "The Sacred Animal Necropolis at North Saqqara: The Cults and Their Catacombs," in *Divine Creatures: Animal Mummies in Ancient Egypt*, ed. Salima Ikram (Cairo and New York: American Research Center in Egypt Press, 2005).

29 Elizabeth Anne Hastings, *The Sculpture from the Sacred Animal Necropolis at North Saqqara, 1964–76* (London: Egypt Exploration Society, 1997), xxxiii (6).

30 Ibid.

31 Ibid., xxxii–xxxiii (4).

32 The only Serapeum bronze dated by cartouche, a statuette of Osiris in the Cairo Museum, bears the name of Apries; Ziegler, "Les bronzes du Sérapeum," 31; Georges Daressy, *Statues de divinités*, Catalogue general des antiquités égyptienes du Musée du Caire 28 (Cairo: Institut français d'archéologie orientale, 1906), p. 74, no. 38245.

33 The Louvre acquired the statues of Sepa and Nesa (one of Sepa and two of his wife Nesa) in the 1837 sale of the collection of Consul Jean-François Mimaut. Dated to the Third Dynasty, thus older than the seated scribe, they are the earliest known life-size statues of non-royal individuals. See *www.louvre.fr/en/oeuvre-notices/statues-sepa-and-nesa*.

34 Ferri Pisani, *Bronzes égyptiens*, 276.

35 Ibid.

36 Ibid., 277.

37 Ibid.

38 Maurice Olender, *The Languages of Paradise: Race, Religion, and Philology in the Nineteenth Century*, trans. Arthur Goldhammer (Cambridge, Mass.: Harvard University Press), 12.

39 Roman d'Amat et al., *Dictionnaire de biographie française* (Paris: Letouzy et Ané, 1975), 13: 1116 (3).

40 *Prince Napoleon in America: Letters from his Aide-de-camp*, trans. Georges J. Joyaux (Bloomington: Indiana University Press, 1959).

41 Ibid., 100.

42 "The Egyptian spirit, totally inclined as it was toward fantastic and marvelous creations, as evidenced by the curious tale discovered and translated, two years ago, by M. de Rougé, the Egyptian spirit, we believe, could never transform the dreams of its imagination into poetry," Ferri Pisani, *Bronzes égyptiens*, 277. Rougé's translation of the Tale of the Two Brothers in fact first appeared in 1852: Emm. de Rougé, "Notice sur un manuscrit en écriture hiératique, écrit sous le règne de Merienphthah, fils du grand Ramsès, vers le XVe siècle avant l'ère chrétienne," *Revue archéologique* 9 (1852): 385–99.

43 Jules Barthélemy Saint-Hilaire, *Lettres sur l'Egypte* (Paris: Michel Levy Frères, 1856), 303–40.

44 Plat. Laws 2.656e–657a; Plato, *Plato in Twelve Volumes*, vols. 10 and 11, translated by R. G. Bury, Loeb Classical Library (Cambridge, Mass.: Harvard University Press, 1967, 1968); online at *www.perseus.tufts.edu*. For Plato and Egyptian art, see Whitney M. Davis, "Plato on Egyptian Art," *Journal of Egyptian Archaeology* 65 (1965): 121–27.

45 Barthélemy Saint-Hilaire, *Lettres sur l'Egypte*, 317.

46 Ibid., 337–40.

47 Mohamed Saleh and Hourig Sourouzian, *The Egyptian Museum Cairo: Official Catalogue* (Mainz: Philipp von Zabern, 1987), nos. 40 and 41.

48 Ernest Renan, "Les antiquités et les fouilles d'Egypte," *Revue des deux mondes* (March–April 1865): 671.

49 Ibid., 678.

50 Ibid., 686.

51 Deborah Manley and Peta Rée, *Henry Salt: Artist, Traveller, Diplomat, Egyptologist* (London: Libri, 2001), 175; Stephanie Moser, *Wondrous Curiosities: Ancient Egypt at the British Museum* (Chicago: University of Chicago Press, 2006), 101.

52 Ian Jenkins, *Archaeologists and Aesthetes in the Sculpture Galleries of the British Museum 1800–1939* (London: British Museum Press, 1992), pp. 61–65, frontispiece and color plate 6.

53 Ibid., 235, 236n23.

54 Todd Porterfield, *The Allure of Empire: Art in the Service of French Imperialism 1798–1836* (Princeton: Princeton University Press, 1998), pp. 87–91, fig. 46; *http://cartelen.louvre.fr*.

55 Ferri Pisani, *Bronzes égyptiennes*, 270 (fig.), 279–280. For the dagger, now in the Royal Library of Belgium, Brussels, see Martin von Falck and Susanne Petschel, *Pharao siegt immer: Krieg und Frieden im alten Ägypten*, exh. cat. (Bönen: Kettler, 2004), no. 131, p. 131; Christiane Ziegler, ed., *The Pharaohs*, exh. cat. (Milan: Bompiani Arte, 2002), p. 428, no. 103; Joan Aruz, Kim Benzel, and Jean M. Evans, eds., *Beyond Babylon: Art, Trade, and Diplomacy in the Second Millennium B.C.*, exh. cat. (New York: Metropolitan Museum of Art, 2008), p. 118, no. 66. For the bracelet, now in the Louvre (E. 7168), see Christiane

Ziegler and Marc Desti, eds., *Des dieux, des tombeaux, un savant: En Egypte, sur les pas de Mariette pacha*, exh. cat. (Paris: Somogy, 2004), p. 220, no. 106.

56 The story is well told by H. E. Winlock, "The Tombs of the Kings of the Seventeenth Dynasty at Thebes," *Journal of Egyptian Archaeology* 10 (1924): 260–62.

57 Cairo 14/12/27/12, lid JE 4944; Ziegler and Desti, *Des dieux, des tombeaux, un savant*, 222–23. It was not until fifty years later that another distinguished French Egyptologist recognized the name on the lid of the coffin as Kamose, the last king of the Seventeenth Dynasty (1552–1550 BC), whose younger brother and successor Ahmose (1550–1525 BC) is regarded as the first king of the Eighteenth Dynasty. See Georges Daressy, "Le cerceuil du roi Kamès," *Annales du Service des antiquités de l'Egypte* 9 (1908): 61–63, and "Les cerceuils royaux de Gournah," *Annales du Service des antiquités de l'Egypte* 12 (1912): 64–68.

58 Ferri Pisani, *Bronzes égyptiennes*, 280.

59 Ibid., 280–85. For the statue of Amen protecting Tutankhamen, now in the Louvre (E 11609), see Ziegler and Desti, *Des dieux, des tombeaux, un savant*, pp. 276–77, no. 134. For the Calendar of Elephantine (now Louvre D 68 = E 3910), see ibid., p. 259, no. 127.

60 Gaston Maspero, Mariette's successor as head of antiquities, gives this account of the boat in *Egypt: Ancient Sites and Modern Scenes* (London: T. F. Unwin, 1910), 6: "From 1881 to 1886, the period of my first sojourn in Egypt, a steamboat, the *Menchieh*, was put at my disposal. . . . She was a flat-bottomed brigantine, provided with an engine of a type archaic enough to deserve a place in the Museum of Arts and Crafts. From 1840 to 1860 she had regularly performed the journey to and fro between Alexandria and Cairo once a month. She was then invalided on account of old age, but was again put into working order for the visit of Prince Napoleon to Egypt in 1863. In 1875 she was presented to Mariette, and after a long period of inaction, descended to me, and I made my journeys in her for five years. My successors, however, did not preserve her, and on my return I found a princely old dahabieh, the *Miriam*, which I have used ever since." Online at *http://timea.rice.edu.*

61 "On ne salit pas une page d'histoire." Gaston Maspero, *Notice biographique sur Auguste Mariette (1821–1881)* (Paris: Ernest Leroux, 1904), 138.

62 François Lenormant, "L'Egypte (deuxième article)," *Gazette des beaux-arts* 23 (1867): 31. Prince Napoleon's bronze Osiris-Iah appears on the first page of the first article in the installment, though it is not mentioned in the text either; François Lenormant, "L'antiquité à l'Exposition universelle: L'Egypte (premier article)," *Gazette des beaux-arts* 22 (1867), 549.

63 Donald M. Reid, *Whose Pharaohs? Archaeology, Museums, and Egyptian National Identity from Napoleon to World War I*, (Berkeley: University of California Press, 2003), 105.

64 Jean-Marcel Humbert, Michael Pantazzi, and Christiane Ziegler, *Egyptomania: Egypt in Western Art, 1730–1930*, exh. cat. (Paris: Éditions de la Réunion des Musées Nationaux; Ottawa: National Gallery of Canada, 1994), 354–56.

65 "Nous allons faire, en effet, pour l'art égyptien, ce que le prince Napoléon avait fait pour l'art de Pompéi. Ce serait moins un monument destine à contenir quelque chose qu'une étude en quelque sorte vivante d'archéologie;" Auguste Mariette to Charles Edmond, May 3, 1866, cited by Maspero, *Mariette*, 155.

...

66 "Un traité d'archéologie d'une science profonde écrit en pierre et qu'on peut habiter;" Dahl, "A Quartet of Pompeian Pastiches," 6; Maspero, *Mariette*, 155.

67 Auguste Mariette, *Description du parc égyptien* (Paris: Dentu, 1867).

68 "Il y a quelqu'un de plus puissant que moi à Boulak; c'est à lui qu'il faut vous addresser en dernier ressort." Maspero, *Mariette*, 162.

69 Théodule Devéria, "Acquisitions du Musée égyptien au Louvre," *Bibliothèque égyptologique* 5 (Paris: Leroux, 1897), 9–10, originally published in *Revue archéologique*, 2nd series, no. 9 (1864): 220–21; False door of Isis (Louvre C 164 = E. 3909): Christiane Ziegler, *Stèles, peintures et reliefs égyptiens de l'Ancien Empire et de la Première Période Intermédiaire vers 2686–2040 avant J.-C.* (Paris: Réunion des musées nationaux, 1990), no. 10, pp. 83–85. Drum lintel of Kanefer (Louvre C 155 = E 3908): ibid., no. 43, 238–39; Ziegler and Desti, *Des dieux, des tombeaux, un savant*, no. 133, pp. 275–76. Block inscribed for Ramesses II (Louvre D 62 = E. 3907): Ziegler and Desti, *Des dieux, des tombeaux, un savant*, no. 135, p. 278.

70 Houssaye, *Confessions*, 173–74.

71 Wilhelm Fröhner, a curator in the antiquities department at the Louvre, prepared the catalogue: *Catalogue d'une collection d'antiquités par M. Fröhner, conservateur-adjoint des Musées impériaux* (Paris, 1868).

72 Georges Bénédite, "Amon et Toutânkamon (au sujet d'un groupe acquis par le Musée égyptien du Louvre)," *Fondation Eugène Piot: Monuments et Mémoires* 24 (1920): 47.

73 *Catalogue des objets d'art antiques, du Moyen Age et de la Renaissance, dépendant de la succession Alessandro Castellani et dont la vente aura lieu à Rome . . . du lundi 17 mars au jeudi 10 avril 1884* (Paris: J. Rouam, 1884), no. 754. See also Céline Ben Amar, "The Dagger of Pharaoh Kamose, the Oldest Glory of the Royal Library of Belgium," *In Monte Artium* 5 (2012): 53–54.

THE COLLECTOR

1 I am here inspired by the words of Bernard B. Bothmer: "It is significant that the man who brought to America the finest Greek sculpture of the Classical period in the Western Hemisphere, the Boston companion piece to the 'Ludovisi Throne,' should also have acquired by far the best Ptolemaic portrait sculpture owned by any museum in any country." Bernard V. Bothmer with Herman de Meulenaere and Hans Wolfgang Müller, *Egyptian Sculpture of the Late Period 700 B.C. to A.D. 100*, exh. cat. (Brooklyn: Brooklyn Museum, 1960), 138. For the "Boston Throne," see MFA 08.205.

2 Martin Burgess Green, *The Mount Vernon Street Warrens: A Boston Story, 1860–1910* (New York: Scribner's, 1989), 27.

3 The Warrens' firstborn child, Josiah Fiske, died at the age of three.

4 Osbert Burdett and E. H. Goddard, *Edward Perry Warren: The Biography of a Connoisseur* (London: Christophers, 1941), 364.

..

5 Carol Troyen and Pamela S. Tabbaa, *The Great Boston Collectors: Paintings from the Museum of Fine Arts* (Boston: Museum of Fine Arts, 1984), 20.

6 MFA 77.249.

7 Erica E. Hirshler, *Impressionism Abroad: Boston and French Painting*, exh. cat. (London: Royal Academy of Arts, 2005), 21–22, 131.

8 She had at least six Corots, five Millets, and four paintings by Charles François Daubigny, in addition to works by Thomas Couture and Narcisse Virgile Diaz de la Peña, many now in the MFA. See Alexandra R. Murphy, *European Paintings in the Museum of Fine Arts, Boston: An Illustrated Summary Catalogue* (Boston: Museum of Fine Arts, 1985).

9 See Rollin Van N. Hadley, ed., *The Letters of Bernard Berenson and Isabella Stewart Gardner, 1887–1924* (Boston: Northeastern University Press, 1987), 55–56.

10 Ibid., 249. The Lippi tondo is now in the Cleveland Museum of Art, cmA 32.227.

11 Green, *The Mount Vernon Street Warrens*, 58–60.

12 Burdett and Goddard, *Edward Perry Warren*, 5, 13.

13 Ibid., 3.

14 Ibid., 364.

15 Ibid., 14.

16 Ibid., 9.

17 Ibid., 10, 347.

18 Ibid., 18–20.

19 Ibid., 33, 39.

20 Ibid., 56.

21 Ibid., 60.

22 Ibid., 61.

23 MFA 87.1; see Walter Muir Whitehill, *Museum of Fine Arts, Boston: A Centennial History*, 2 vols. (Cambridge, Mass: Harvard University Press, 1970), 1: 67, left.

24 Burdett and Goddard, *Edward Perry Warren*, 111; Green, *The Mount Vernon Street Warrens*, 94.

25 Burdett and Goddard, *Edward Perry Warren*, 122.

26 The principal characters are discussed by David Sox, *Bachelors of Art: Edward Perry Warren and the Lewes House Brotherhood* (London: Fourth Estate, 1991).

27 For life at Lewes House, see Burdett and Goddard, *Edward Perry Warren*, 128–134, 139–150, 257–258.

28 Burdett and Goddard, *Edward Perry Warren*, 259. The Lippi tondo is now in the Cleveland Museum of Art, the Cranach in the Courtauld Gallery, London. Warren placed the Rodin on loan in the town hall at Lewes, but it made the Lewesians uncomfortable, so they returned it; it is now in the Tate Britain (N06228); see online catalogue entry at *www.tate.org.uk*.

29 Green, *The Mount Vernon Street Warrens*, 117; also Burdett and Goddard, *Edward Perry Warren*, 134.

30 Burdett and Goddard, *Edward Perry Warren*, 142.

31 Plat. Sym. 180c–185d: Plato, *The Symposium*, trans. Christopher Gill, Penguin Classics (London: Penguin Books, 1999), 12–13.

32 Burdett and Goddard, *Edward Perry Warren*, 333.

33 MFA 95.27.

34 Edward Robinson, "Report of the Curator of Classical Antiquities," *Annual Report of the Museum of Fine Arts, Boston, 1890*, 15–21; for the earrings, see Christine Kondoleon and Phoebe Segal, eds., *Aphrodite and the Gods of Love*, exh. cat. (Boston: MFA Publications, 2011), p. 96, no. 69.

35 Architrave with Herakles and centaurs, MFA 84.67; architrave with facing sphinxes, MFA 84.68.

36 Edward Robinson, "Report of the Curator of Classical Antiquities," *Annual Report of the Museum of Fine Arts, Boston, 1889*, 12. By 1889 Boston had the third largest collection of classical casts in the world, after Berlin and Strasbourg.

37 Whitehill, *Museum of Fine Arts, Boston*, 1: 147–48.

38 Ibid., 1: 147.

39 Ibid.

40 Ibid., 1: 169.

41 MFA 95.67.

42 Whitehill, *Museum of Fine Arts, Boston*, 1: 150–51.

43 Kondoleon and Segal, *Aphrodite and the Gods of Love*, p. 111, no. 82 (Douris), and pp. 114–15, no. 94 (Nikosthenes).

44 See Walter Muir Whitehill, "The Vicissitudes of Bacchante in Boston," *The New England Quarterly* 27, no. 4 (December 1954): 435–54.

45 Ibid., 448.

46 Ibid., 449. Turned out of Boston, *Bacchante* went to New York, where she was welcomed. Today Boston has two *Bacchantes*, one in the MFA (30.521), and another in the Public Library where she was meant to be all along.

47 Burdett and Goddard, *Edward Perry Warren*, 146; also Whitehill, *Museum of Fine Arts, Boston*, 1: 142.

48 Whitehill, *Museum of Fine Arts, Boston*, 1: 160.

49 "Report of the Curator of Classical Antiquities," *Annual Report of the Museum of Fine Arts, Boston, 1903*, 55.

50 "Report of the President," *Annual Report of the Museum of Fine Arts, Boston, 1904*, 18–19.

51 Hadley, *Letters of Berenson and Gardner*, 417.

...

52 Green, *The Mount Vernon Street Warrens*, 180–81.

53 Burdett and Goddard, *Edward Perry Warren*, 348.

54 Albert M. Lythgoe, "Report of the Curator of the Egyptian Department," *Annual Report of the Museum of Fine Arts, Boston*, 1904, 73.

55 Arséne Houssaye, *Les confessions: Souvenirs d'un demi-siècle 1830–1890*, vol. 5 (Paris: E. Dentu, 1891), 173–74.

56 Richard Delbrück, ed., *Antike Porträts* (Bonn: A. Marcus und E. Weber, 1912), p. xxviii, no. 12.

57 Bothmer et al., *Egyptian Sculpture of the Late Period*, 139.

58 British Museum EA65443; height: 46 cm; height of head: 8 cm; online at *www.british museum.org*.

59 G. Maspero, *Art in Egypt* (London: Heinemann, 1921), 252–53.

60 Cairo CG 726 from Mit Rahina, Dynasty 27, graywacke, height: 44.5 cm; Bothmer et al., *Egyptian Sculpture of the Late Period*, no. 65; Edward L. B. Terrace and Henry G. Fischer, *Treasures of Egyptian Art from the Cairo Museum: A Centennial Exhibition, 1970–71*, exh. cat. (Boston: Museum of Fine Arts, 1970), no. 39, pp. 169–72.

61 See Edna R. Russmann, *Eternal Egypt: Masterworks of Ancient Art from the British Museum*, exh. cat. (London: British Museum, 2001), 253–55.

62 Euphrosyne Doxiades, *The Mysterious Fayum Portraits: Faces from Ancient Egypt* (London: Abrams, 1995); Susan Walker, ed., *Ancient Faces: Mummy Portraits from Roman Egypt*, exh. cat. (New York: Metropolitan Museum of Art, 2000).

63 For the location, see Studebaker Map of World's Columbian Fairgrounds (1893); see also the *Official Catalogue of Exhibits on the Midway Plaisance* (1893), no. 34: "On view in the town hall of the Old Vienna grounds is a collection of ancient Greek paintings 2,000 years old, from the tombs of Faijum, (Egypt). Also a face mummy, of the period of Christ, the oldest existing Bible manuscript on papyrus, and other antiquities. Admission, 25 cents." Both online at *www.encyclopedia.chicago history.org*.

64 "Report of the Committee on the Museum," *Annual Report of the Museum of Fine Arts, Boston*, 1893, 8.

65 MFA 93.1450–1451; *Catalogue of the Theodor Graf Collection of Unique Ancient Greek Portraits, 2000 Years Old* (1893), p. 30, nos. 71, 79.

66 MFA 11.2892.

67 Lorelei H. Corcoran and Marie Svoboda, *Herakleides: A Portrait Mummy from Roman Egypt* (Los Angeles: J. Paul Getty Museum, 2010), 20, citing Mary McCrimmon, "Graeco-Egyptian Masks and Portraits in Toronto," *American Journal of Archaeology* 49, no. 1 (Jan.–Mar. 1945): 61.

68 The J. Paul Getty Museum in Malibu is not known for its Egyptian antiquities, but its world-class collection of classical antiquities embraces twelve mummy portraits and one intact portrait mummy. David L. Thompson, *Mummy Portraits in the J. Paul Getty Museum* (Malibu: J. Paul Getty Museum, 1982).

69 See Lawrence M. Berman, "Egypt Lost and Found in Boston," in *MFA Highlights: Arts of Ancient Egypt* (Boston: MFA Publications, 2003), 11–24; idem, "The Prehistory of the Egyptian Department of the Museum of Fine Arts, Boston," in *Egyptian Museum Collections around the World: Studies for the Centennial of the Egyptian Museum Cairo*, ed. Mamdouh Eldamaty and Mai Trad, 2 vols. (Cairo: Supreme Council of Antiquities, 2002), vol. 1, 119–32.

70 MFA 75.10.

71 See Sue D'Auria, "The American Branch of the Egyptian Exploration Fund," in *The Art and Archaeology of Ancient Egypt: Essays in Honor of David B. O'Connor*, ed. Zahi Hawass and Janet Richards, *Annales du Service des Antiquites de l'Egypte*, cahier no. 36 (Cairo: Publications du Conseil Supreme des Antiquites de l'Egypte, 2007), 185–98.

72 Fifth Annual Report of the Egypt Exploration Fund (1886–87), 19.

73 MFA 89.555, 89.556a–b, and 89.558; *MFA Highlights: Arts of Ancient Egypt*, 132, 162, 173.

74 MFA 04.1760 and 04.1761.

75 Davis, a retired American businessman from New York, held the right to excavate the Valley of the Kings from 1903 to 1912.

THE PRIEST

1 Herod. 2.36.1, Robert B. Strassler, ed., *The Landmark Herodotus: The Histories*, trans. Andrea L. Purvis (New York: Pantheon Books, 2007), 133.

2 Herod. 2.37.2–5, Strassler, *The Landmark Herodotus*, 133–34.

3 Serge Sauneron, *The Priests of Ancient Egypt*, new ed., trans. David Lorton (Ithaca: Cornell University Press, 2000).

4 *Handbook of the Museum of Fine Arts, Boston* (Boston, 1907), 29.

5 Berlin Inv.-No. ÄM 12500; Delbrück, *Antike Porträts*, p. xxviii, nos. 11 (Berlin), 12 (Boston); pls. 11 (Boston), 12 (Berlin).

6 Ibid., xiii.

7 Ibid.

8 Most notably, that of Mentuemhat, mayor of Thebes in the reigns of Taharqa and Psammetichus I, in the Egyptian Museum, Cairo (JE 31884); Delbrück, *Antike Porträts*, p. xxviii, no. 9. The head has been often illustrated: W. Stevenson Smith, *The Art and Architecture of Ancient Egypt*, 3rd ed., rev. by William Kelly Simpson, Pelican History of Art (New Haven: Yale University Press, 1998), p. 204, fig. 409; Edna R. Russmann, *Egyptian Sculpture: Cairo and Luxor* (Austin: University of Texas Press, 1989), p. 173, no. 79.

9 Delbrück, *Antike Porträts*, xxviii. Compare Claude Vandersleyen, "De l'influence grecque sur l'art égyptien: Plis de vêtements et plis de peau," *Chronique d'Egypte* 60 (1985): 370: "Si l'on veut y voir une influence grecque, il faut se souvenir les Grecs n'ont jamais rien fait qui meme de loin ressembe à cette tête" (If one wishes to see a Greek influence there, one has to remember that the Greeks never made anything that even remotely resembles this head).

10 Dows Dunham, "Two Egyptian Portraits," *Bulletin of the Museum of Fine Arts* 35, no. 211 (October 1937): 70–73. The man in a bag wig is MFA 37.377.

......

11 William Stevenson Smith, *A History of Egyptian Sculpture and Painting in the Old Kingdom* (London: Oxford University Press, 1946).

12 William Stevenson Smith, *Ancient Egypt as Represented in the Museum of Fine Arts, Boston* (Boston: Museum of Fine Arts, 1942), 155. In the sixth edition (1960) the word "probably" has been deleted (p. 176).

13 William Stevenson Smith, "Three Late Egyptian Reliefs," *Bulletin of the Museum of Fine Arts* 47 (June 1949): 26, 28–29. For the reliefs in Alexandria and Cairo, see Smith, *Art and Architecture*, 3rd ed. (1998), p. 246, fig. 412; Gay Robins, *The Art of Ancient Egypt* (London: British Museum Press, 1997), p. 246, fig. 296. See also a relief fragment of girls boating acquired by the MFA in 1940 (40.619).

14 The bust of Prince Ankhhaf is MFA 27.442.

15 W. Stevenson Smith, *The Art and Architecture of Ancient Egypt*, Pelican History of Art (Harmondsworth, Middlesex: Penguin Books, 1958), 252; Smith, *Art and Architecture*, 3rd ed. (1998), 247.

16 Smith, *Art and Architecture*, 3rd ed. (1998), 247–48. Smith knew what he was talking about when it came to interconnections in ancient art: his *Interconnections in the Ancient Near East: A Study of the Relationships between the Arts of Egypt, the Aegean, and Western Asia* (New Haven: Yale University Press, 1965) revealed an astonishing breadth of knowledge and broke new ground in its scientific approach to the subject.

17 Richard A. Fazzini, "Bernard V. Bothmer," *Journal of the American Research Center in Egypt* 32 (1995): i–iii; T. G. H. James, "Bernard V. Bothmer: *doctor doctissimus optimisque artibus eruditissimus*," in *Egyptian Art: Selected Writings of Bernard V. Bothmer*, ed. Madeleine E. Cody (Oxford: Oxford University Press, 2004), xvii–xx.

18 Bernard V. Bothmer, "A New Field of Egyptian Art: Sculpture of the Late Period," in Cody, ed., *Egyptian Art*, 144.

19 Bernard V. Bothmer with Herman de Meulenaere and Hans Wolfgang Müller, *Egyptian Sculpture of the Late Period 700 B.C. to A.D. 100*, exh. cat. (Brooklyn: Brooklyn Museum, 1960), no. 108, pp. 138–140, pls. 100–101 (Boston), and no. 127, pp. 164–166, pls. 100, 118–119 (Berlin).

20 Ibid., 139.

21 MFA 99.343.

22 Susan Walker and Peter Higgs, eds., *Cleopatra of Egypt: From History to Myth*, exh. cat. (Princeton: Princeton University Press; London: British Museum, 2001), p. 223, no. 199.

23 Bothmer et al., *Egyptian Sculpture of the Late Period*, 175; restated in Bernard V. Bothmer, "Egyptian Antecedents of Roman Republican Realism," in Cody, ed., *Egyptian Art*, 427.

24 He loved telling the story of how the distinguished Danish scholar Frederick Poulsen, from photographs, mistook a fragmentary late Egyptian head in graywacke for a Roman portrait: Bernard V. Bothmer, "Roman Republican and Late Egyptian Portraiture," *American Journal of Archaeology* 58, no. 2 (April 1954): 143–44; idem, "Egyptian Antecedents of Roman

Republican Realism," 416. For the classical view, see R. R. R. Smith, "Greeks, Foreigners, and Roman Republican Portraits," *The Journal of Roman Studies* 71 (1981): 32–33.

25 Susan Walker, in *Cleopatra of Egypt*, p. 223, no. 199. See also Jack A. Josephson, Paul O'Rourke, and Richard Fazzini, "The Doha Head: A Late Period Egyptian Portrait," *Mitteilungen des Deutschen Archäologischen Instituts, Abteilung Kairo* 61 (2005): 230.

26 Robert S. Bianchi et al., *Cleopatra's Egypt: Age of the Ptolemies*, exh. cat. (Brooklyn Museum, 1988), pp. 140–142, nos. 45–46.

27 Arielle P. Kozloff, "Is There an Alexandrian Style—What is Egyptian about It?" in *Alexandria and Alexandrianism: Papers Delivered at a Symposium Organized by the J. Paul Getty Museum and the Getty Center for the History of Art and the Humanities and Held at the Museum, April 22–25, 1993* (Malibu: J. Paul Getty Museum, 1996), 251.

28 Dynasty 30: Jack A. Josephson, "*Egyptian Sculpture of the Late Period* Revisited," *Journal of the American Research Center in Egypt* 34 (1997): 18–20; Josephson et al., "The Doha Head," 226–28. Ptolemaic Dynasty: Russmann, *Eternal Egypt*, p. 39, fig. 26; Olivier Perdu, in *Le crépuscule des Pharaons: Chef-d'oeuvres des dernières dynasties égyptiennes*, exh. cat. (Paris: Musée Jacquemart-André; Brussels: Fonds Mercator, 2012), pp. 90–93, nos. 33 and 34.

29 *MFA Highlights: Arts of Egypt* (Boston: MFA Publications, 2003), 186. Berlin: www. egyptian-museum-berlin.com/c42.php; Friederike Seyfried and Matthias Wemhoff, eds., *Neues Museum Berlin: Egyptian Museum and Papyrus Collection, Museum of Prehistory and Early History* (Munich: Prestel, 2010), 70; Dietrich Wildung, *Ägyptisches Museum und Papyrussammlung Berlin* (Munich: Prestel, 2005), 53; Dietrich Wildung, ed., *Ägypten 2000 v. Chr.: Die Geburt des Individuums*, exh. cat. (Munich: Hirmer, 2000), p. 187, no. 91.

30 Bothmer et al., *Egyptian Sculpture of the Late Period*, 139–40.

31 Alexander Henry Rhind (1833–1863) was a Scottish lawyer who came to Egypt in 1855 for his health. He focused his activity on Theban tombs. He spent two seasons (1855–56 and 1856–57) digging at Thebes, visited Egypt again in 1862–63, and died at the age of thirty having made little impact on the practice of Egyptology. Joseph Hekekyan (1907–1975), a British-trained geologist, was director of the School of Engineering in Cairo under Muhammad Ali; dismissed by Abbas, he turned to archaeology. His achievements in that field are only now receiving their due. See David Jeffreys, "Joseph Hekekyan, Pioneer Archaeologist," *Egyptian Archaeology* 37 (Autumn 2010): 7–8.

32 A. Henry Rhind, *Thebes, Its Tombs and Their Tenants* (London: Longman, 1862; reprint Piscataway, N.J.: Gorgias Press, 2002), 271.

33 Christiane Ziegler, "Une découverte inédite de Mariette, les bronzes du Sérapeum," *Bulletin de la Société française d'Egyptologie* 90 (April 1981): 31; Georges Daressy, *Statues de divinités*, Catalogue general des antiquités égyptienes du Musée du Caire 28 (Cairo: Institut français d'archéologie orientale, 1906), p. 74, no. 38245.

34 Diod. 16.51.2–3. Diodorus of Sicily, *The Library of History VII: Books XV.20–XVI.65*, trans. Charles L. Sherman, Loeb Classical Library (Cambridge, Mass.: Harvard University Press, 1963), 381–83.

35 H. S. Smith, "Saqqara, Nekropolen, SpZt," in Lexikon der Ägyptologie (Wiesbaden: Otto Harrassowitz, 1972–92), 5: 420–21.

36 Museo Gregoriano Egizio 22690: Il senso dell arte nell'Antico Egitto, exh. cat. (Milan: Electa, 1990), pp. 167–69, no. 115.

37 Jean-Marcel Humbert, Michael Pantazzi, and Christiane Ziegler, Egyptomania: Egypt in Western Art, 1730–1930, exh. cat. (Paris: Éditions de la Réunion des Musées Nationaux; Ottawa: National Gallery of Canada, 1994), p. 63, fig. 31; Anne Roullet, The Egyptian and Egyptianizing Monuments of Imperial Rome, (Leiden: E. J. Brill, 1972), p. 114, no. 198, pl. CLXI; Johann Joachim Winckelmann, Storia delle arti del disegno presso gli antichi (Rome: dalla stamperia Pagliarini, 1783–84), pl. VII; online at http://archive.org/stream/storiadel leartid01winc, accessed 2/19/13.

38 Miriam Lichtheim, Ancient Egyptian Literature: A Book of Readings, vol. 3, The Late Period (Berkeley: University of California Press, 1980), 36–41.

39 Herod. 2.3.16, 2.3.29; Strassler, The Landmark Herodotus, 214, 220; Pierre Briant, From Cyrus to Alexander: A History of the Persian Empire, trans. Peter T. Daniels (Winona Lake, Ind.: Eisenbrauns, 2002), 55–61.

40 Lichtheim, Ancient Egyptian Literature: The Late Period, 38.

41 Ibid., 39.

42 Examples of such animal-head bracelets, made of gold, some inlaid with colored stones, glass, and faience, have survived; they were highly prized gifts of the Great King to his most distinguished subjects. See John E. Curtis and Nigel Tallis, eds., Forgotten Empire: The World of Ancient Persia, exh. cat. (Berkeley and Los Angeles: University of California Press in association with the British Museum, 2005), 137–43.

43 Hdt. 2.154.4; Strassler, The Landmark Herodotus, 190.

44 A fine example is the sarcophagus of Kheperra in the MFA (34.834b).

45 Smith, "Saqqara," 417. Grids on the stelae of Djoser (in Room III under the Step Pyramid) preserve extensive grid traces. The grids conform to the later grid system of 21 squares from the soles of the feet to the hairline and were presumably put on by Saite artists studying the earlier figures; Gay Robins, Proportion and Style in Ancient Egyptian Art (Austin: University of Texas Press, 1994), 169–70.

46 This is recorded in a magnificent stele now at the Louvre: http://www.louvre.fr/en/oeuvre-notices/stele-dedicated-king-amasis-apis-bull-died-during-his-reign; Lawrence M. Berman and Bernadette Letellier, Pharaohs, Treasures of Egyptian Art from the Louvre (Cleveland: Cleveland Museum of Art in association with Oxford University Press, 1996), pp. 80–81, no. 24.

47 Herod. 2.3.16, 2.3.29; Strassler, The Landmark Herodotus, 214, 220; Pierre Briant, From Cyrus to Alexander: A History of the Persian Empire, trans. Peter T. Daniels (Winona Lake, Ind.: Eisenbrauns, 2002), 55–61.

48 Curtis and Tallis, Forgotten Empire, p. 99, no. 88; John Boardman, Persia and the West (London: Thames & Hudson, 2000), pp. 77–79, figs. 2.61–62, and pp. 115–16, figs. 3.36–37.

49 J. D. Ray, "Egypt 524–404 B.C.," *The Cambridge Ancient History*, 2nd ed., vol. 4: *Persia, Greece and the Western Mediterranean c. 525 to 479 B.C.* (Cambridge: Cambridge University Press, 1988), 262–63. Fragments of similar statues suggest it may have been one of several. See Prudence O. Harper, Joan Aruz, and François Tallon, *The Royal City of Susa: Ancient Near Eastern Treasures in the Louvre* (New York: Metropolitan Museum of Art, 1992), pp. 219–20, fig. 50.

50 Dieter Arnold, *Temples of the Last Pharaohs* (New York: Oxford University Press, 1999), 105–36.

51 Ibid., pp. 138–39, fig. 93.

52 Bark shrine of Philip Arrhidhaeus: Arnold, *Temples of the Last Pharaohs*, pp. 131–132, figs. 87–88; doorway of Alexander IV: ibid., pp. 140–41, figs. 94–95. Fragments of the bark shrine are in Boston (MFA 75.11a–d): Bernard V. Bothmer, "Ptolemaic Reliefs I: A Granite Block of Philip Arrhidaeus," *Bulletin of the Museum of Fine Arts* 50, no. 280 (June 1952):19–27.

53 Robert K. Ritner, in *The Literature of Ancient Egypt*, 3rd ed., ed. William Kelly Simpson et al. (New Haven: Yale University Press, 2003), 393.

54 Smith, "Saqqara," 418–19.

55 Louvre N 432 B and C; Jean-Philippe Lauer, *Saqqara: The Royal Cemetery of Memphis—Excavations and Discoveries since 1850* (London: Thames & Hudson, 1976), pl. 7; Humbert et al., *Egyptomania*, no. 208, pp. 345–47; Christiane Ziegler and Marc Desti, eds., *Des dieux, des tombeaux, un savant: En Egypte, sur les pas de Mariette pacha*, exh. cat. (Paris: Somogy, 2004), no. 60, pp. 122–23; *www.louvre.fr/en/oeuvre-notices/guardian-lion-entrance-chapel-serapeum-saqqara*.

56 Berman and Letellier, *Pharaohs*, pp. 86–87, no. 27.

57 See Frédérique von Kaenel, "Les mésaventures du conjurateur de Serqet Onnophris et de son tombeau," *Bulletin de la Société française d'Égyptologie* 87–88 (March and May 1980): 31–45; Dieter Arnold, "The Late Period Tombs of Hor-khebit, Wennefer and Wereshnefer at Saqqâra," in *Études sur l'Ancien Empire et la nécropole de Saqqâra dédiées à Jean-Philippe Lauer*, ed. Catherine Berger and Bernard Matthieu (Montpellier: Université Paul Valéry, 1997), 33–39, 44–54.

58 Gustave Lefebvre, *Le tombeau de Petosiris*, 3 vols. (Cairo: Institut français d'archéologie orientale, 1923–24); Nadine Cherpion, Jean-Pierre Corteggiani, and Jean-Francois Gout, *Le tombeau de Pétosiris à Touna el-Gebel: Relevé photographique* (Cairo: Institut français d'archéologie orientale, 2007).

59 The superstructure takes the form of a contemporary temple with *pronaos*, or forehall, with columns connected at the bottom by screen walls, an architectural feature that first appears—at Hermopolis in fact—in the reign of Nectanebo I and that became a fixture in temple architecture of the Ptolemaic and Roman periods. Arnold, *Temples of the Last Pharaohs*, pp. 111–13, figs. 66–67; Aidan Dodson and Salima Ikram, *The Tomb in Ancient Egypt: Royal and Private Sepulchres from the Early Dynastic Period to the Romans* (London: Thames & Hudson, 2008), pp. 293–94, figs. 348–49.

60 Briant, *From Cyrus to Alexander*, 861.

61 Lichtheim, *Ancient Egyptian Literature: The Late Period*, 51.

62 Ibid., 53–54.

63 Ibid., 45–48.

64 Lefebvre, *Le Tombeau de Petosiris*, 1: 21–25; Sauneron, *Priests of Ancient Egypt*, 10.

LIST OF ILLUSTRATIONS

Objects and publications are from the collections of the Museum of Fine Arts, Boston, unless stated otherwise.

194

ACKNOWLEDGMENTS

The idea for this book came to me in an odd way. In 2009 the MFA published *Sargent's Daughters*, by my colleague Erica E. Hirshler, Croll Senior Curator of American Paintings. Subtitled *The Biography of a Painting*, the book told the story behind John Singer Sargent's *Daughters of Edward Darley Boit*: how the work came about, the artist, the subjects, and the aftermath of the painting. I asked myself, what well-known masterpiece (for it had to be both) in the Egyptian collection had a similar allure, and such a fascinating past? The answer was obvious: the Boston Green Head, a world-renowned yet mysterious masterpiece of Late Egyptian sculpture. For Sargent's group portrait of 1882 we are sure of both the artist and the subject, whereas with the Green Head we know neither; even the date of the sculpture is disputed. But still, there was plenty of material on which to hang a story, indeed many stories—about the head, the circumstances of its discovery, its modern owners, its reception by scholars and connoisseurs, and its influence on how we perceive Egyptian art.

I am grateful to Malcolm Rogers, Ann and Graham Gund Director, and Katie Getchell, Deputy Director, for their support, which enabled me to pursue a number of lines of research that converged on this singular masterpiece, and which I hope will bring it to an even wider audience. Rita E. Freed, John F. Cogan, Jr. and Mary L. Cornille Chair, Art of the Ancient World, knowing how important the project was to me and sharing my enthusiasm, encouraged me to pursue it and graciously allowed me the necessary time to see it through. Emiko K. Usui, director of MFA Publications, welcomed the idea with enthusiasm.

My colleagues in Art of the Ancient World each read the manuscript in whole or in part. For their comments and suggestions, and above all for their ever-ready support, I thank Denise M. Doxey, Curator of Ancient Egyptian, Nubian, and Near Eastern Art; Susan J. Allen, Research Associate, Egyptian Expedition Archives; Christine Kondoleon, George D.

and Margo Behrakis Senior Curator of Greek and Roman Art; Mary B. Comstock, Cornelius and Emily Vermeule Curator and Keeper of Coins, Greek and Roman Art; and Phoebe Segal, Mary Bryce Comstock Assistant Curator of Greek and Roman Art.

An Egyptologist (even a Francophile like myself) ventures into the dangerous waters of Second Empire France with mixed joy and trepidation. I am grateful to Emily Beeny, former assistant curator of European paintings at the MFA, now associate curator at the Norton Simon Museum in Pasadena, for reading over the chapter on Prince Napoleon and for her perceptive comments and suggestions.

I could not have asked for a more sympathetic editor than Jennifer Snodgrass. The perfect collaborator, Jennifer grasped exactly what I was trying to do and how best to achieve it; it was a real pleasure to work with her on this project. Katherine Harper obtained images from various and sundry sources. Anna Barnet and Terry McAweeney assisted in key ways. At Marquand Books, I am most grateful to designer Jeff Wincapaw, for his sensitivity to our ideas while coming up with a pleasing, elegant, and appropriate design for the book.

We are fortunate at the MFA to have an excellent library, rich in Egyptological holdings. I thank Head Librarian Deborah Barlow Smedstad and her staff, who responded quickly and with good cheer to my every request. Special thanks go to book conservator Marie Oedel. It was an inspiration to be able to use our own copy of Henri Alexandre Wallon's *Notice sur la vie et les travaux de François-Auguste-Ferdinand Mariette-Pacha* (1883), inscribed by Mariette's daughter Sophie to Luigi Vassalli Bey, and Vassalli's own copy of Mariette's *Sérapeum de Memphis*. I can only hope some of their connection to the original events rubbed off.

Lawrence. M. Berman
Norma Jean Calderwood Senior Curator of Ancient Egyptian, Nubian, and Near Eastern Art
Museum of Fine Arts, Boston

INDEX